LANDSCAPE PAINTING IN WATERCOLOR

LANDSCAPE PAINTING IN WATERCOLOR BY ZOLTAN SZABO

WATSON-GUPTILL PUBLICATIONS/NEW YORK

PITMAN PUBLISHING/LONDON

GENERAL PUBLISHING CO. LTD./TORONTO

First published 1971 in the United States by Watson-Guptill Publications,
a division of Billboard Publications, Inc.
1515 Broadway, New York, N.Y. 10036

Library of Congress Catalog Card Number: 79-141045
ISBN 0-8230-2620-5

Published in Great Britain 1974 by Sir Isaac Pitman & Sons Ltd.,
39 Parker Street, Kingsway, London WC2B 5PB
ISBN 0-273-00842-0

Published in Canada 1974 by General Publishing Company, Ltd.,
30 Lesmill Road, Don Mills, Ontario
ISBN 0-7736-0034-5

Manufactured in Japan

First Printing, 1971
Second Printing, 1972
Third Printing, 1973
Fourth Printing, 1974
Fifth Printing, 1975
Sixth Printing, 1976
Seventh Printing, 1977

DEDICATION

An artist is a little bit like God. Out of the demands of his intellect and influenced by his intuition, he creates. Yet, in his role as creator, man is far from perfect. The creation of even a simple snowflake is beyond man's capability. To me, as an artist, this humble little ice crystal symbolizes beauty and simplicity. The purity of a snowflake is the result of all the colors of the rainbow combining to become the whitest white. The snowflake responds with extreme sensitivity to the slightest change in its environment, taking on the blue tint of the sky, the greens of the forest, the pink and golden colors of the sun, to offer the painter a power potential limited only by his imagination. Therefore, I dedicate this book to a single little snowflake. A snowflake which fell from the heavens, like pure love, to make this earth a little cleaner and my life more beautiful.

ACKNOWLEDGMENTS

Special thanks are due Coutts Hallmark Cards, Toronto, Ontario, for their cooperation in providing the publishers with color separations for paintings from the Painters of Canada Series. In the photography department, I'd like to thank Tom Beckett, Beckett Galleries, Hamilton, Ontario and H. Michael Brauer, Sault Ste. Marie, Ontario.

CONTENTS

1. INTRODUCING WATERCOLOR

In this chapter, we'll discuss the characteristics of transparent watercolor and the materials and equipment used by the watercolorist.

THE NATURE OF WATERCOLOR

Watercolor differs a great deal from other painting media because of its transparency. This means that the bright whiteness of your paper reflects the light through the thin layer of your paint. Watercolor is at its best when it results in transparency — that is, when the paper shows through.

Clean Color

Clean color is essential for transparency and fresh painting. If you put several layers of paint on top of one another, allowing them to dry in between applications, you'll end up with a muddy color. For example, if you paint a flat yellow wash, let it dry, then put a blue wash over it, theoretically you'll end up with a green wash. However, in reality, this green wash will be a lot dirtier than if you mix and apply the same amount of yellow and blue pigments in a *single* wash. The more layers of paint on the paper, the chalkier and duller the result will be.

Color Value

Good watercolor papers are absorbent. Because of this, the colors dry much weaker than they look while wet. To avoid disappointment in your final color, exaggerate the value of your wet color by about 20%. The softer your paper, the more paint it will absorb and the more you'll have to exaggerate the wet color to end up with the correct value. This will stop being a problem once you get used to the paper's behavior.

Opaque Watercolor

Watercolor doesn't always have to be transparent, of course, even though most of us think of it that way when we talk about it. Opaque watercolor — which covers up what's underneath — is basically the same as transparent watercolor, but the pigment is usually coarser, grainier. Egg tempera, gouache or designers' colors, casein, and the new acrylics are all opaque, water-based paints. The uses of opaque watercolors are so different from transparent watercolors that I don't intend to elaborate on them in this book.

However, I thought you should know that they exist and that they're very interesting to work with, if you should decide to experiment later on.

MATERIALS AND EQUIPMENT

Your watercolor painting will be as permanent and as good as the paint and the paper you use.

Paper

What do I mean by good paper? I mean 100% pure rag, handmade, watercolor paper. At first, these papers will seem too expensive, but I hope to convince you that they're not. Because of the temperamental nature of the medium, you need all the material help you can get to succeed. A good paper is essential. A cheap paper cannot respond to treatment like a good one, and your paint and brushes will get only as good a response as your paper will allow. If you learn on cheap pulp paper, you'll not only suffer through a discouraging, slow advance, but you'll also face the problem that whatever you learn will have to be relearned again when you graduate to serious painting and good paper — which behaves differently than cheap paper. You'll use handmade paper eventually, so my advice is to start with it.

The many different makes offer a wide choice of papers. Most of them come in imperial size (22" x 30") and in three finishes: rough, medium rough (cold pressed), and smooth (hot pressed). The three most common weights are 72 lb. (thin), 140 lb. (medium), and 300 lb. (stiff as cardboard). Most good papers are from Europe. D'Arches, Fabriano, Royal Watercolour Society, Green, and Whatman (no longer made, but you can still find it) are all good quality papers. There are many more, but I know from personal experience that these are reliable makes. I use d'Arches 300 lb. rough paper most of the time, but I also use their medium rough (cold pressed) paper occasionally.

Stretching Paper

To prevent a lightweight paper from buckling when wet, it must be stretched. The 72 lb. and 140 lb. weights are thin and require stretching; the heavier 300 lb. paper won't buckle, so it doesn't need to be stretched. There are wet and dry methods available for stretching.

Wet stretching starts with wetting the paper thoroughly. Wipe or blot — don't rub — excess moisture off with a sponge or soft cloth until the limp, damp paper is no longer shiny from the water. Lay the paper on a stiff board at least 2" larger on all sides than the paper. Using a water-soluble glue tape (like old-fashioned brown wrapping tape), tape down all four edges of the sheet, overlapping about 1/4" of the paper. The wider remaining part of the tape sticks to the board. After the paper dries and shrinks you'll have a tight, flat, workable surface to paint on.

Dry stretching is similar, except that you don't wet the paper. Lay the dry paper on the board as before. Use a wide masking tape instead of the water-soluble glue tape for mounting the edges to the board. Now you can either wet the paper or you can just start painting on it (which, of course, means wetting it anyway). While it's wet, the paper may buckle a bit, but after drying it will be flat again.

I've devised a stretching frame that's quick and efficient, if you don't mind losing 1/2" of your paper on all sides (A, B).

A

B

Drawing Board

To be able to use your paper, you must have a hard surface under it. A regular drawing board is good to

have, but an ordinary piece of 1/2" or 3/4" plywood board cut to about 2" larger than the size of your paper is fine. 17" x 24" is a good outdoor size; it will receive a 1/2 sheet paper, or smaller, and will have enough room for the tape if you want to stretch your paper. You could paint a coat or two of shellac or varnish on your board to make it water-repellent.

Easel

An easel is not essential, but it's a very handy thing to have. Any easel that's sturdy and has an adjustable surface that can stay horizontal (flat) or vertical (upright) will do the job. After many years of searching for a good watercolor easel, I designed my own(C, D).

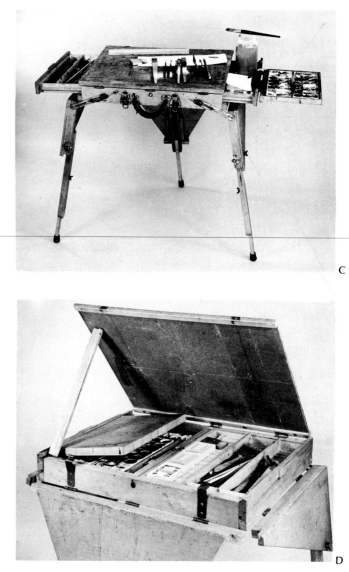

C

D

Water Carrier

When you go painting, I advise you to carry your own water supply. Very often you'll end up in a spot where there is no water or where the water is dirty. Make sure that your water carrier holds enough water to use

it freely. I use a plastic milk jug with a handle. Glass bottles are not only clumsy, but dangerous should they break. While painting, use a plastic food container with a wide top for your water.

Watercolor Paints

To do justice to good quality paper, you need good paints. Students' quality paints are all right to start with if they're made by reputable manufacturers. They're less expensive than artists' quality paints, though not as permanent and not as easy to maneuver on the paper. I naturally recommend artists' quality paints if you can possibly afford them. They'll last longer and help you enjoy better results sooner. I suggest you buy just a few tubes of good artists' quality colors.

As far as the makes go, the British Winsor & Newton and the American Grumbacher are the leading names in watercolors. You can buy the same quality paint in tubes or in pans. Most watercolorists prefer tubes because the moist consistency of the paint lends itself to immediate response at the touch of a moist brush. I prefer Winsor & Newton artists' quality paints.

This is my palette of proven colors, suited to my particular needs. I've noted the ones I find essential.

Cadmium lemon pale (essential)

Cadmium orange

Cadmium scarlet

Vermilion (essential)

Alizarin crimson (essential)

Brown madder

Manganese blue

Cerulean blue (essential)

Cobalt blue

French ultramarine blue (essential)

Antwerp blue

Winsor (phthalocyanine) or Thalo blue (essential)

Hooker's green dark

Yellow ochre (essential)

Burnt sienna (essential)

Sepia dark (essential)

Davy's gray

Charcoal gray

Payne's gray

The permanency of these paints is good (watercolor is more lasting than oil paint). Their chemical composition is simple: water-based glue (gum arabic) and finely ground pigment. Detailed information is available if you write to the manufacturers.

Brushes, Knives, Palette

In addition to paper and paint, you also need good brushes and a palette knife. I prefer a round No. 10 and a round No. 5, long hair, pure sable brush, but a sabeline of the same size is acceptable and a lot less expensive. One flat 1″ oxhair brush and a flat, wide background brush, made of either oxhair or bristle, are also necessary.

A palette or painting knife is an excellent tool for special touches that are impossible to achieve in other ways. The knife should be flexible and very thin. Before you can use it, you'll have to scrape off the protective lacquer that the manufacturer puts on the blade. After the bare metal is clean of the lacquer, stab the blade into a lemon, leaving it in overnight. The acid in the lemon juice will make the metal more receptive to watercolor. (See *Painting Knife Techniques* in Chapter 2 for further details.)

Any kind of white mixing palette from your local art supply dealer is good. However, a white enamel butcher's tray, or even an ordinary white porcelain plate, will serve the purpose. It's necessary for the palette to be white so you can see the washes you mix before you apply them to your painting.

Finally, add an ordinary pocket knife and a razor blade to the preceding, and you're ready to paint!

Experiment

To help you actually experience the behavior of transparent watercolor, do these comparison washes. Apply a strong wash of cadmium lemon. After it dries, paint a strong but transparent wash of Winsor or Prussian blue overlapping the yellow. Now do the same experiment in reverse. Paint the blue wash first. Let it dry and apply the yellow wash. Both times be quick with the second wash so as not to lift up the first layer of paint. Finally, mix the same two colors together and paint the mixture on in a single wash. Try to keep your wash about the same density as the previous green overlapping washes.

If you compare the three greens which will result, you'll notice that they're not the same hue. The cleanest color will be the one that you painted in a single wash. Any two colors will be duller if they're applied separately, brighter in a combined wash.

COLOR

We're all aware of the importance of color in everyday life. But as a painter, you must be more than aware; you must know how to use color.

Using Color

It's worth the learning process involved to be able to use color as a tool to create effects, moods, and abstract qualities which can turn your work into a

personal, inventive statement. For example, in summer or in winter, when nature tends to impose one pervasive color on our minds, we have to invent colors and accents to liven up a landscape. A green forest looks dull if you use only one green all over your painting. But if you start with an orange undercoating and paint a mass of varied greens over it, allowing the orange to sparkle through, you'll create a feeling of heat. Doing the same thing with a rich blue undertone will create a calm, cool impression.

Painting a portrait in a natural color scheme can be pleasing; but strong, sunny, orange highlights on the cheek can brighten the head and turn it into a dramatic eye catcher. The same highlight in blue could suggest calm silence; in red, dangerous expectations, etc.

Selecting Colors

Before you start painting, decide what colors you're going to need. You almost never need all the colors on your palette for any one painting. Three to six colors are plenty for most paintings. To aid you in making a choice, make yourself a color wheel (A).

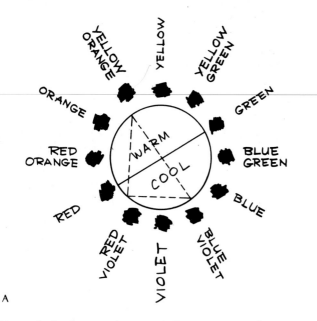

A

Keep it in front of you until you remember every shade of every hue, and its location in relationship to every other hue.

You can see that the wheel is divided into warm and cool colors. Try to keep your picture predominantly either warm or cool, depending on the light conditions of your subject. This will assure color harmony.

If you connect any three colors on the wheel with a line, forming a triangle as shown in A, you'll have an interesting color combination that can form the basic color choice for a successful painting.

Opposite each color on your color wheel is its complementary. If you mix equal amounts of two

complementary colors, they'll either neutralize each other or create a dirty, third color wash, regardless of how clean the original two colors were. Used separately, side by side, they'll heighten each other's impact.

You can read volumes on color, but if you remember two rules, you won't be far from everything that all the books could say. First, good taste keeps down the number of colors you use; second, never use any color unless you have a good reason to.

Experimenting With Colors

Use colors to complement each other or to contrast with each other in some exciting way that will eliminate drabness. A single orange bloom can have a powerful effect in a large blue-gray background area of leaves, but will lose its effectiveness if the same background is yellow-green, lit by the bright, setting sun.

If you're uncertain as to what color to use in a given spot, paint it on a small piece of paper and hold it over the area for a test. Don't be hesitant to paint the same subject several times in different color combinations. Avoid placing strong, vibrating colors next to each other — unless you're searching for an extremely powerful impact.

If a strange color drops onto your painting, take a second look before you anxiously erase it. It may be the very touch that will give an unusual quality in your painting. Make color accidents work for you as they occur, in whatever form they happen. But whatever you do with color, make certain that the result is both imaginative and purposeful.

Paint a simple sketch using the drawing below (B) as a basic layout. Limit your palette to only three colors, using your color wheel. For example: burnt sienna, Antwerp blue, and cadmium lemon. Take advantage of all the hues you can get by combining different values of these three colors. Do several versions of the same subject using a different three colors each time.

B

2. LANDSCAPE PAINTING TECHNIQUES

A great variety of techniques is available to the watercolorist. In this chapter, we'll cover the conventional ones, such as wash and drybrush, as well as the not-so-conventional ones.

BASIC WASHES

In transparent watercolor, the number of ways you can apply fluid paint is limited only by your own imagination. However, there are some basic washes which are important for a beginner to learn. Without perfecting these washes first, you may find watercolor an uncontrollable headache!

Flat Wash

Let's start with the most basic wash, the flat or even tone wash (A). The even tone of this wash is its most important quality.

Mix enough paint in a utensil (a cup or a drinking glass) to last until you've covered the entire surface. Don't wet your paper. Place your paper so that it slopes slightly toward you. Using a soft and comfortably wide brush, apply the paint with sure and speedy horizontal strokes, starting from the top of your paper. Allow the paint to collect in a slight pool at the bottom of each stroke; then overlap this pool and bring the color down with the next stroke. Don't leave the pool of paint too long before the next brushstroke carries it further. If left too long, it can form a hard edge.

After you reach the bottom of the area to be covered by the wash, squeeze the moisture out of your brush and gently drag it along, touching the pool at the bottom of the last stroke. The thirsty brush will pick up the excess paint, allowing the whole wash to remain even. Avoid touching the drying paint or adding more paint to correct a mistake; this will cause "freak spots" and ruin your even wash.

If you want to arrive at an extremely dark, flat wash, make sure that you use enough pigment. (Remember: watercolor dries lighter.) To make sure of the strength of your pigment, paint a brushful on a piece of test paper, let it dry, and decide if it's what you want. Only practice will give you the experience you need.

Graded Wash

Another fundamental wash is a graded wash (B). Use this technique when you want your wash to graduate from dark to light (or vice versa) as it moves down the paper. The approach is similar to that of the flat wash. The difference is that you start at the top with the darkest pigment, if you're going from dark to light, and add a little more water to each new brushful of paint, reducing the strength of the pigment as you go. The secret of a graded wash is knowing how much water to add to get the result you want. Again, practice! A lot!

B

Streaky Wash

To get a streaky wash (C), start by covering your wash area with clear water. While the paper is still saturated and dripping wet, put a heavily loaded brushful of pigment where you want it to be darkest. Quickly tilt the paper to a vertical position (dark on top) and let the paint run into the wet area. To stop the running pigment, lay the paper in a horizontal position and let it dry this way.

A

C

Wet-in-Wet

I'll mention wet-in-wet washes (D) only briefly, because *Painting on Wet Paper* (p. 19) will give you a more detailed idea of the process. If you want a blurred edge on a wash, wet your paper with clear water or a light color wash and apply your final wash while your paper is still wet. The wetter the paper is, the more the second brushstroke will blur. Timing is extremely important, plus the correct consistency of the paint in your brush. Hold your paper horizontally, unless you want the paint to run.

D

Practice

Practice these basic washes. Apply them one at a time on scrap paper of any kind. Make sure that you vary the paper quality. This will demonstrate to you how much easier it is to control a wash on good paper than on cheap pulp stock. Make the washes as large as your paper will permit.

CONVENTIONAL OR DIRECT PAINTING

Direct painting is the watercolor method best known to most people. It's a proven way to face an empty sheet of paper with the greatest likelihood of ending up with a respectable picture. With direct painting,

you apply proven methods and take the least number of chances, considering the temperamental medium you're trying to tame. The English were the first to master watercolor as we know it, developing a practical procedure — direct painting — to control the wildness of the medium. (See demonstration, pp. 73-75.)

Pencil Drawing

Start off with a pencil drawing (A) to establish your composition. Use a good quality HB pencil with a light touch. An HB is soft enough to leave a good line with little pressure, yet it will erase easily with a soft eraser. You can use art gum or a kneaded eraser (dough rubber). I prefer the latter because it doesn't leave particles to clean up; besides, art gum can get dirty and accidentally cause a smear mark.

A

Tracing

If you're a beginner, and if you're not sure of your drawing ability, a sheet of tracing paper is a helpful tool (B). It has to be at least as large as your painting surface (your sheet of watercolor paper). Draw on the tracing paper as you would on the watercolor paper. It's not necessary to erase the mistakes, just ignore them.

After you're finished with your drawing, you're ready to trace it onto the watercolor paper. Cover the

B

back of the tracing paper with tightly scribbled criss-cross lines, using a 4B or 6B graphite pencil. To spread the graphite more evenly, smear it with a ball of absorbent cotton until the graphite is dense enough to leave a strong impression when you trace through it from the opposite side. Then turn the drawing right-side up. Fasten it over your future painting by the top corners with small pieces of masking tape. This way, you can check your drawing while you work, just by lifting the lower corners for observation. After this, proceed to transfer your drawing onto the watercolor paper.

Painting

Now you're ready to paint. Your drawing has organized and divided the painting into various color areas to allow you to work on several areas simultaneously. This is necessary so that you'll be able to let one spot dry while you're painting another (C).

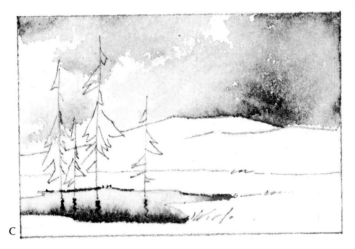

C

As you paint an area that borders on an already painted space which is still wet, encourage your new wash to flow into the other, here and there, as the two touch. This seemingly careless stroke will add a great deal of spontaneity and freshness to your work.

The important thing is to visualize the finished painting and complete each area as you go, without overemphasizing the unimportant details. In the heat of painting, the temptation is great to stay with one spot too long and work it to death. Only experience will enforce good judgment and eliminate hesitation.

If you feel that you've missed some sparkles or highlights, scratch them out with a razor blade or a sharp scraping tool of some kind. (See *Masking Technique and Using the Razor Blade*, p. 23.)

After your painting is finished and completely dry, erase the remaining pencil lines. You'll probably notice that most of them have blended into the paint, but an odd one survives here and there. Use your eraser lightly, being careful not to rub out the paint.

On a good watercolor, you should never be able to

detect strokes as afterthoughts. They spoil the unity of the whole effort. Try to finish your painting with the first washes. Blend them while the paint is still wet. The more layers of paint you apply on top of one another, letting them dry in between, the dirtier and chalkier your colors will end up.

On pp. 73-75, I demonstrate this direct method in a painting which I did in the Canadian Rockies. The day was moody and the cloud conditions were changing so rapidly that I chose the direct method to give myself a chance to make small changes midstream.

DRYBRUSH

Drybrush doesn't mean that the brush is actually dry. A drybrush stroke is made by a comfortably moist soft hair brush. The rougher your paper is, the better the result will be. Don't wet your paper. Hold your brush at a low angle, almost parallel with the painting surface. Drag it across the paper with a light touch. The paint should cover only the tops of the little lumps on the irregular paper surface (A).

It's very important that you don't saturate your brush with paint, but have it just wet enough to leave the desired mark. One way to check this is to shake your brush gently before you touch the paper; if the paint stays in your brush, it's not too wet; if some of it drops off, you have too much moisture in your brush. This fundamental (but tricky) brushstroke can be maneuvered differently, depending on the type of brush you use. (See demonstration, pp. 85-87)

A

Round, Soft Brush

A round, soft brush will leave a mark which is slightly irregular on both sides (B). For the most part, use the belly of the brush instead of the point. The amount of pressure you apply will determine how full or light the tone of your brushstroke will be. Try a few practical examples: treetrunks, wood textures, moss, rocks, breeze patterns on a distant water surface, etc. (F).

Flat, Soft Brush

A flat, soft brush will leave straight edges on both sides, creating a wide, even strip of drybrush stroke (C). If you press a little harder on one edge, holding the other edge in the air, your stroke will be sharp where your brush edge touched the paper and irregular where it didn't (D). Some examples of where to use flat brush would be for large, rough surfaces, such as aged boards, driftwood, etc. (G).

Knife Strokes

Illustration E shows two ways to arrive at "drybrush" effects with a painting knife. The first stroke was made by loading the knife with paint (without letting it drip) and dragging it across the paper at a low angle, and with an even motion, as if it were a flat brush. The other way is to leave a wet paint area on dry paper and use the knife to drag some of the wet paint onto the nearby dry surface, wiggling the knife and letting it create lacy, uneven edges. Examples of when to use this technique would be for foliage, the grass covered edge of a distant hill, etc. (H).

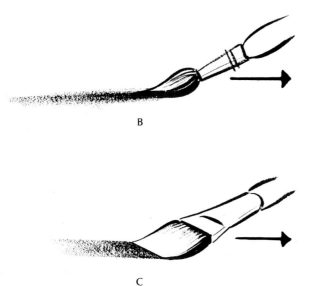

B

C

F

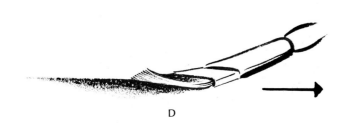

D

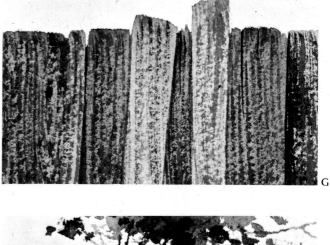

G

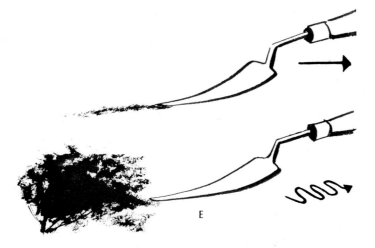

E

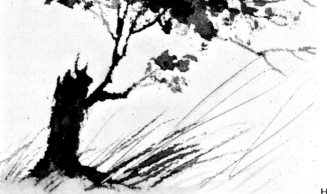

H

Split Drybrush

A split drybrush stroke is simply a drybrush stroke made with any soft brush after you've divided the hair into several uneven clumps.

First, load your brush with paint as you would for the drybrush technique. Then, before touching the paper, separate the hair into clumps with any pointed object. A brush handle will do, or a pocketknife blade. To achieve a more irregular effect, press the neck of the brush firmly against your palette. When you lift the brush, the hair will spring back partially but will stay split, leaving several points for you to work with.

PAINTING ON WET PAPER

Watercolor behaves unlike any other medium when you apply it to wet paper. The amount of water absorbed into the paper and the consistency of the paint on your brush will determine the result of each brushstroke. You can apply water to your paper by soaking it in a sink or bathtub or by sponging or brushing the water on. Let's identify three degrees of wetness in your paper: saturated, moist, and damp. (See demonstration, pp. 76-78.)

Saturated Paper

Paper is saturated when it's no longer able to absorb water (A). You can tell when this point has been reached because the surface of the paper will become shiny. When the paper is in this condition, the action of the paint is the most temperamental. If paint touches the dripping wet surface, the color will flow as gravity forces it. This means that if you want the paint to run in a particular direction, tilt your paper.

If you want the paint to spread evenly, keep your surface in a horizontal position. If your brush is heavily loaded with strong paint, the spreading can be very rapid and violent. The first time it happens, it will seem as if you've released an uncontrollable genie. This effect is very useful for soft hints of form, but you shouldn't attempt to create fine definitions at this stage of wetness.

A

Moist Paper

After the shine disappears from the surface of the paper, we call it moist (B). The sheet is still quite wet inside, but the freshly applied paint will spread a little more slowly and more gently, particularly if the consistency of your paint is not drippy, but fairly thick. Objects painted on moist paper will remain identifiable, but still blurred and without sharp details.

B

Damp Paper

If wet paper that has been drying is still cool to the touch, it's damp (C). Your timing — exactly when you apply a stroke — is critical at this point, and you must proceed with caution; freak, fuzzy runs will creep in minutes after you look away. Humidity in the air, temperature, and the make of your paper will all affect the behavior of your paint and the time your painting will take to dry.

C

A freak touch can disrupt your well-controlled painting, particularly at this damp stage. I call this a "backrun" (D and E). This happens if one part of your surface is still damp, but the spot next to it is already dry. Put a healthy brushful of paint on the dry area; slowly the water from the new brushstroke will creep into the damp area, pulling the pigment off the newly painted surface in an irregular fashion, until all the excess water is used up or the moving color reaches a

dry spot. This floating pigment collects, forming a hard edge, where the water stopped spreading. Beware of this, for it's very difficult to correct. Of course, it can also be caused on purpose and can create very free and unusual effects.

D

E

PAINTING KNIFE TECHNIQUES

Some of the most unexpected effects in watercolor painting come from the clever use of a painting knife. A knife of any size or shape is acceptable as long as you like the feel of it and can use it effectively. My preference is the type of knife shown in A. (See demonstration, pp. 88-90.)

A

Treating the Blade

Before you can use this unlikely tool for watercolor, you must treat it so that water will stay on the blade. This means removing all water-repellent material from the surface. If this is not done, the water-diluted paint will bead and roll off.

If your knife is new, it's usually covered with lacquer. First, you must scrape the lacquer off with a razor blade or with fine sandpaper. After this scraping, the exposed bare metal still isn't ready to paint with because of the greasy surface quality of the steel. To remove all traces of grease, you must use some kind of acid solution. One good method is to reach for your vinegar bottle and soak your knife blade in it for a few hours. A lemon is also good: stab the blade of your knife into it and leave it for twenty-four hours. After this, your blade is ready to paint with.

Don't be horrified if the shiny new blade appears corroded when you remove it from the solution; it won't harm the knife.

Just Enough Paint

You can use the same paint consistency as you'd use with a brush. The condition of your paper — wet or dry — will affect the paint consistency just as it affects color applied with a brush. Learn, by experimenting, to recognize the right amount of paint on the knife. It's very annoying to pick up a good load of paint on the blade, carefully carry it to your painting, and, as you tilt the knife to apply a handsome stroke, see a huge blob of surplus paint fall onto your paper. If this should happen, grab a tissue and blot up the mess. Wait a few minutes for it to dry, and apply a new stroke — this time, with less paint on your knife.

Strokes

If you hold the knife at a high angle and use the blunt side of the tip in a scraping motion, you'll create a branch-like line (B); a slow movement will produce a slight, knuckly, irregular line that's also excellent for branches.

Hold the knife the same way, but move it fast, with a sweeping motion, and it will give you a tall, weed-like line (C).

With just a little paint on the blade, you can use the sharp edge of your tip to create a hairline that's impossible to imitate with a brush (D).

For a loose, drybrush effect that's very useful for bark, rocks, etc., use the flat back of the blade and drag it with the metal pressed against the paper (E).

To give a lacy edge to a freshly painted clump of foliage, drag the wet paint outward in a wiggly movement with the flat back of the blade, pressing hard (F).

These knifestrokes all work best on dry paper.

B

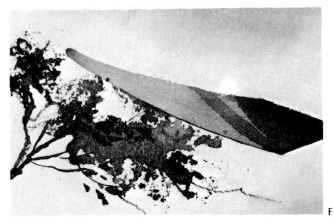

F

C

Wet Paper

The knifestrokes discussed above will blur on damp paper and will be a disaster on saturated paper, as the paint will all rush off your blade as soon as you touch the wet surface.

However, there's one extremely beautiful and delicate touch that can be applied only on wet paper. Begin to paint on your paper with the brush in a wet-in-wet style (see *Painting on Wet Paper,* p. 19). When you're satisfied with the touches of color, reach for your painting knife before the paint starts to dry. Press the sharp edge of your knife tip firmly into the wet surface and draw a line with it (G). At first, the line will

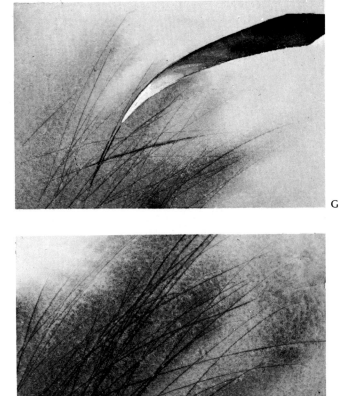

G

E

H

seem invisible; then it will start to come to life as a darker version of the color underneath (H). The reason is that as the metal scrapes the paper where the blade touches the surface, the wet paint is attracted and gushes into the crack, which acts as a blotter, trapping a heavy concentration of pigment.

Just one warning: control this line very firmly, because it cannot be removed. It's final. I think you'll agree, however, that the result is worth the care and the risk involved.

TEXTURE AND PATTERN

Knowing how to paint surface textures and patterns means the difference between monotony and rich design. (See demonstration, pp. 79-81.)

Texture in Nature

Nature is full of texture: the bark on a tree, the surface of a rock (A), the waving distant grass; I could go on and on. In the final analysis, everything has texture. We'll talk more about closeup surfaces than distant surfaces, because the detail on them is more detectable and must be handled with greater care. The older the texture, the more layers of wash you can afford and should apply. However, watercolor tends to lose sparkle when you paint layer over layer; the more washes, the dirtier the color. The last and final wash in most cases is done with a drybrush. Again, you must allow the paint to dry between each application or the washes will blend just as if they were applied together.

A

Man-Made Texture

Mechanical patterns are man-made. They're more organized, and the newer they are, the more difficult it is to make them look interesting (bricks, roof, lumber, stucco, metal, textile, etc.). Don't be too literal in your handling of new surfaces. Paint a little detail — but hint, don't overwork it. Wood surfaces, such as barn boards (B), can be very richly handled if

you suggest grain direction in your first wash with the tip of your brush handle. Finish the details with drybrush strokes. Bricks and shingles can be approached in the same way.

B

Textile

Textile usually has an uneven surface, not only in design but in form as well. Wrinkles and folds must be painted in before any pattern or texture is indicated. When you paint the pattern or texture of textiles, it's best to follow the natural flow of the fabric (C).

C

Practice is Necessary

Unusual surfaces require unusual handling. For example, the fluffy head of a bullrush, the surface of a seashell, a dirty windowpane, the fur of any animal, a single leaf — there's no set way to approach any of them. The experience that you'll gain painting the more common types of texture will help you devise new methods, new techniques, new approaches.

Remember: it's not the way you paint, it's the result that matters. The more difficult the surface seems, the more study and planning it will require. Above all, don't allow texture to destroy form. It must complement, not take over, your painting.

MASKING TECHNIQUE AND USING THE RAZOR BLADE

You can use any ingenious trick to achieve the right effects. The result justifies the means. The important point is to use your technical tools with skill and efficiency. Don't let them become gimmicks that you must use as crutches because you know they've worked on one or two paintings. One of your tools is masking; its purpose is to take advantage of the purity of white paper — and to retain it — when this would be impossible any other way.

Occasionally, you'll paint a subject of extreme contrast (solid birch against a dark hill, white sails against a dark sky, the bright crest of rolling surf, etc.). To capture the drama of such contrasts, you must separate the light area from the darker area directly next to it while you work. Here are a few ways that are commonly used by watercolor painters to do this. (See demonstration, pp. 82-84.)

Masking Tape

Transparent adhesive tape and masking tape (A) are very useful in masking out long narrow shapes. First, lay the tape over the area you want to mask and press it down with a light touch. Cut off the unnecessary pieces of tape with a very sharp knife. (I use a small X-acto knife.) Apply light pressure while you cut, just enough to cut through the tape without damaging the surface of the paper. After peeling off the surplus tape, lay a sheet of thin paper over the now cleanly masked area and rub your thumbnail over the tissue. This will insure that the edges of the tape cling to the paper and that paint will not creep under the tape to form ragged, unclean edges.

Paint the background right over the tape, ignoring it completely. When the paint is dry, peel off the tape, exposing the white paper underneath. Remove the tape cautiously, because it sometimes has a tendency to cling to the paper and tear the surface.

Maskoid

Maskoid (B) is a gray liquid latex which can be applied with a brush. It dries fast and forms a waterproof film which can be peeled off after use or rubbed off with a soft eraser, a ball of soft rubber cement, or a ball of dry Maskoid.

Proceed with the background painting as before; the Maskoid will completely seal the paper surface and will repel the water with the paint in it. The advantage of Maskoid is that it can be applied on irregular edges more freely than masking tape. Its disadvantage is its strong clinging quality which can easily tear the surface of a soft paper during removal.

Remember: the darker the value next to the white (masked) area, the greater its dramatic impact will be. After you remove the masking material from the dry painting, you can complete whatever modeling is necessary to finish the white area.

B

Rubber Cement

Rubber cement (C) is a looser and slightly more unpredictable masking medium. When you apply it, it will seem to cover the area completely, but after drying it exposes small areas of the paper. This allows the paint to leave irregular touches that will survive after you remove the rubber cement. Knowing this,

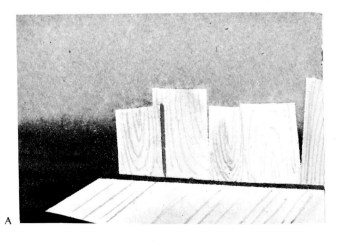
A

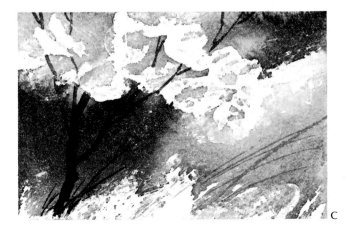
C

you must experiment with its use to understand exactly when and how to apply it. To remove the rubber cement from the finished dry painting, use a ball of dry rubber cement. Rub the ball against the masking cement, avoiding the painted surface directly next to it.

Paraffin or Wax

A stick of paraffin or children's white wax crayon (D) also serves as an excellent masking agent. Painting in the area to be masked out has to be done in advance to the last detail, because complete removal of the wax, at least to the extent that the paper would accept water freely, is impossible. You must visualize how the painting will look after completion and prejudge the amount of detail you want to survive after you apply the dark paint next to the masked spot.

After the light area is painted in detail and is completely dry, rub the wax over it vigorously and generously. Follow the edge of the area carefully. The wax will form a misty, translucent layer of water-repellent coating. Now you're ready to complete the rest of the painting in the manner previously described.

After your painting dries, put three or four layers of absorbent tissue (Kleenex) over the waxed area. Then melt and blot the wax into the tissue with a medium hot iron. Press lightly. Repeat this with fresh tissues until all the wax has been removed. White school crayon is best when you want the masked out area to remain really white. Further details on masking out, specifically with paraffin, can be found in the demonstration on pp. 82-84.

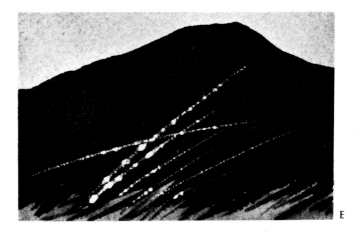
E

Hold the razor blade firmly, press it hard, and scrape through the paint, exposing a white line with only one move if possible, over the same area. If you want to scrape off a larger area — for example, to get sparkle on distant water (F) — hold the blade perpendicular to the paper surface and touch it with the cutting edge. Move it firmly back and forth with a strong scraping motion until you have the desired effect. Dust the morsels of paper off and clean the surface by rubbing with a light eraser.

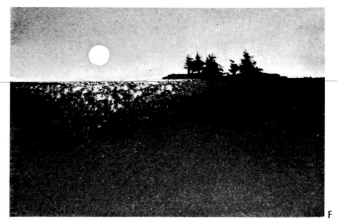
F

UNUSUAL EFFECTS

I'll attempt to describe some additional unusual effects which suit me personally. These are for you to consider, but don't accept them unconditionally.

Chisel Shaped Bristle Brush

I purposely left the use of a chisel shaped bristle brush (A) to this section because, although it's not commonly used, I find it very effective. It's made by Grumbacher and it comes in three sizes: 1/4", 1/2", and 1". It's the best brush (as far as I'm concerned) for wet-in-wet technique. Its firm bristles give fast results on wet or dry paper, because it picks up more paint than a soft hair brush. I really prefer to use it on wet paper because it can pick up thick pigment and spread it on a wide area very fast, allowing me to create exciting results in rapid sequence.

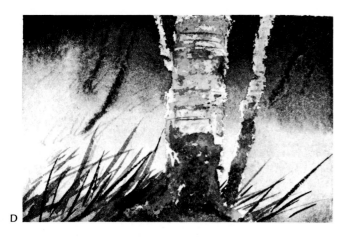
D

Razor Blade

The limited use of a razor blade (E) can also be an effective way to expose white touches in a dark background. These crisp touches of white will add sparkle and snap to your painting. But don't overdo it. Your painting has to be bone dry and the razor blade very sharp.

Brush Handle Point

The top of your brush handle (B) is an extremely useful tool in defining dark lines while the paint is still wet. Immediately after you apply your wash, draw into it with your brush handle point with a firm, well-controlled pressure. The sharp point will scrape into the surface of the wet paper, damaging its fibers enough to create a blotting condition. The wet paint will rush into this crack, allowing the water to soak in but trapping the pigment on the surface. This more concentrated amount of pigment will appear darker after it dries.

One warning: you must be dead accurate, because these scraped lines are final. There is no way to correct them if you make a mistake. You may also use a small twig or any sharp instrument instead of the tip of your brush handle.

Squeezed Pigment

Squeezed pigment (C) is another effective touch and is simple to apply. The dull point of a pocketknife is the best tool to apply it with. The grainier and darker the paint is the better it will look. It can be applied when a dark area is still moist, just after it's lost its shine. You can also create the same condition over the desired area after it's dry by rewetting it. Spread clean water over the area with light pressure from a clean, soft brush. When the paint is in a moist condition, hold the dull point of your pocketknife at a low angle, pressing very firmly. (Make sure the angle of the blade is low or you can easily tear the surface of the paper.) Squeeze the paint off the area it touches. A light tone of the color it has just removed will be left.

Wiping Off

Wiping paint off (D) can be a very effective way to achieve transparency after you've gone too dark. Grainy pigments lend themselves better to this effect. After your painting is dry, rewet the area that you want to make lighter. The more often you go over the same area with a wet brush, the more it will disturb the paint on the surface of the paper. When you feel the pigment is loose enough, quickly blot it up with a very absorbent tissue, using a fresh, clean piece each time to avoid carrying the paint back onto the painting. This same method works equally well on a wide area or on a thin hairline. Only your wetting brush will differ. The point of a fine bristle brush lends itself to wiping back fine lines (twigs, weeds, wires, etc.) and a wide, soft brush is best on a large surface.

You should constantly look for unusual effects. If you paint a lot, chances are that you'll stumble onto accidental touches that can make instant improvements in your watercolor painting skill. Learn to recognize these accidental effects, because they'll help you create your own personal style.

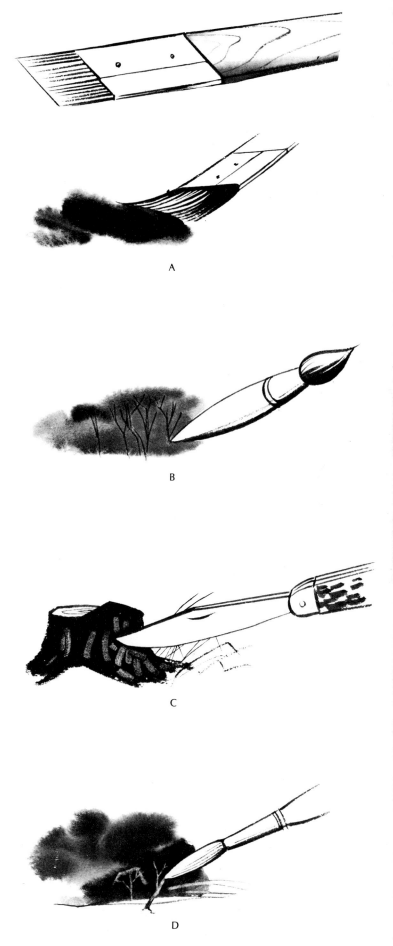

A

B

C

D

3. LEARNING TO SEE THE LANDSCAPE

The first thing the landscape painter must do is learn to see his subject — the landscape — and to become intimately acquainted with the many facets of its personality.

KNOW YOUR ENVIRONMENT

Familiarizing yourself with the area you intend to paint is as essential to a good painting as having the necessary technical skill. In fact, it's a fundamental part of this skill. A palm tree in the snow looks out of place; palm trees don't grow in a climate cold enough for snow. If you're painting in unfamiliar territory, your sense of observation controls what you will paint or will not paint. The character of the vegetation and the rock formations, the animal life, the colors, the behavior of water and sky, the kind of structures — all are determined by locale and climate. The harmony of these factors, which in life create the balance of nature, will also have to be truly obeyed in a successful painting. (See demonstration, pp. 70-72.)

Harmony

To insure this harmony of natural elements, regardless of how realistic or how "designy" your painting may be, don't improvise details unless you're certain that the invented element could exist in the environment of your painting. Keep everything in its place and related to one another. For example, bulrushes are a very fascinating part of the landscape in most parts of North America, but they only grow in swampy, water-saturated areas. Consequently, if you put them on a high, rocky ledge, you would create an impossible combination (A). You would allow an uneasy, unnatural condition to spoil your painting.

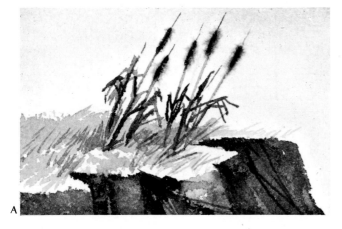
A

The most important advice I can offer is this: either try to paint familiar landscapes or keenly observe the details of unfamiliar ones, and stick to the decisions that are the results of this observation.

Local Conditions

A thorough knowledge of your surroundings goes hand in hand with the need to be familiar with local conditions. Atmospheric conditions differ from place to place; the four seasons influence every area in a different way; a valley differs from a mountain; elevation makes an enormous difference in the vegetation. The almost constant presence of high winds on a mountain peak will twist, torture, and even break a tree which would survive at a lower altitude. Foggy conditions have such a special set of qualities that I advise you not to add to their natural details. However, you can safely leave out anything from a foggy scene that you do not wish to use in your painting — fog eliminates distant objects anyway!

The combination of familiarity of environment and of conditions is of fundamental importance to a successful landscape painting. Conflicting elements will not only offend the senses of a knowledgeable viewer but will quickly give away the painter's lack of experience as well.

CHOOSING YOUR SUBJECT

The first and most important necessity for any painter (landscape painters in particular) is to learn to see. This sounds like an easy task, but it involves more than just opening your eyes. It means seeing beauty hidden or camouflaged by interfering clutter. For example, if you walk in the forest you're conscious of trees, foliage, and the color of ferns around you. To see a little violet tucked away behind a stump you must make an effort. You must stop and carefully look. And when you spot something like this, you must recognize it as a potential painting subject. Just look; beauty is all around you if you look for it. (See demonstration, pp. 169-171.)

Discriminate

Never paint anything exactly as it appears in front of you. A painter should not be merely a poor substitute for a camera. Evaluate everything and try to visualize the finished painting before you start. Decide in

advance what you want to leave out, what you want to paint, and where you want to paint it. Your creative mind, not your eyes, must control your decisions.

Nature tends to look very complex to the eyes. Let's face it, nature is complex! It's up to the artist to be discriminating, to judge how much of the scene in front of him should be part of his painting and how much should be eliminated. Complexity by itself is not wrong. It is wrong, however, to accept it merely because it's there.

Simplify

In the beginning, you'll find it difficult to know what part of nature will make a particular painting a good one. To help you see the main forms, here's a helpful suggestion: when in doubt, squint hard. Only the important elements will be visible, making it easier for you to judge if you're looking at a good potential subject or not. Squinting simplifies forms to their basic structure, and these are the core of your painting.

Commit Yourself

A painting is like a tape: it plays back the personality, the mood, of the artist. Unless you're just exercising, don't start a painting if you're not really excited about the subject. If you're excited, your flying mood will help you create a painting with impact and will give you a much greater sense of achievement than if you just paint a pretty picture.

SIMPLE SUBJECTS

When you face a simple subject that you want to paint, the first thing you must do is observe it carefully. Study the intricate little details in form as well as in color. Analyze the number of colors you'll need for your palette and stay with them. Imagine that no other colors exist. This limited use of color will permit you to pay more attention to form, value, and composition. (See demonstration, pp. 172-174.)

Detail

To illustrate what I mean, let's take a few examples. A single, dried-up Queen Anne's lace stuck in the heavy snow (A) is the first example. The many tones of browns and grays on the delicate stems of this delightful little weed can only be seen from very close up, but you must render the subject accurately even at the cost of slight exaggeration in color. A floating leaf in a quiet pool of water (B) is the second example. Painstakingly observe the form of the leaf and the way it looks where it's partially submerged, including its shiny sparkles. In this case, I wiped back the background after I held a paper cutout of the shape of the leaf tightly to the surface of the dry paint of the water.

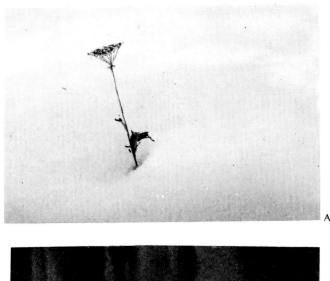

A

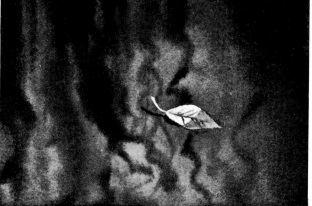

B

Drawing

When you paint simple subject matter, pay careful attention to good drawing. I don't mean necessarily drawing with a pencil before you paint; I mean pay attention to the correct proportions and the drawing quality of every little detail that you consider important. The grass blades next to a stump, for example, on an extreme closeup, will destroy your painting if they're merely thrown in as a confused pattern (C). Draw them with a carefully controlled brush, composing each one of them to complement the total impact of your painting (D).

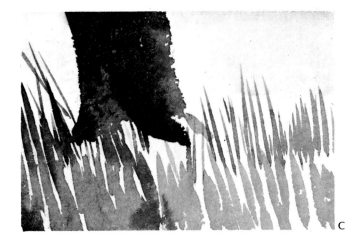

C

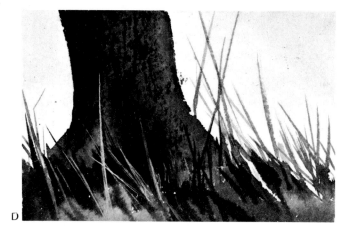

D

A

Don't Overwork the Subject Matter

I have emphasized the importance of carefully drawn details in this section, but I must warn you of a very real danger: don't overdo it. The line between a well-done, detailed but fresh rendering and an over-worked painting is very thin. You must use your own discretion to know when to stop. Your own artistic taste and creative discipline must be the judge. Simple subjects don't take too much physical time. If you're not satisfied with the first one do it over several times if necessary, until you get one just right. Don't keep the bad ones. Bad paintings have the habit of showing up from nowhere to embarrass you should you become an accomplished painter!

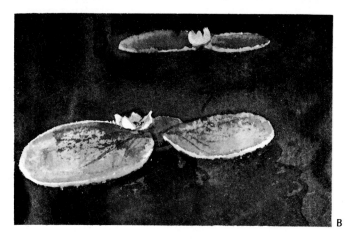

B

COMPLEX SUBJECTS

When an artist is able to render a complex subject on a painting in an organized manner, he shows a mature discipline that can only be achieved through a conscious period of evolution. To do this, you need a positive, daring, and imaginative approach. (See demonstration, pp. 175-177.)

Simplifying

Simplifying is essential. As I've mentioned before, one practical way to do this, particularly in the beginning, is to observe the subject through squinting eyes. The blur which results from your squinting eliminates the clutter and emphasizes the essential. This method is extremely helpful in allowing you to analyze your composition; it insures that you capture not the pretty clutter but the real substance of the scene before you.

C

Let's take a few examples: the lush interior of a forest; bouncing reflections in a lazily moving body of water; a crowd of people; the colorful texture of a hunk of rock. Any of these could arouse your interest. Technical skill is essential to do justice to the problems involved in painting them which can only be acquired through practice.

Very often you'll find a charming, pattern-like, busy subject without a real center of interest. In this case,

D

add your own center of interest. Let's use the examples above to illustrate what I mean: a small, misty opening through the forest (A); a floating water lily in reflecting water (B); a child sitting on its father's shoulder in the crowd (C); a sharp crack in the rock (D). All these devices would serve the purpose of adding a center of interest to an otherwise dispersed scene and focusing the eye on a specific point.

Detail Studies

Prepare a few detail studies before you plunge into the finished work. Keep in mind that details, however skillfully they may be rendered, should never inter-fere with the unit of your composition. They can easily creep into your work in the heat of creation. Stop frequently while you paint and check the unity of the whole painting. If you're satisfied that the painting needs more work, continue up to the next uncertain spot, then look again.

Don't Work When You're Tired

Don't work on complicated paintings when you're tired. They need more of your concentrated energy than other subjects. When you're tired, you'll tend to be impatient and you won't be able to achieve as good a result as when in a refreshed frame of mind.

4. LANDSCAPE COMPOSITION

Composing a landscape is basically the same as composing any other subject. The picture space must be arranged according to the same principles of relationships, balance, and perspective that govern all composition.

RELATIONSHIPS

Fundamentally, a painting is made up of relationships between objects and the space that surrounds them. Setting up these relationships by combining forms and spaces to produce a harmonious unit is what composition is all about. Composition involves the orderly placing of forms, shapes, and spaces so that they look and feel pleasant. You cannot throw together X number of objects in a hodgepodge and expect it to be pleasing. You must exercise judgment in placing these elements. (See demonstration, pp. 91-93.)

Space

Space is that area in your painting that objects don't occupy. It's as important as form, for the two together make a composition healthy. Space is negative form; objects are positive form. You can use the space between objects as a flat surface (A) or as the illusion of space in depth (B).

Avoid apparent holes in your composition. The best way to do this is by arranging areas not symmetrically but in harmony. Monotony is the killer of composition. Don't place important objects in the geometric center of your painting. There are visual centers which are points of proven magnetism to our sense of vision, and they're the points which give our

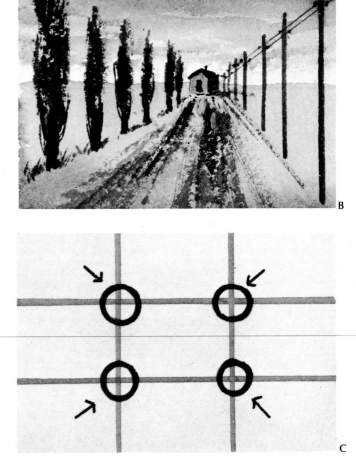

B

C

esthetic sense the most satisfaction. Four of these points are very easy to find, regardless of the dimensions of your painting. Imagine two vertical lines dividing your painting into three even spaces. Do the same horizontally. The four points where the lines cross are the strongest attention points (C).

Value

The value of an object is its degree of darkness or lightness in relation to other objects. You can't measure it; it's a matter of judgment. Developing the ability to recognize good tone balance can result in many simple compositions in black and white, with two or three extra tones (different grays). A dark or light object looks dark or light only if you relate it to some other value. Holding this light-dark relationship in a composition is what is meant by holding a picture in key. The simpler the subject, usually the better the

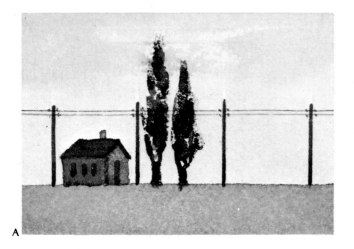

A

picture. I cannot overemphasize the importance of doing basic tonal arrangement sketches of every subject. Give these sketches much thought and planning, until you can no longer improve on your composition.

Light next to dark creates a dramatic effect. More white suggests a happy mood; black injects mystery and drama. Dark gray (moonlight, for example) indicates a romantic quality; while light gray can form a pleasant background for other tones, giving a landscape a warm, rainy mood (D).

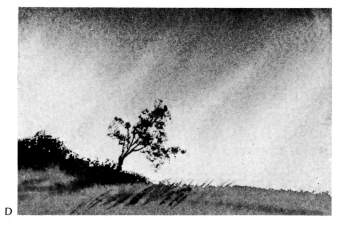

D

Rhythm

Rhythm helps the eye follow the order of the composition. A good use of rhythm can give your painting not only harmony but a sense of movement as well. An element repeated without a change of shape or size is monotonous. You can create good rhythm in seemingly monotonous subjects by purposely varying the size and position of the repeated elements (E).

When two or more forms are of a similar shape, they should differ in size, and vice versa. Your composition should lead the eye freely from point to point. Never allow the eye to become trapped in a corner; create good rhythm, order, and balance.

The theme of your composition should surround your center of interest, not detract from it. A well-planned rhythm will lead the eye unconsciously through various elements to the center of interest. By rhythm, I mean rhythm of line or space or similarity of contrast in values. The same rule applies to pictorial composition as to all good organization: a single theme should be complemented by subordinate elements.

Harmony

Harmony is the artistic balance which results when you place everything with regard to its proper rhythm and relationship within your picture area. Never allow your composition to fly apart. Never permit monotonous repetition. A good composition should have a variety of textures. In the final analysis, a good composition must "feel" esthetically correct to your senses. To sum up: try to develop a good artistic taste and always listen to it.

Repetition

A well-painted, fresh watercolor is an exciting thing to look at, but even a technically skilled artist can ruin a painting if he allows monotonous elements to creep into his composition. Repetition is one of the biggest dangers to preserving spontaneity in a painting. The human mind tends to organize everything to death. Take, for example, a dozen trees. If planted by man, they'll most likely be in a mechanical order of some

A

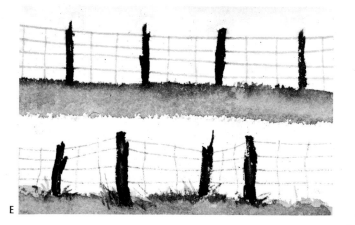

E

B

sort (A). In contrast to this, nature manages to grow the same number of trees in an uneven, more natural, and more pleasing disorder (B). In a painting, a too-stringent kind of organized rhythm is monotonous, dull, and much less pleasant than the more disordered order found in nature. Even if natural objects are accidentally in a perfect, monotonous rhythm, the artist must move them around and shuffle them into a natural, easy-to-look-at composition.

Sameness of Direction

Another danger is too many forms running in the same direction. Too many verticals or too many horizontals give away a poor artist's uncertainty every time. You'll find opportunities to use your imagination when nature doesn't supply you with complementary forms. For instance, in a panoramic scene of rolling farmland continuing up to the horizon (C), you may see a challenge in color or in the play of interesting patterns. However, you're conscious of the monotony, and you want to do something to break it. Since all the lines run in a horizontal direction, complement them with some vertical object or objects (D). The soothing relief this creative move offers to the senses should be obvious to you as you look at the examples given here.

C

D

Correcting Monotonous Composition

The closeup detail of the wall on an aging barn (E) is an exercise to test your technical skill. In the example given here, you can see that all forms and tones run vertically, creating a drab pattern which is not adequate for a good composition. It needs a horizontal complement. A solution is found in F: an extra piece of board nailed horizontally across the others creates the needed interest.

Remember: the shape of a cross is the most perfect complementary form with the most powerful impact. In it, the complement of horizontal and vertical is the most complete. An angular vertical is good, but not as perfect a complement to a horizontal line as a 90° angle. The closer you come to this the more pleasing the result will be. However, a slight play in the lines is important. I'm talking pure theory. Nature, of course, always appears freer than theoretical perfection. This is why you should never, never use a ruler!

E

F

CENTER OF INTEREST

The center of interest is the most important element of, and represents the main interest in, your composition. This is the point of concentrated esthetic energy around which your whole painting revolves. The word "center" doesn't refer to the geometric center of your painting. Quite the contrary. The

center of interest should almost never be in the geometric center of the picture. The strength of this most important element of your painting can and will determine the degree of impact of your composition. It can be an object, a person, or even a touch of color. (See demonstration, pp. 94-96.)

Object as Center of Interest

You will most likely select an object for the center of interest, because a particular object is often the very reason that an idea was born in your mind in the first place. The strength of this object can be measured by the relationship between it, as the center of interest, and the rest of your painting. Take a tiny feather caught in a farm fence, for example. If you paint this accidental little touch as just another detail, far enough in distance not to demand much attention, it will survive only as a mere incident. However, if you bring it up close (A) and make it the most important part of your painting, subduing everything else, you'll create a powerful center of interest out of an otherwise insignificant object. You can have a good idea for a painting, but its success depends on the center of interest. For an example of the importance of a strong center of interest, see the raven beating his wings against the misty morning sky in B.

Color as Center of Interest

An accidental touch of color can also liven up a painting and create your center of interest. For example, if you're painting a gray and lifeless rotting stump, this stump will probably be your center of interest. Your grayish subtlety in color will cause the strong form of the old tree to occupy a place of importance. But if you decide to paint a fungus on the side of the stump in a bright orange color, this touch of brightness will be strong enough to relegate the tree stump to a place of secondary importance. Using color in this way must be natural — an essential, related part of the rest of your painting. You cannot use it as a crutch to rescue an otherwise weak work. You have to plan it as part of your painting from the beginning to insure the unity of the picture.

Location of Center of Picture

The location for your center of interest is as important as the choice of what it will be. Because it is the strongest element in your composition, the center of interest must occupy the choicest location. The four visual (esthetic) attention points (see *Relationships*, p. 30) are strong locations, but they're not good as a location for the center of interest. Remember: the center of interest rules the rest of your painting.

THREE DIMENSIONS, PERSPECTIVE

The impression of three dimensions in a painting is achieved first by the use of form perspective, which means the representation of objects on a flat surface so that they give the illusion of depth. The three dimensions are width, height, and depth. Every object has three dimensions; none can be ignored. Every object is in space. (See demonstration, pp. 97-99.)

Basic Elements of Perspective

There are three important basic elements of perspective. They must be clearly understood (A). The first is the eye viewpoint from which the view is seen.

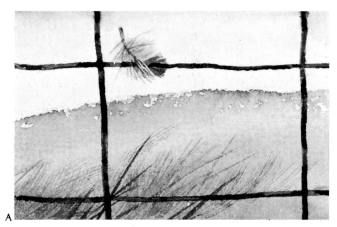

A

B

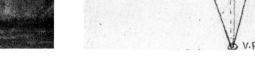

A

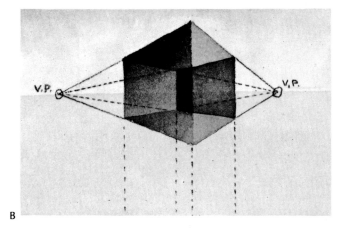

B

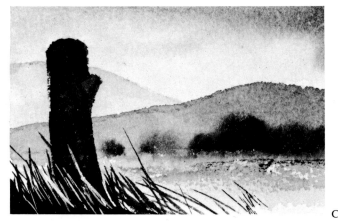

C

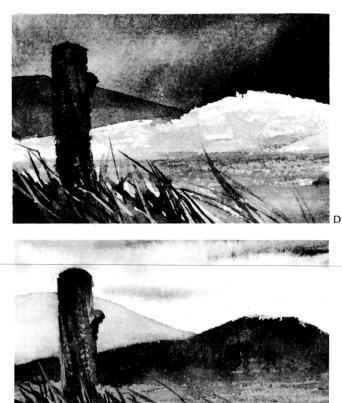

D

E

The second is the horizon or eye level. The third is the vanishing point.

There are three vanishing points in every view. Your eye viewpoint is one of the vanishing points. Two of the vanishing points of every object will fall on the eye level line, but not necessarily within your picture area. The third one (your eye viewpoint) will be either above or below the eye level line, depending on how the object is placed (B). Several objects in one painting may have different vanishing points, but the eye level will always be the same.

Planes of a Painting

To make your painting appear three dimensional, use perspective in color and tone as well as in line. To simplify the problem, divide the depth of your painting into three easy-to-identify units. Let's call them foreground, middleground, and background. Pay careful attention to the measureable distance from your eyes to the furthest object from you. They're essential to an accurate, believable representation of any scene. If you emphasize one at the expense of the other two, you'll be able to create dramatic effects.

Simplify the thousands of intricate values (degrees of darkness) to light, medium, and dark values. Don't confuse color with value. Any color will appear lighter in the distance than close up.

Emphasis

You can add more importance to the foreground, middleground, or background by painting each either very light or very dark but in strong contrast to the other two areas. Emphasizing the foreground (C) is the most natural approach, because of its nearness. We're more aware of details simply because we can see them clearly. When you accentuate the middleground (D), you give the impression of changing light conditions caused by moving cloud patches. By accentuating the background (E), you're running the risk of painting too much detail. Control your value and color perspective.

Contrast

The degree of contrast in your painting is entirely at your command. Various moods can be created with strong contrast or with subtle, hardly noticeable tones. If you're in doubt, small thumbnail sketches will help you decide in which direction to go. Remember: the greater the contrast you create between your dark and light values, the more dramatic the result will be.

VALUE AND FORM

When an artist talks about values in his painting, he's talking about the tone, the strength, the lightness or

darkness of his colors, much as he might talk about the blacks, whites, and grays in a photograph. Form — the way objects are painted to appear three dimensional on a two dimensional surface — is the result of correct values. (See demonstration, pp. 100-102.)

Painting in One Color

To learn about values, and to prevent becoming confused too soon by multiple colors, paint a little sketch with only one color. Think before you paint each stroke. Make sure the distant objects appear lighter than the close ones. Objects in sunlight should be more detailed, more carefully defined, than shaded ones. A good color to use might be Payne's gray. Copying from a black and white photograph could help you get started.

Painting in Two Colors

If you feel satisfied with your sketch, paint the same thing with two colors. Add burnt sienna to your Payne's gray. You can use the colors separately or mix them. The combined washes will give you a dark, greenish color. Don't let color confuse you. As you apply your washes, don't think in terms of color, but in terms of value — think of them as grays — and you'll be able to achieve a good result easily.

Painting in Three Colors

Now paint the same picture with three colors on your palette. Manganese blue might be a good choice for your third color. Now that you're using three colors, you'll find the control of values a little more demanding. Remember that warm colors appear closer than cool ones. Think of a pale blue mountain, for example; it's pale blue only when you're far away. As you move closer to it, it warms up in color — perhaps even to a rich brown rock color. If you're able to control your values, you'll achieve a sense of distance, a feeling of three dimensions in your painting. (See *Three Dimensions, Perspective*, p. 33, for further details.)

Visualizing Form

It takes experience and skill, but above all knowledge, to give form to everything you paint. For example, a treetrunk can be painted flat (*D*) or it can be painted solid, round, and rugged (*E*). The treetrunk in *E* has good form; the treetrunk in *D* hasn't. As you paint any object, keep the form in mind. Don't paint the front of an object only; try to paint the solidity or the look of solidity of the object. "Think form while you work" is a good rule to go by.

In the demonstration on pp. 100-102, I show the sequence in which I painted a clump of lovely birches in the snow. Their forms are fairly strong, yet their

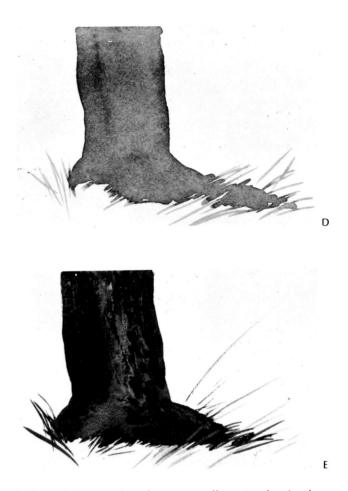

D

E

relationship to each other, as well as to the background, shows carefully considered values. While I painted the birch trunks with their ragged peelings, I constantly tried to make the trunks feel round and solid, while the bark peelings had to feel thin. The young trees in the middleground are a pleasant contrast; they lead your eyes into the massive, distant forest, where value becomes especially important. Because of the distance, the form of the total forest is more apparent than the forms of individual trees.

THE VALUE OF WHITE SPACE

One of the most unexpected demands of watercolor for a beginner is understanding the importance of white space. (See demonstration, pp. 103-105.)

White Space is Paper

In true transparent watercolor, a white space is a negative quality, because white space is not painted. White paint is never used because it's opaque and less brilliant than white paper. Train your mind to accept the challenge in planning your painting around these white areas of clean paper. It's the white paper that allows the colors to look brilliant, because the reflective quality of the paper bounces the light through the thin layer of paint and produces the sensation of

A

B

C

D

translucency in a watercolor painting. The thicker, the more opaque the paint is, the less the white light of the reflecting paper will be. Since you're trying to take full advantage of the transparent nature of watercolor, allowing opacity would be an imperfection.

Plan Ahead

In transparent watercolor, the ultimate in purity is your white paper; it's the most brilliant value that you have at your command. Wherever you leave white space, make sure it's thoughtfully planned to be an integral part of your composition. Intelligent use of pure space is a rare virtue even among the best watercolorists. Pure space creates extreme contrast with dark hues. It adds drama and clean freshness to your work. The more daring you are with it, the better the result will be.

Mood

With the wet-in-wet technique, you have the most subtle and intimate blending of color and pure white at your command. The use of color next to white creates varying moods in spite of the fact that the white itself never changes (A). For example, a bright group of trees in the fall, painted with a generous amount of white around it (B), will make the space appear warm in tone and will indicate a happy and relaxed disposition. If the same group of trees is painted in a dull, gray, wintry mood (C), the white area will look more somber and cool, adding to the mood of your subject.

Try to visualize a closeup of a mass of lush, drying weeds in the fall looking bright and sunny. You can add more snap to the brightness of this sketch if you scrape one or two white lines to indicate shiny highlights on those weeds (D). Remember: this must be done after the paper is completely dry.

White space is a psychological aid in the hands of a skilled artist. It can keep you excited while you paint. It suggests clean freshness. Brave use of it adds a touch of the unexpected to your painting. From a completely vignetted effect to a tiny, sparkly star in the dark sky, white paper is yours to use.

SEQUENCE OF PAINTING

The sequence or order of application of elements in your painting is important, because it can help you emphasize or underplay certain parts of your composition. There are different approaches available to the painter; I shall mention a few.

Center of Interest

My own preference is to start with the center of interest (A) and then go on to the next important

element, then the next and the next, until I reach the least important touches at the end. The most significant part of my composition is the center of interest. This must be painted with the greatest care. Because the less significant parts are related to the already existing interest point, the risk of overplaying the wrong area is eliminated.

A

Light to Dark

Another proven method is to paint from light value to dark (B). This is a safe, conventional approach, because of the transparent quality of watercolor, and involves the least amount of risk.

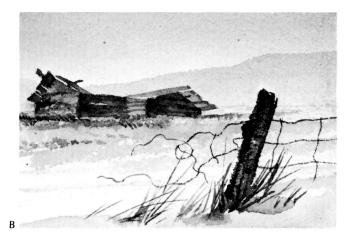

B

Dark to Light

Dark to light (C) is the opposite method. The danger of ruining your work is constantly with you, because you have to keep touching, and occasionally go over, already successfully rendered details as you apply more washes. The sparkle and freshness of the dark to light sequence, however, gives a very satisfying result.

Don't be afraid to touch already dry, dark washes; just make sure you're quick with your brushstrokes and never go back immediately for a second touch. The first wash over dry paint loosens the pigment but doesn't move it. The second touch of the brush will smear the loose pigment.

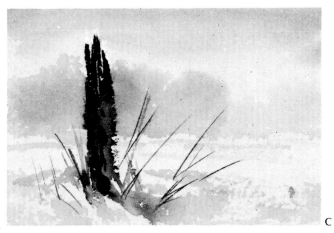

C

Correcting Dry Painting

Occasionally, you'll miss some details. After your painting is finished, you may want to correct the problem on the dry painting. Analyze the area where you want to add more wash. If you have to rewet the paper, use a soft haired, wide brush which is perfectly clean. Apply a wash of clean water quickly and gently. Make sure the wet area is a lot wider than you want your new wash to run, unless you wish the color to seep all the way to the edge of the dry spot.

REFERENCE SKETCHES

To achieve a high level of perfection in painting, you must strive to be more than a craftsman; you must strive to be a painter. A painter is one whose emotions are reflected in his work. He uses his technical skill as a tool to communicate to his viewers through their visual sense.

Sketching Helps You Choose

When you face nature as a landscape painter, you can, and probably will, experience many emotions at the same time. You may find it difficult to distinguish the scene which has greatest impact on you. One of the ways to crystallize your thoughts is to make reference sketches. These little decision-makers can be small but they should show their purpose clearly in the variety of their treatment.

For example, take this simple scene: close to you a handsome tree leans over a cold trout stream rushing around shiny, dark rocks; you can see the deep, rich colors of vegetation on the opposite bank. You may see the light changing under the rushing clouds which hide the sun's direct light. It's quite possible that the clouds will move away momentarily and allow bright sunshine to light up some parts of your subject. If you like these changing conditions, you may decide to do several reference sketches to see which would make the best painting to represent your feeling (A, B, C, and D).

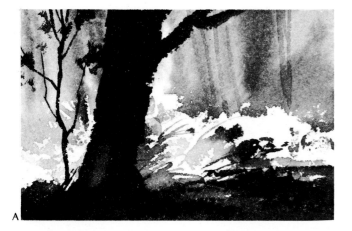

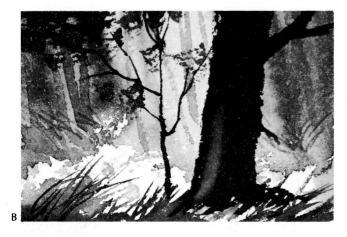

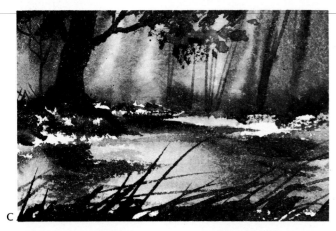

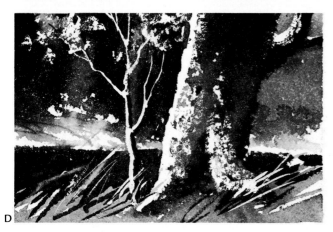

Sketching Captures the Moment

You may do little pencil or ink drawings as reference sketches, but if you want to do real justice to them, and if conditions allow, try using paint. Create a color mood as well as a drawing; establish composition and tone values. But don't attempt to capture unnecessary details, as this is a time consuming part of the painting procedure. Speed is the most important thing in reference sketching. It's important to make sure that the excitement which triggered your painting a particular subject will not diminish or weaken before your painting is finished. This quality of excitement will give your final work the value that comes from its being the fruit of your own feeling.

Quite often these reference sketches will have so much charm and freshness that you may find it hard, if not impossible, to transfer this quality to your finished work. You should not be discouraged, however, because chances are that your painting will still have more of your personality in it than if you hadn't had that extremely successful first rough sketch to work from.

Keep Sketches Loose

You may find your reference sketches so enjoyable to do that you'll tend not to try larger paintings. If this happens, you could end up with small sketches which are overworked, because you'll inevitably attempt details which are only possible in larger scale paintings. If you find yourself trapped in this kind of frustration, paint a few larger pieces of work to loosen up again. After all, the reason for reference sketches is to improve the quality of your paintings, not to substitute for them.

Speed is the greatest value of these reference sketches. The short painting time will allow you to capture short-lived subjects such as sunsets, rainbows, moving waves, etc. Use them often; their value is certain.

5. PAINTING THE SEASONS

The four distinctly different faces of the landscape are seen in the four seasons. Each season offers a different challenge and requires a different approach; each has a unique personality and mood.

SPRING

I think of spring as the time when nature is reborn; the urge to paint seems to get a little boost also! Color is the key note for spring. Climate has a lot to do with the vigor of spring. Generally speaking, spring shows up with the greatest impact in areas where snow is a part of winter. This includes the largest geographical part of North America, and is the spring I'm most familiar with. (See demonstration, pp. 157-159.)

Color

A keen eye that sees subtleties is very important to a painter. Spring offers subtleties in great abundance, but you have to be able to spot them. I associate fresh, clean colors with spring; new shoots, outbursts of color, buds (A), and all the million shades of fresh color that appear only in the springtime. An early spring landscape is very much like one of late winter. The transfer is so subtle that at first you really have to search for it. The tree buds begin to have a livelier color as the snow starts to melt. Then the dry weeds and grass show touches of green. After the buds turn into flowers, and then into leaves, you must be on your toes not be be overwhelmed by the bright colors. The fresh brilliance of spring hues can easily turn your painting into a "pretty," commercial looking effort.

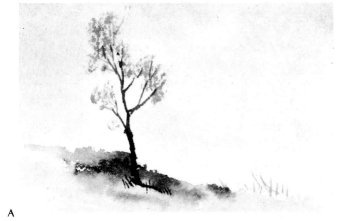

A

Masses of Green

Flowers in a mass (B), either on trees or on the ground, should be treated as a color area — with little definition — unless they're very close. If they're very close, they form the center of interest, and the details must be carefully controlled (C). Fresh greens can be either friend or foe. Overexaggerating an area of brilliant new green foliage is a sure way to kill a good painting. Consciously avoid this tendency and listen to your good taste.

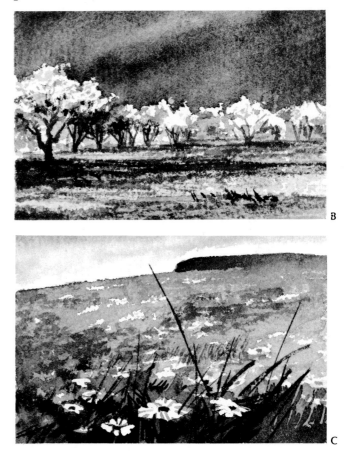

B

C

Spring Fever

I want to point out the emotional value of spring fever. The smell of fresh spring air and the song of birds have a strong influence on human emotions. A landscape painter is no exception. This excitement adds new vigor to a painter's enthusiasm. Take advantage of it. When you feel the need for a fresh spring walk in the country, take your paints and brushes with you. There's an excellent chance that

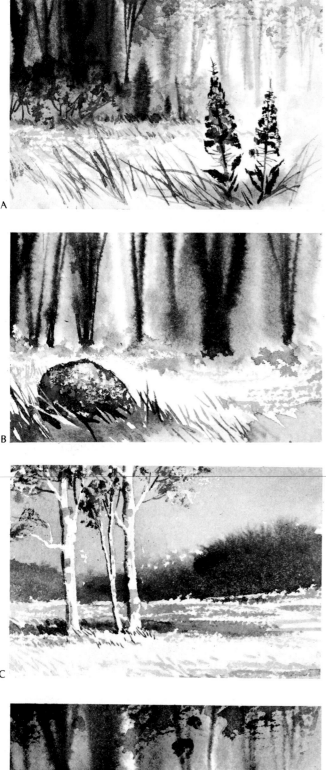

A

B

C

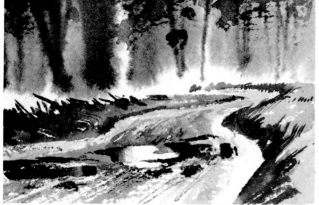

D

you'll come back with some exciting sketches that you didn't even realize you had in you. Dress warmly, to make sure any physical discomfort will not discourage you from staying as long as you feel like painting.

SUMMER

Summer is a time of maturing. The heat of the sun causes a lush summer landscape. This heat, and the brightness of the summer sun, is a real problem for a watercolor painter. Avoid painting in direct sun if possible. Find a shady spot, and make sure the shade won't move off you before you're finished with your sketch. (See demonstration, pp. 160-162.)

Avoid Direct Sunlight

Here are some of the reasons that you should avoid direct sun. First, you're working on white paper, and the glaring whiteness will blind you while you paint and will distort your sense of values. Second, the heat from direct sun dries your paint on the warm paper almost as soon as your brush touches it — this limitation prevents you from taking advantage of all the techniques available to a watercolorist. And finally, the sun's light is brighter than any indoor lighting in which your painting will be viewed — the colors will look dull in direct sun, but the same colors will become bright and loud in subdued lighting because you used more paint to cover the glaring white paper.

Sunglasses

Using sunglasses is a trick that I myself avoid. In theory, distortion that colored glasses cause applies not only to your subject but to the colors you paint with as well. In practice, however, it's a different story. While you will be able to mix greens as greens, blues as blues, etc., you won't be able to control the subtle, inbetween shades to your satisfaction when wearing sunglasses.

Monotony

Monotony is another danger during the summer. Most trees have lush green foliage that can look uninteresting to the untrained eye. A creative mind has to improvise a little. Look for the touches that add variety and interest to your painting: flowers (A), colorful objects, rocks (B), houses, tree bark, discolored leaves, strongly sunlit spots (C), puddles (D), are but a few details that can have a prominent place in your summer landscape.

Summer sky is a very powerful element (see *Painting Skies* in Chapter 9). White fluffy cumulus clouds or enormous thunderheads will always add powerful

impact to an otherwise plain summer landscape. A child's fright at the sound of thunder is a little bit in all of us. When you paint a thunderstorm in summer it should reflect this tense alertness. This dramatic quality is essential; it's what makes a work of art out of a doodle. Don't be afraid to reflect your own disposition in your painting. A cool, breezy day or a hot, muggy afternoon should play back these very conditions to the viewer. Using warm colors will make your painting look hot; cool colors will appear fresher. Consciously select your colors to complement the weather conditions. A painting of summer rain should have the same silent, thirst-quenching quality that the rain drops have as they kiss the flower petals and roll into tiny, sparkling beads before soaking into the soil. In a summer landscape, play down monotony and exaggerate the exciting.

AUTUMN

With the outburst of autumn, a landscape painter faces the opposite problem to that of summer painting. Instead of monotony, everything is filled with excitement. The bright reds of maple trees, the brilliant yellows of birches, an infinite number of shades of glowing color, all demand self-control from a painter. If you paint a brightly colored autumn scene exactly as it is, you'll most likely end up with a garish looking sketch. Too much color is the danger in a fall landscape. (See demonstration, pp. 163-165.)

Light Conditions

Light conditions play a very important role, as well. Sunshine opposes gray, overcast, or rainy days. When you paint in brilliant sunshine, use one clean pigment to get maximum brilliance out of your washes. Use your paint lavishly. Remember that watercolor looks much denser when wet than after it dries. Fight for color unity in your painting. Look for color accents. Take advantage of reflections. Observe how much brighter the light colors and how much deeper the darks are during or after a rainfall.

I prefer gray, cloudy conditions to sunshine. The subtle lighting of a gray day introduces a calming element to otherwise overwhelming color. Gray skies can very successfully be blended with the colorful foliage by permitting the sky and the foliage to flow into one another as you apply both simultaneously. Lack of contrast is the best method of insuring the calm mood a gray sky contributes to an autumn landscape. Weeds and ripe vegetables are also strong contributing factors to the colors of fall (A). In farm country, the fields offer fascinating color patterns, while the busy activity of animal life enhances the impact of autumn painting.

Reflecting Water

I'd like to bring to your attention the importance of reflecting water in the fall (B). If you handle it right, preferably in an unusual way, it will add strength to your work. Too many people, however, including some competent painters, feel that they must have water in their autumn paintings at any cost. Avoid falling into this rut. It could dull your thinking and make you lose interest. Too much of a good thing is simply too much!

Late fall has a calm beauty that seems to influence most subjects. Some leftover color is all that reminds us of the fiery brilliance that blinded us only a few weeks before. Play up these little insignificant color

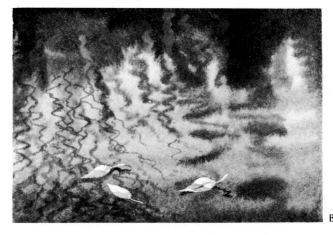

B

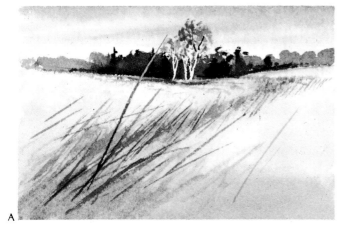

A

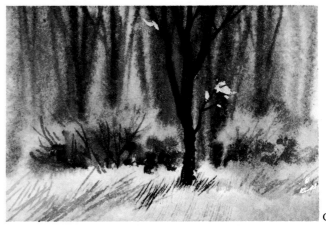

C

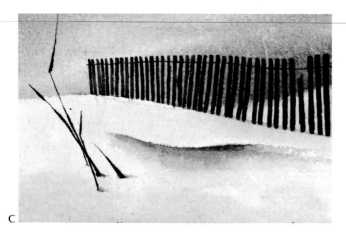

A

B

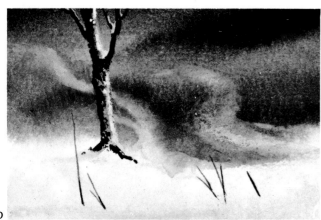

C

D

spots *(C)*. However tiny they are, they'll look very strong if you contrast them against subtle surroundings. The brilliant colors of autumn are short-lived, so don't hesitate too long to capture them.

WINTER

The clean beauty of white snow makes a star performer out of a humble blade of grass. This is the time of year when I feel justice is being served to the insignificant members of nature's kingdom after the giants have had their grandstand play. (See demonstration, pp. 166-168.)

Characteristics of Snow

In the winter, form, design, and composition become extremely important. Colors are subtle and few. Take full advantage of the white paper, but don't labor under the false impression that snow is pure white; it isn't. White snow reflects other hues much more vividly than any other color. On a sunny day it looks blue, particularly in the shadows, as it reflects the blue sky above. No matter how quiet or obvious these reflections may be, find them — because these are the touches that add life to a winter landscape.

The drama of white against other colors constantly challenges the artist. Study a single snowflake *(A)*. It's crystallized water. The beauty of this tiny particle of winter's building material should remain in the back of your mind as you paint snow. After all, any amount of snow on the ground, on the heavily packed branches, or on the roof is made up of billions of these little crystals *(B)*. Try to get out of the city to see winter at its best. Make a manhole in the waist-deep snow to feel the warmth of the snow as you stand in it. A blizzard to winter is like thunder to summer. It makes man feel insignificant in front of nature's power. To paint such an experience, to capture this feeling of isolation, you have to work vigorously. Only immediate objects will be defined, depending on how heavy the snowfall was.

Carefully observe the snow on the ground: is it darker or lighter in tone than the sky above it? It varies depending on the weather conditions. Snowdrifts *(C)* are fascinating forms and add interest to an otherwise weak subject. Study each one with care. The light that defines their form can be either very subtle or very severe and should be painted with care.

Blowing Snow

You can paint blowing snow *(D)* very effectively as follows. Paint your background, ignoring the mist of drifting snow. After it's dry, repeatedly wipe the pigment back from the area where the wind-blown snow appears with a firm brush and clean water. Avoid hard edges. Continue these light wiping touch-

es, blotting up the loose pigment after each stroke of the tissue. With each wipe, imitate the direction of the blowing snow.

Technically, winter painting in watercolor is difficult because of the temperature problem. Try to paint in a sheltered spot. You can use chemicals in the water to avoid freezing. Alcohol and a few drops of glycerin diluted in water acts as an antifreeze. Too much glycerin, however, may prevent drying completely. Heating facilities are the best solution. The necessary heat you need to overcome the problem of freezing can be obtained by an ice-melting blower plugged into your car's lighter, or the car heater, or by a bonfire.

Whatever problems or slight discomforts you face painting in the winter will fade into obscurity after you experience the rewards which result from taking home a little piece of winter in your painting. At any cost, try to do your sketches on the spot, for the subtle beauty of winter is too difficult to paint from memory. (See *Snow* in Chapter 8 for further details on painting the winter landscape.)

6. TREES IN LANDSCAPE

A basic element of most landscapes is trees. Trees differ according to locality and each species should be studied as a distinctly unique form. I will discuss deciduous trees, evergreens, and palm trees in this chapter.

DECIDUOUS TREES

Deciduous trees are the most commonly known trees. A deciduous tree is one which has a shedding type of foliage and changes its appearance from season to season, offering the landscape painter a new experience with each change. (See demonstration, pp. 151-153.)

Roots, Trunk, Branches

The anatomy of a deciduous tree (A) starts with a large root system below ground level, which most often spreads out as far as the crown or branch structure of the tree. A deciduous tree has a heavy trunk, covered with protective bark. The trunk divides into branches which get thinner and smaller the further they are from the trunk, ending up in a mass of fine, lacy twigs where the leaves grow. The mass of leaves on the top is referred to as the foliage, because of its unified appearance.

Foliage

The foliage of a deciduous tree (B) could be compared to an umbrella, or to several small umbrellas. The upper side of the foliage is light, the lower, or inner, side is darker. The branches are partially hidden here and there by concentrated clumps of leaves. Toward the outer edges, at the top, you can't distinguish the twigs from the leaves.

One of the most common mistakes a landscape painter makes in the beginning is in trying to paint the foliage leaf by leaf. This approach is, naturally, wrong. You don't really see leaves with your eyes; your eyes see only units of color masses. It's your mind that tells you they're leaves. If you doubt what I say, squint gently as you look at a tree. Always believe your eyes. Your eyes are a much better judge of the visual reality of objects than your mind is.

A tree and its foliage is a three dimensional object; you must paint it that way if you expect it to look believable. It has to be correct in perspective. It has to show its weight. You can achieve this with the help of correct value and color.

Each tree has a character, a personality, of its own. Study each specimen and try to give back this character in your painting. A young tree looks different from an adult of its own kind.

A

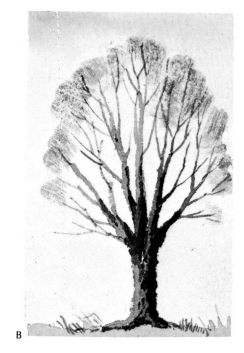

B

Autumn Foliage

Autumn foliage (C), with its brilliant color impact, must be controlled with sound judgment and good taste. The trunk and branches have more contrast (they're darker) in value than in spring or in summer. The approach to painting of the foliage is similar to that of painting summer foliage, except for the color.

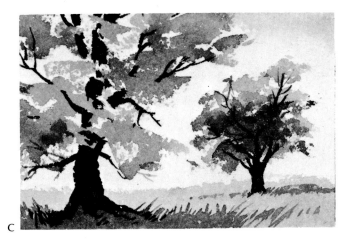

C

Twigs

All deciduous trees show their character most clearly after they lose their leaves (D). Their fine twigs are no longer hidden from view by thick leaves. The same rule applies here as for painting leaves: don't ever paint individual twigs on a large tree. Paint them as tone, subtly flowing into heavier branches and getting larger toward the trunk.

Drybrush strokes are an excellent way to paint lacy twig structure, but not the only way. Drybrush would be too harsh for a tree which is in haze or fog, for example. Squinting, again, will come to your rescue if you're in doubt.

Individual trees are beautiful and an extremely important part of most landscapes. You must like them, respect them, and learn to paint them well if you want to be a good landscape painter.

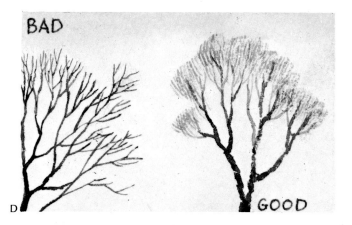

BAD

D GOOD

EVERGREENS AND PALM TREES

Evergreens are trees which retain their foliage throughout the year. They have needle-like leaves that stay green all year round, or at least their color change is hardly noticeable. The main question in painting evergreens is how to relate them to their surroundings. While an evergreen itself doesn't change, its environment does — very drastically (A). An evergreen tree in the snow stands out much more than if it's nestling in the middle of a green forest. I won't go into all the different species and their botanical characteristics, because there are too many of them. In any case, their essential differences can easily be detected with your own eyes. (See demonstration, pp. 148-150.)

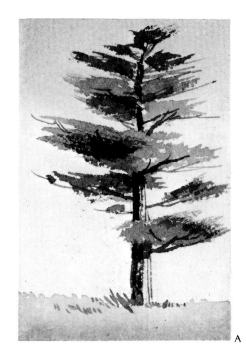

A

Evergreen Trunk and Branches

Basically, all evergreens have a central trunk. Their branches protrude sideways all around the trunk at a sharp angle. The branches are usually, but not always, largest at the bottom of the tree, becoming progressively smaller toward the top. The elements shape the character of evergreens as they grow. If the environment includes a strong, year-round prevailing wind, the constantly rushing air will twist the tree and force the branches to grow in the direction of the wind (B).

Evergreen Colors

Evergreens change color with age. A young shoot will have a very fresh, clean, bright green color, while an old specimen of the same species will be much darker in color. When you paint an old evergreen, try not to reach for the green paint. I know the tendency is to use green because your mind thinks it's green. In-

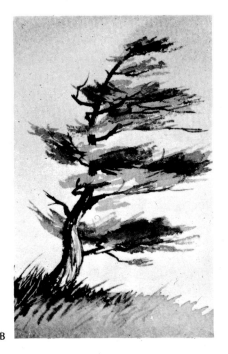

B

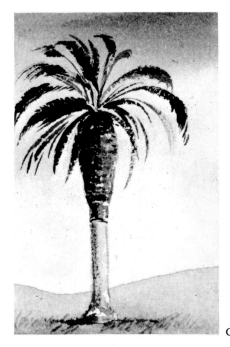

C

stead, look at the tree and believe your eyes. A mixed color is necessary to get the right hue. Burnt sienna, Winsor (phthalocyanine) blue, sepia dark, ultramarine blue, and cadmium orange will give you the variety of greens that are dark enough, yet alive enough, to represent a healthy evergreen.

Painting Knife

Painting a single evergreen as the center of interest requires more attention to detail. I find a painting knife an excellent tool with which to paint the branches, and even some of the lacy clumps of foliage. For the technique, please refer to *Drybrush* in Chapter 2. Pay careful attention to the broken branch stumps: these are likely to occur at any part of the tree, but are usually in the bottom area.

Palm Trees

Palm trees require a tropical, warm climate, and because they grow only in warm areas of the world they're a species of tropical vegetation. The trunk of the palm tree appears straight, but it should always be painted with a slight, playful curve. The branch structure is confined to the very top of a single trunk. The palm tree has two main types of leaves: those which form a fan-like unit at the end of a strong stem and those which grow like feathers *(C)*. Directly under the crown of the palm tree are clinging dead leaves or stubs. These add character to a palm. If you aren't familiar with palms, don't ad-lib without careful observation. Their outstanding silhouette value lends itself to simple brushstrokes, and you can take full advantage of all the drybrush you want. Again, if in doubt as to technique, refer to *Drybrush* in Chapter 2.

FORESTS

When I speak of forests, I generalize, because they differ so much from place to place. A forest can be composed of many species of trees; it can be dense or open. And, naturally enough, the same forest will change its appearance with the changing seasons. (See demonstration, pp. 154-156.)

The Four Seasons

Spring in the forest brings lots of fresh green buds, which form a lacy screen that allows light to filter through without heavily shaded areas. In summer, the leaves are large and deep green in color, showing heavily concentrated dark green areas. The reason that the leaves have this rich, dark color is that we're usually looking at the underside of the closer foliage, and this is usually shaded.

Autumn is the time when deciduous trees play havoc with the painter. The glowing, bright color inside an autumn forest is a breathtaking experience. In Ontario, Quebec, or New England, the vivid yellows and reds completely take over the color scheme. This is the time to use the cadmium colors bravely.

The forest is most subtle in winter. Various tones of grays (mixed grays) to suit conditions, subtle color notes (few clinging leaves), can be major influencing elements. If you paint the forest in winter, listen to the silence; try and bring this into your painting.

The Anatomy of a Forest

A forest, just like anything else, has an anatomy of its own. Let's break this anatomy of the forest up into three parts: the distant forest, the edge of the forest, and the interior of the forest.

The Distant Forest

The distant forest (A) must hug the ground structure. It cannot be just a color blob without character. The more distance there is between you and the forest, the paler it will appear in color as well as in value. A forest in the distance usually doesn't make a center of interest, which means it has to be played down to complement a center of interest other than itself.

The Edge of the Forest

As we approach the woods, we first reach the edge of the forest (B). In a dense forest, this is more defined than in an open one. To paint it successfully, it's necessary to take great care in choosing your subject (center of interest). The closer trees and undergrowth will have to be well-defined; the further ones will lose detail as they fade into the distance, finally turning into a mass of slightly varying tone to create a three dimensional effect. One way you can achieve this successfully is to wet your paper for the dense, distant forest area and apply the paint in various consistencies, imitating the form and growth of trees here and there. The paint will blur slightly, creating the feeling of a distant mass of trees. As your paper dries, add trees and undergrowth which are less and less blurred and more detailed. The final crisp notes should be added after the drying is complete.

The Interior of the Forest

As you reach the interior of the forest (C), you have 360° of the forest to use for your model. Be discriminating and make sure you have a center of interest. It's easy to fall into the trap of monotony. Don't paint two or more trees the same shape or color. Place them unevenly. Pay careful attention to the space between units and trees. Remember the importance of negative forms. Most often you'll see very little or no sky at all. Avoid — at any cost — a single blue hole through the foliage, which is a disturbing, distracting element. Note: when you paint forest interiors, play down the sky.

A

B

C

7. THE LANDSCAPE AT YOUR FEET

Every landscape has ground in it, whether it's undergrowth, mountain rocks, or desert sand. This chapter covers the various things that you may see when you look down at the landscape at your feet: stumps and moss; undergrowth, shrubs, and weeds; rocks; and sand and soil.

STUMPS AND MOSS

It may seem unnecessary to devote a section to this seemingly insignificant part of landscape, but because I get such a terrific amount of satisfaction out of painting stumps and moss I decided to share my experience with you.

These neglected stepchildren of the landscape painter can add nostalgia and sentimental contact with the past, a contact which is so subtle that often it only works on your subconscious. (See demonstration, pp. 145-147.)

Cut Stumps

To paint a freshly cut stump or log (A) can hurt; it should hurt — at least a little bit. The bright, clean, yellowish color of the cut exposes the age rings. This bright color is usually seen in contrast with the sliver-like, ripped fibers on one edge, which are caused by the cut tree falling from its own weight. Light conditions add to this drama. As you paint, think of this cut tree as a life that has bled through that wound. Your feeling will make, or break, the emotional value of your painting. Be extremely careful of the location — as well as the pointing direction — of this bright wound of freshly cut stump. It has a strong impact and should be handled with a certain delicacy.

Rotting Stumps

A corroding stump (B) is usually dark in tone, crumbly and subtle in color. When it's wet, it reflects the bright colors around it (usually the sky). Small insects and animals leave fine pieces of corroded wood around it. Most often such stumps are nestling among weeds and other signs of neglect. To add snap to your painting, exaggerate some of the subtle colors, edges, or shine you may discover as you carefully analyze your subject. Contrast is the most likely quality of a rotting stump that you'll spot. Don't be afraid to exaggerate this contrast.

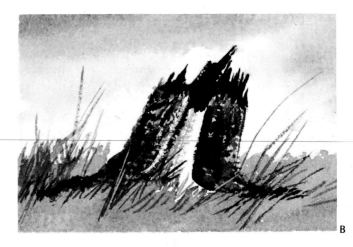

B

Uprooted Stumps

Uprooted stumps (C) are perhaps the most dramatic victims of man's activity. They always tell a story. A root stump fence is undeniably a powerful subject to paint, so you must paint it with strong technique.

A

C

Drybrush lends itself beautifully to this. The color is usually weatherbeaten gray, exposing the strong-lined texture of the twisting roots. Vines and weeds quite often grow into the deep twists. These bright color touches should be carefully maintained, as they add a sense of belonging to nature. Because of the neutral, gray color of the exposed gray stump, it will pick up any reflection of color near it. Look for these subtle touches and don't ignore them. Note: painting these stumps from a low angle adds to their impact.

Stumps as Center of Interest

Stumps, by their natural strength, create a temptation to make them your center of interest. This means that the stump you paint will dominate your painting. Its importance will demand all the attention you can give. Remember, in spite of dark color, you still have to show it as a three dimensional object if you want to do justice to its form. Take your time with the details. Take more time deciding on technical touches than it actually takes to make the marks. The stump's being the center of interest means it has to be the center of your interest. The amount of attention you show to the structure of detail will prove how much the stump occupied the center of your interest while you painted it; not only to the viewer but to yourself.

Moss

Stumps and moss (D) naturally go together. To list the number of different kinds of moss in existence is virtually impossible. Fortunately, to a painter, they differ only in color and the shape of their patch structure, and these things can easily be observed visually. The color of moss is its most important identifying element — from vivid yellow green, through hazy blue, to dark grays and brown. Moss occurs in almost any color. The edges usually offer an interesting line design as moss crawls over almost anything offering moisture. Moss is lush and bright in color in shaded, damp forests, dry and dead looking on rocks which get only the occasional fresh rainfall.

D

Moss on stumps is usually well-modeled, painted with a splattered technique, and carries the form of the stump into the color of the moss, to form a unit.

Don't ever walk by an insignificant looking stump. You may be walking by one of your best paintings.

UNDERGROWTH, SHRUBS, AND WEEDS

Shrubs are small trees. They can be painted in a similar manner to small tree branches. They're delicate in structure and should be treated delicately. Your method of painting shrubs should differ depending on where they're located on your painting and on how much importance you want to give them. (See demonstration, pp. 136-138.)

Shrubs in the Foreground

In the foreground (A), you can paint in as much detail as you like, short of overworking it. Because of their nearness, the shrubs should look believable. If they have foliage, this should be painted as large healthy leaves or as a good size clump.

A

Shrubs in the Distance

In the distance (B) shrubs, like everything else, lose detail. A safe way to paint them is by using simple tone and paying careful attention to silhouetted shapes. You should indicate little or no structural detail.

B

Grass

Grass (C) is an element in your painting that can be very flat and uninteresting if you always treat it the same way. Never paint grass with only one color even if it looks that way; vary the hue. Grass which is cut short isn't my cup of tea. I don't often paint subjects with cut grass by choice, although it can be done very effectively if you lay a large wash first. After this wash dries, add small drybrush touches indicating texture.

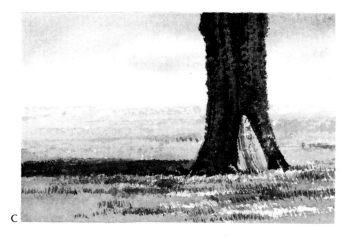

C

Weeds

Weeds (D) look like overgrown grass if they're in the distance. Close up, however, they show off their size and beauty. One good way to approach weeds is by applying brushstrokes and painting knife strokes in varying sizes, combined with larger washes freely flowing into each other.

Weeds in season are a healthy color, most often green. Lack of moisture or change of season will dry up most weeds. Their color will drastically change. Make sure you observe these conditions and mix your colors correctly. These color differences are accentuated even more in late afternoon.

In cold climates, dead weeds create a fairyland when the hoarfrost settles on them, and early birds who go out painting before the sun has a chance to melt the frost will experience an unforgettable emo-

D

tion painting these jewel-like beauties. Antwerp blue, mixed with the weeds' own color, is useful in painting the forest.

Note: be playful when you paint weeds; they're not organized, monotonous lines, but living forms with characteristics of their own. Practice a lot with them.

ROCKS

To give you a complete and accurate list of the characteristics of rocks is as impossible as to count the raindrops that make a rainbow. However, I'll give you a few general categories. I'm sure you'll find many exceptions in the many natural and man-made stone formations which exist. Natural rocks show their geological origin as well as their age to an expert's eye. To an artist, they offer form, color, and a touch of the unusual. (See demonstration, pp. 139-141.)

Stratified Rocks

Stratified rock formations (A) show long, angular layers, sometimes on an unexplained slant, and are usually the result of the earth's constantly shrinking crust pushing and buckling the surface of its shell. The colors of these rocks vary infinitely depending upon location.

The best way to approach the layers of these rocks is with a split drybrush technique, because you can paint several lines at the same time. (See Drybrush in Chapter 2 for further information on split drybrush technique.)

A

Glacial Rocks

Other commonly visible rock types are of a glacier-deposited kind (B). Alone, with worn, round surfaces, these usually seem unrelated to their surroundings. Roundness is the giveaway sign of their origin. Rocks which are exposed to the elements have a bleached-out color, exposing the splattered inner composition. Those which are surrounded with vegetation are frequently partly nesting in soil, and if enough moisture is available, have a moss cover.

B

To paint glacial rocks, I put down a single wash, the approximate color of the rock. With this, I give it form and shading. Several applications of varying colors follow, splattered on with a toothbrush or shaken off a paintbrush, or both. Several approaches are necessary to avoid the unevenly spaced color dots running together. Allow each layer to dry before adding the next. If the odd little splatter does fall in an unwanted area, blot it up immediately with a tissue and it won't leave a mark. Lay down a tissue directly behind the surface you're working on, in the direction of the splatters, to mask a clean area. This will also make it easy for you to grab a tissue to blot that unruly splatter that got in the way. Finish with drybrush.

Volcanic Rocks

Volcanic rocks (C) are usually dark in color and look like outpouring, lazy lava — because that's how they originated. Their dough-like surface appearance gives them away. The elements (wind and water) create endless patterns in them. The larger openings can be caves. You can see excellent examples of volcanic rocks around Blue Rocks, Nova Scotia, but they can occur in any location. To paint them, use several washes. Let each one dry before applying the next. I use the tip of a brush handle to scrape line patterns into the wet paint. Final touches are done with drybrush.

C

Man-Made Rocks

Artificially created rocks (D) can also be interesting to paint. These are usually the result of construction. Artificially split rocks look sharp at the edges and have clean, flat sides. It's easier to paint them because they lean toward mechanical shapes. You see these rocks on the roadsides in any mountainous area. Quite often water seeps through cracks, adding darker color as it runs down the surface. Paint these rocks with large, bold, flat washes allowing the sharp edges to survive. I paint cracks and surface design mostly with the edge of a painting knife after the basic washes are dry. I also use the tip of the brush handle quite generously in the washes.

There's one important hint I can offer you: when you paint rocks, always let them nest in weeds, soil, or whatever surrounds them. They must be tied into your composition. Another must is solidity: rocks must feel heavy and look solid. These two suggestions apply to all rocks.

D

SAND AND SOIL

In this section, I'd like to discuss some approaches to painting exposed soil. It's a seemingly minor issue among more important details, but a lack of skill in painting sand and earth quite often detracts from what could otherwise be a good painting. (See demonstration, pp. 109-111.)

Pigments

It's very important to be familiar with the behavior of pigments. Those colors which separate easily, if applied in a single wash, are ideal for grainy, sandy areas (A). Let's list a few: yellow ochre, burnt sienna, burnt umber, and sepia separate well from ultramarine blue, cobalt blue, cerulean blue, and manganese blue. Don't use these colors exclusively — these are only some examples, and even they differ depending on the different manufacturers and the type of paper you use. As I've emphasized before, it's essential that you experiment with different pigments and papers for yourself.

A

Sandy Beaches

Sandy beaches are commonly painted subjects on our continent. Before you start painting, match the color very carefully. Observe the pattern of the small debris the waves have generously deposited (B). Drybrush dragged on the already dry first wash offers a good method for this purpose. Take advantage of texture-creating elements — for instance, larger pebbles, washed-out seaweed, shadows, etc. Often, you can observe fresh reflections on the wet surface of shore sand caused by the tidal backwash. Paint these reflections in strong contrast to the dull, smooth sand. And take advantage of the patterns created by little entering streams of water.

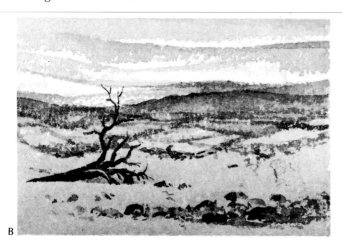

B

Deserts

Deserts are other common locations for exposed sand. The extreme heat usually bakes all but the hardiest and most scrawny vegetation. The wind adds its contribution by blowing the fine sand and piling it in drift-like formations similar to snow. Study the subject before you paint it. Again, color is of extreme importance.

Sand Banks and Pits

Sand banks and pits (C) are a little more varied. They, in addition to color and the separating paint, need additional work to suggest pebbles, stones, roots, etc. After you've painted the basic washes in a manner similar to sand, let it dry. Apply some dark splatter with a toothbrush to indicate the small stones strewn about. If larger stones appear close by, paint a few of these individually to add interest. For additional life, place a few weeds strategically in the sand.

C

Plowed Fields

Plowed fields (D) make difficult subjects: you must use darker washes, yet you have to keep them transparent. To insure this, use well-loaded brushfuls of paint. Paint the semimechanical lines of the plow marks which are up close one at a time. This gives each line time to dry enough by the time you touch it with the next wash to keep its edge for direction, yet blend a little. These lines should be slightly irregular to avoid monotony. Pay attention to shiny, reflecting lumps in the earth if the field is moist. Allow some of the turned-over grass to peep out here and there.

D

8. THE LIQUID LANDSCAPE

The liquid landscape refers to water — standing still, rippling, in waves, or falling in mist, rain, or snow.

STILL WATER AND REFLECTIONS

Calm bodies of water are usually fairly good reflectors. By a good reflector, I mean that the images that the water's surface reflects are almost as clear in detail as the objects themselves. I said "almost," because the depth and color of the water itself, plus particles of dust, take away from perfection. To simplify reflections, imagine that the water is a mirror and you're looking at a mirror image. Reflection is usually dimmer and darker than its source. (See demonstration, pp. 130-132.)

Oceans

Of large bodies of water, the largest are the oceans. They're very seldom calm enough to be described as "still." Just remember that if they are ever really still, what you know about lakes would also apply.

Lakes: Measuring Reflections

A calm lake offers great opportunities to study reflection. Look at it for a long enough period of time to become familiar with it before you start painting. If you stand at the edge of the water, or in it, and drop an imaginary line from your eyes to where your feet touch the water surface, and another one to the reflection that your eyes look at, and a third one from the reflection back to your eyes, you create a triangle of vision (A). Let's mark these lines a, b, and c in

sequence. Lines a and b theoretically form a 90° angle. The angle between b and c is the determining factor in how much reflection you can see. In other words, the lower the angle of your vision or the further the reflection is from you, the clearer the reflection is, because you're looking more at the surface of the water than through it (B). If you look at the water directly at your feet (C), you'll see very little reflection and you'll be looking right through it. The color of the water and the vegetation in it will add color.

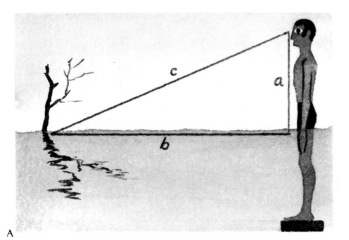

Giving Movement to Still Water

To give the feeling of water and not glass, indicate some lazy wave movement on the water surface close to you by giving a gentle wiggle to this part of your reflection. If you look carefully at the calm lake, you'll soon experience some of this wave movement regardless of how motionless the water seems. The color

of the water close to you is darker, gently fading into light, almost pure white, as it approaches the horizon, where it's the lightest.

Puddles

I want to mention puddles at this point, because they're almost always still. To dramatize them, contrast their value with their immediate surroundings. If the ground next to the puddle is dark, leave the puddle almost white, showing an extremely dark reflection in it (D). Leave the very edge of a puddle which has any value of its own pure white. If you can't leave this hairline of separating shine, scrape it in with a sharp razor blade point after the paint is dry.

Remember: if you paint a puddle dark, its whole surface reflects some object which is dark. Unless your horizon is very close to the top edge of your painting, you should show the source (or part of the source) of that reflection. There's never an exception to the physical laws of reflection: if there's a reflection, there must be a source, even if it's outside your picture area and you can't show it. Don't ad-lib, observe.

D

Pollution

I would like to briefly touch on the subject of pollution. There's natural and man-made pollution. Natural pollution (leaves, mud, small vegetation in swamps, etc.) is generally more pleasant to look at and to paint than man-made pollution (chemicals, rust, etc.) for obvious reasons. Pollution also detracts from the reflective qualities of water. Surface pollution does this to a greater extent than underwater pollution, because reflected images are caused by the surface of the water.

As a last hint, remember that water acts as a mirror. Objects that lean left will also lean left in their reflection, never the other way.

MOVING WATER, MOVING REFLECTIONS

Moving water is much more difficult to observe than calm water. It's essential to become familiar with its

behavior before you can attempt to paint it. Paint many thumbnail detail studies from nature until you really feel competent. Let's talk about the ocean first. (See demonstration, pp. 133-135.)

Large Waves in Oceans

Because of the enormity and great depth of the ocean, the waves are large. Paint them that way, as large as they appear. The color of the water far from the shore is a clean, bluish green, but it turns duller near the

A

shore. Don't paint individual waves without connecting them in some way with the whole body of water. Leave the foamy peaks of the waves white (A). A loosely held drybrush touch will give a fresh, lacy edge to a wave head and will indicate the bubbly splashes freely, just as they happen. You can add some of these touches with a razor blade after drying. Keep in mind that scraping is only a secondary solution to drybrush.

Remember: waves are caused by wind, however gentle or fierce it may be, wind has a direction and the waves must relate to this direction.

Lakes

Lakes behave similarly to the ocean in strong wind. However, gentle water movement will create a fasci-

B

nating play of dancing reflections, wiggling and twisting in an abstract pattern (B). If the water has waves, the reflections will have small interrupted units but will otherwise follow the general laws of mirror reflection. Splashes are best left white. Slight modeling with lighter color can be added later after the surrounding washes are dry. The color of the sky and the surrounding terrain will have a direct influence on the color of moving water just as it would on still water.

Rivers and Creeks

Rivers and creeks always have moving water (C). Whether it moves gently or fast, the water always moves. Flowing rivers and creeks should be painted with the addition of directional patterns. These are always apparent and should be indicated as important elements in your composition.

C

Rushing Water

Water in rapids or in rocky creek beds (D), with small or large brightly colored water splashes exposing the color of vegetation against wet rocks, will play havoc with an organized mind. With rushing water of this kind, reflections can only be shown effectively as form in pool areas where the stream is calm enough.

D

Waterfalls

Waterfalls are made up of combinations of dropping water units, clearly indicating the direction that gravity moves them. These are bubbly splashes at the point of impact, or steam-like water vapor in the case of large falls such as Niagara (E). The vapor can be approached in the following ways: wet the area of the vapor — as you approach the moist paper with your detail washes, they'll suddenly blend, forming a soft vignette, and creating the illusion of cloud-like form; don't wet the paper in advance — paint your visible forms as you see them, going easy on the value as you approach the future vapor area.

After the paint has dried, vignette the edges by washing back the sharp details vigorously with a water-loaded bristle brush. When the paint feels loose, blot it with a tissue. Repeat this until you achieve the desired result.

Above all, it's important to capture the drama of moving water, whether ocean or rushing brook, and to convey this excitement to the viewer.

E

FOG AND MIST

Fog and mist are nothing more than water vapor in the air which are sometimes mixed with pollutants like smoke or dust to form a filter of lesser or greater density. (See demonstration, pp. 112-114.)

Fog Is a Filter

To an artist, at least to a landscape painter, fog means a great deal. It not only simplifies even the most complex scene by eliminating most of the clutter, but it neutralizes the color of everything. It behaves like a gray filter on a camera. Values jump up and the three dimensional feeling becomes very obvious (A).

When you paint fog, use mixed grays instead of bought grays. A gray that you mix yourself is more alive, because you really mix slightly varying combinations of quantities for each brushful of paint. A factory-made gray is monotonous and opaque and should be avoided. Complementary colors (see *Color*

A

in Chapter 1) are good gray mixers, but I prefer to use the browns (earth colors) with blues. Each combination will give you a gray which is slightly different. Some colors, however, will survive in the closer details. Take advantage of these, and exaggerate their color slightly to add interest to the usually overwhelming grays.

Total Fog

Total fog *(B)* is a dense fog, in which only extremely close objects are visible. As a result, only subjects with powerful forms make good paintings. A possible washed-out object or objects can add a third dimension and complement your main center of interest. Paint it simultaneously with the fog itself while the paper is still soaking wet. The bursting fuzzy image adds exciting movement — to say nothing of mood — to your painting.

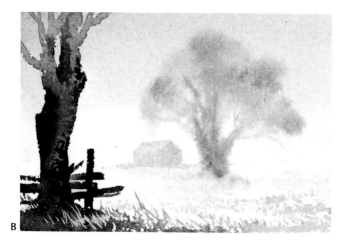
B

Partial Fog

Partial fog *(C)* allows you to see more detail and several layers of items in varied values. A light, dominating color in your grays (a touch of green, for example) will create strong color unity and at the same time add a sense of the time of day, as well as freshness. Otherwise, treat partial fog as you would dense fog.

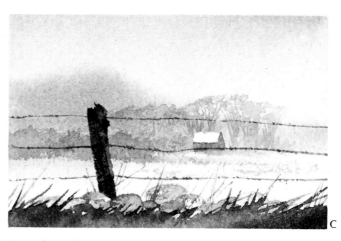
C

Morning Mist

After a cool night, the rising sun can cause a lazy mist, turning any scene into a mirage-like adventure. Backlighting is the most dramatic way to approach morning mist. Transparency is essential in capturing the subtle hints of light values. Don't hesitate with your sketch after you've decided to paint, because your lighting will change so rapidly that you'll need all your skill to keep up with it.

Use a simple palette; values and forms are more important than color. Again, I want to emphasize the use of a uniting hue all over your paper before starting. Your subject will usually suggest one, so believe your eyes. Let this thin wash dry before proceeding with the details.

RAIN

Don't shy away from painting rain. Watercolor especially lends itself to painting rain. The wet appearance of a well-handled watercolor is a natural for wet rain. Whatever kind of rain you paint, all objects will be wet and shiny. (See demonstration, pp. 115-117.)

Drizzle

A gentle drizzle *(A)* can be suggested better than painted. Any hint of the weather under these conditions should be subtle (open umbrellas in people's hands, dripping eaves, small ripples in puddles, etc.).

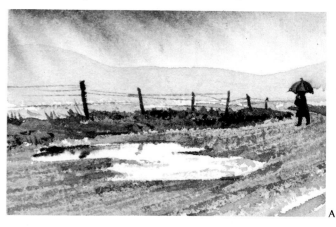
A

Reflections

?eflections *(B)* on wet surfaces are important and ?uld be handled well. Basically, you can approach a ?ction in rain similar to still water reflections (see *Water and Reflections,* P. 53).

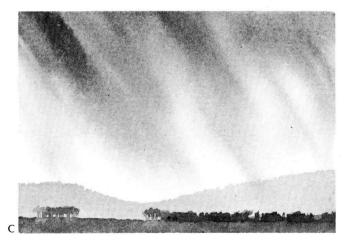

B

Showers

Showers ? ?ainfalls and can stand bolder and braver ? ?g. If your subject allows you to show the ? ?ve it a consistent direction. If a wind c? ? shower, indicate it with bending tree? ?ible subject matter). The quickly movin? ?imes create interesting, fast changing l? — and sometimes an occasional rainb? ? to indicate the direction of rain in fr? ?ects, a very effective way is to wipe ba? ? ?e of the paint after it's dry. Only slight pressure and a few touches are required. Don't destroy the details behind, just lighten the value.

C

Distant Rain

Rain in the distance *(D)* is really nothing but a wash with a vignetted softness between the heavy clouds and the ground. "Softness" is the key word. The wash should have a slight angle, tilting from the vertical.

Wet paper will give you the softness. The angle of the rain should help, not hinder, your composition. The value, or darkness, of your wash will suggest how heavy the rain is. Lighter wash indicates a light shower; a darker wash means a heavy downpour.

D

Storms

During storms, reflections are broken up with splashes. Flexible objects bend more in the strong wind which always accompanies storms. Accents, such as broken trees, turned-out umbrellas, etc., are useful tools. During a thunderstorm, lightning can really add the right touch *(E)*. Never paint it yellow or straight, however. Lightning jumps in a zigzag line. Study a few photos — camera magazines usually offer excellent examples of lightning. Scraping a white line into the dark area of your clouds is an effective approach to indicating a bolt of lightning.

E

Rain at Night

Rain at night means wet ground, strong reflections, and bright colors. Paint wet-in-wet, but keep the darks transparent. Take a good look at night subjects before and while you paint them. Don't paint everything; eliminate and compose.

SNOW

To paint snow successfully, first we must know our subject matter. Snow doesn't necessarily mean winter. For instance, high altitudes have all the snow you want even in the middle of summer. If you associate cold, suffering, heating bills, and shoveling with snow, it could be difficult for you to paint a good snow scene. On the other hand, if you associate fun, clean beauty, a walk in the snow covered forest, sleighrides, or the beauty of a single snowflake with snow, you're halfway to success. (See demonstration, pp. 106-108.)

The Color of Snow

In spite of the fact that snow is one of the purest natural whites we know, it almost never appears pure white. The reason for this is its very purity. The white picks up even the most subtle color influence and reflects some of it. We tend to associate blue with snow because the blue of the large color mass of the sky is reflected in it. Trust your eyes, not your untrained mind, which tends to ignore indistinct color impressions.

Color unity in a snow scene simply means that the snow is modeled using the most dominant color in your painting. For example, a warm, gray snow cloud will mean that the same warm, gray should be used for the shading of your snow. A sunny blue sky demands more liberal use of blue, particularly in the shadows. A thick evergreen forest will tint your snow with a touch of green.

Hoarfrost

I'd like to mention hoarfrost (A) here, because its impression and method of painting is similar to that of snow. After all, like snow, it's frozen moisture. Anything which is covered with frost needs careful study for closeup rendering. Frost covered trees in the distance should be painted accurately in color and soft in form. Avoid painting twigs on distant trees. Paint masses of color. The wet-in-wet technique is ideal for this purpose.

A

Early Snow

The first snow in the fall is an event like a birthday — it comes once a year. The lush weeds and atmospheric conditions will cause the first snow to be short-lived, however thick the first snow cover may be. One sure way to illustrate early snow conditions is to accurately paint the color touches that won't exist later through the winter. Observation of minute details is very important.

Late Snow

Later on in the season, after several snowfalls have collected, wind and the effect of the sun will cause the snow to settle in hardpacked layers (B). The drifts become limp and the trees are usually free of snow. Freezing rain occasionally lays a shiny crust on top of the snow. The brittle, crisp shine of this icy surface makes excellent composition material. The pattern of glare related to other objects can be a terrific directional tool.

B

Falling Snow

Falling snow (C) is one of the puzzles that winter supplies to a beginner. The usual question is, "How do you paint falling snow without white paint?" Watercolor, with its flexible qualities, offers several solutions. The best one was supplied to me by nature accidentally.

I was painting an oncoming blizzard with a large generous wash of raw umber, Antwerp blue, and a touch of ultramarine blue. (See painting on p. 99.) The modeling of the foreground and partly snow covered red chairs was coming along just right. I was trying to finish the sketch before the blizzard overtook me. It was a damp day and my wash was slow to dry. As the shine from the sky wash was about to disappear, the snow started to come down so fast that by the time I could turn the painting upside down more than a dozen flakes had fallen into the drying pigment.

I ran into a nearby cottage, but it was too late. I felt the disappointment that comes with having ruined a

C

D

good painting at the last minute. As I turned the painting up to look at the mess, I discovered the varied little backruns that the melting snowflakes had caused in my sky. The effect was exciting, real looking, and absolutely unpaintable.

Since then, I've learned to create the same effect by scraping frost off the refrigerator tray into areas of my paintings. I also use a wet toothbrush to get this effect. I hold it about 10" away, spraying tiny droplets into the drying pigment with a flick of the thumb. The important thing here is timing. The result is best just after the shine of a wet wash has faded.

Snowstorms

A blizzard (D) which is painted up close means a few large flakes and short visibility. A distant snowstorm is usually seen as a wide, angular streak connecting the dark sky with the ground. To achieve this effect, wet your whole sky. Apply an extremely heavy layer of well-mixed color to your clouds. Don't paint the angular streak of the blizzard. Instead, lift your paper upright; at the desired angle, and allow the heavy pigment to flow freely on the saturated paper, creating the effect you wish.

I must emphasize the importance of applying an extremely heavy wash in the clouds, so there will be enough paint to spread when you form the angular run. When you lay your painting down flat again, to stop the flow, you may find that the color spread from the clouds was too thin. You can add more heavy pigment to increase the impact. But this time, don't tilt the paper. Leave it flat so as not to disturb the angular run.

The Sound and Smell of Snow

Last, but not least, I'd like to bring to your attention the sound and the smell of snow. If you've not experienced this before, do me a favor and try it. Drive out to the country during a heavy snowfall. A forest is the best place. Avoid all other sounds. Turn off the motor of your car. Step out into the snow and stop. Stay dead still for a few minutes and listen. There is a silent sound that cannot be matched even by the skill of the best composer or the greatest orchestra. The relaxing, peaceful, quiet whisper lets your mind drift into creative depths that only your imagination can limit. The clean smell of moist snow, along with its sound, is the best spiritual tool I know.

9. PAINTING THE SKY

The importance of sky to a landscape painter really doesn't have to be explained. It's an essential part of landscape, and its understanding is essential to any painter.

SKY AND CLOUDS

Let's look at a few ways to paint skies in different conditions. The most important thing to remember is that a too dominant sky can divide an otherwise good painting; it must blend with the composition and be a part of it. (See demonstration, pp. 124-126.)

Clear Skies

Clear skies may appear to be pure blue — but careful observation will show that many colors infiltrate and soften this raw blue. The sky is virtually never the same. Atmospheric conditions, the time of year, and even the time of day all make a great difference in its appearance. Instead of blindly copying the sky as you see it, make sure that it complements the subject of your painting in value as well as in color.

The color and value of the sky comes from the sun's light reflecting off the particles of the atmosphere. Without atmosphere, we would be looking at black space. Because the light originates from behind the atmosphere, the color you see has a deep, luminous quality. To recreate this feeling in a painting has always been one of the toughest problems facing the landscape painter.

Transparency makes watercolor the most compatible medium to paint a good sky with. Watercolor, too, gets its color and value from light reflecting off the white paper through a thin layer of pigment.

Avoid using thick, heavy paint in your wash when you paint skies. To insure luminosity in a colorful sky, don't blend the colors into one combined wash. Instead, apply separate, thin washes of separate colors on top of one another, allowing them to dry after each layer. Let's take an example: you want to paint a yellowish haze on the horizon and a blue sky overhead. This condition quite often appears in wintertime. Turn your painting upside down and put a very light tone of well-diluted yellow ochre, with a touch of cadmium orange, on the edge of the horizon. Carry this wash downward, briskly applying more and more water, diluting the color hue as you descend. By the time you reach the bottom edge, you

should have pure white paper. After the yellow wash has completely dried, turn your paper back to its original position and go through the same procedure with the blue, starting at the top edge and ending up at the horizon. During both washes, tilt your paper toward you to help the flow of the wet paint.

Cloudy Skies

Cloudy skies mean using much more than white on blue, because cloud formations vary in structure and in color. Cumulus clouds (A) are common in summertime. They're large, white, fluffy puffs against deep blue skies. The relative position of these clouds and the direction in which they move are of extreme importance to a successful composition. They appear thick and are white on top and gray at the bottom. As you paint them, steal a little touch of your ground coloring into the lower gray part — as if the ground below were reflected in them.

A

Rain and Snow Clouds

Rain or snow clouds are called nimbus clouds (B). They're usually a cold gray color and they cover the whole sky. At times, they have a break through which a higher layer of wind-blown stratus clouds or even blue sky will show. They can be painted with a layer of dark gray wash suitable to your general composition. To add interest and transparency, don't allow the wash to dry even and monotonous. Immediately after application, mop up some of the wet paint with a squeezed-out (thirsty) brush, tissue, or any absorbent material. To add drama while your wash is still saturated, tilt your paper at a 90° angle, allowing the paint

B

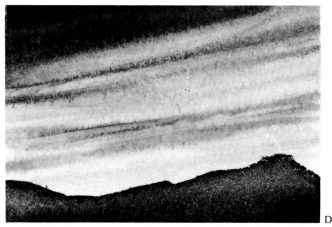

D

to rush in an angular direction. To do this more successfully, start off by wetting your whole sky before applying your gray wash. Avoid strong whites in nimbus clouds, and relate the color to the rest of your painting.

Thunderhead Clouds

Thunderhead clouds (C) are usually gigantic in size. A thunderhead is virtually a mountain of turbulent clouds, brightly lit at the front and rapidly turning darker toward the rear. Because it will dominate your composition, you must be extremely careful with its esthetic location. Don't waste time on minute details; instead, concentrate on capturing the impact and enormity of this majestic cloud formation.

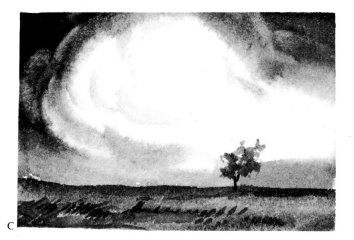

C

Wind-Swept Clouds

High, wind-swept clouds (D) are excellent direction-giving tools for your composition. They're usually subtly defined at the edges and should be painted as negative form. By this, I mean that after wetting the sky, paint the color between the clouds, leaving the white parts clean.

Speedy application of paint does justice to the nature of the fast-moving clouds. They should appear fresh and loose.

Perspective in Clouds

In all cloud formations, you must follow the rules of perspective. All clouds appear larger, more handsome, more detailed overhead and become smaller and less defined as they descend toward the horizon.

Familiarizing yourself with the different aspects of the varying cloud formations is the only way to learn to paint the sky. Always, always keep the color of the sky and clouds in harmony with the rest of your painting.

SUNSETS

Because of the shortness of its duration, painting the setting sun requires a lot of preparation. There are only ten to twenty minutes available in the crucial period of a sunset. (See demonstration, pp. 127-129.)

Setting Up

First, choose your subject about an hour before sunset appears. While the orange glow turns into pinks and reds, set up your easel and your paper (because of the short period of the sunset, I suggest you use small paper), squeeze clean paint onto your palette, and make sure your water and all tools are easy to reach. After you've placed everything in readiness, just sit and wait. Wait until the time is just right to start your painting. The timing of the starting moment is extremely important, for you'll have only about ten minutes to establish your colors and composition, and another ten minutes (maybe) to put some finishing touches on the vital areas.

Color

Pure, bright colors are very effective contrasted against strong silhouetted forms without too much color detail. The borderline between a "cheesy" and a tasteful color rendering is very thin. Should your colors turn out too garish you can always do it over from your original sketch at your leisure and benefit by what you've learned on the first attempt.

Atmospheric conditions, such as humidity and clouds, make enormous day-to-day changes in the same subject. Try to paint (from the same spot and at the same time) a sunset over a period of several consecutive days (A). Don't look at your paintings in between. When you've done enough (three or four) sketches, lay them out in front of you to study. You'll most likely see a considerable difference between them. The reasons for this are not only the varying sunset conditions, but your own changing moods as well.

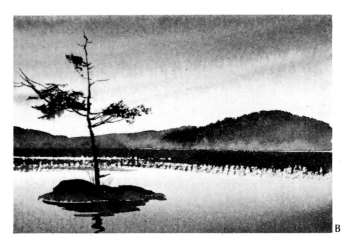

After the Sunset

After the sun has descended, you have a period of about half an hour when exciting color impressions offer themselves to be painted. The length of available time varies depending upon the time of the year and the geographic location. This post-sunset condition usually lasts long enough to finish a quick sketch. The silhouettes against the sky, as well as the color of the sky, are darker than while the sun is visible. Simple line patterns with well-defined silhouettes must be carefully composed to form your center of interest (B).

The sky with the setting sun is best used as a complementary element. You can never paint colors as brilliant as you see them, because you're looking at very brilliant direct light instead of the reflected light from a much less pure pigment coated paper. You can achieve an impression of brilliance, however, by using contrasts. Brightness of color to equal nature is impossible.

Looking East

Sometimes a pleasant surprise awaits you when you turn your back to the setting sun and look east. Conditions are as equally short-lived looking in this direction as they are looking west, but the colors are more subtle and the objects on the ground are well-lit instead of being silhouetted (C).

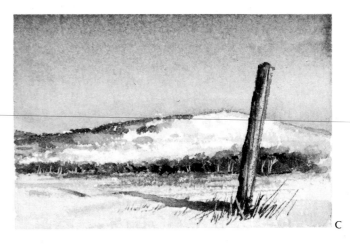

Discipline

Disciplining yourself is extremely important. This means you must finish painting during the available time and you must control your colors so they won't take away from the prominence of form and value. Never get discouraged if you don't succeed. Try again and again. In my opinion, painting sunsets is the most difficult task that a landscape painter ever has to face.

10. OBJECTS IN LANDSCAPE

This chapter deals with those "extra" elements so often found in landscapes, such as fences, buildings, people, and animals.

FENCES

In our society, where free enterprise respects private property, fences are a necessary part of landscape. The material they're made from varies as much as their age. Older fences are made of wood, newer ones of metal. Piled-up rocks are also common where the culture of the pioneer settlers is still visible. (See demonstration, pp. 142-144.)

Old Fences

Old fences show signs of age. Their color is weatherbeaten, and they often show signs of neglect. An old cedar fence (A) is a very strong element as it zigzags through the landscape. Root fences (B) are also powerful. They still exist, but you have to look for them. Wood, by its nature, shows age by splitting, twisting, and changing color as the weather works on it. If boards are used, nails are a natural part of the fence (C), creating beautiful, rusty washes on the texture of the graying wood.

Wooden Fences

To paint wooden fences, I use one wash to establish tone, form, and design. Rust marks are painted with a strong touch of burnt sienna into this first wash while it's still wet. I also indicate a few splits with the tip of my brush handle. I do the modeling and texture with drybrush after the first wash is dry.

A wooden fence in the distance shouldn't have much detail. Its design is usually a useful tool to guide your eyes in the composition. Play it down in value or it can cause confusion, appearing to be in the foreground rather than in the distance.

Picket Fences

A picket fence (D) is another delightful part of small town architecture. Its charming quality is important to maintain. In spite of the fact that picket fences are most often white, don't leave them as pure white paper when you paint them. Add a little tone, texture, or shading to give them form.

A

B

C

D

Wire Fences

Wire fences (E) are relatively young in the American landscape. Wire, crisscrossing in different patterns, is usually used as a protection to keep animals within the owner's property. These fences are fastened to wooden posts or metal supports. The wire pattern sags, and the occasional ripped wire disturbs the fence's mechanical appearance. Rust is a natural result of metal exposed to oxidation, and should be painted carefully when you do a closeup of a wire fence. The mesh pattern of the wire traps all kinds of goodies in the wind: old newspapers, tumbleweeds, piles of leaves, etc. I find that these are fascinating subjects to paint and that they offer a great sense of satisfaction.

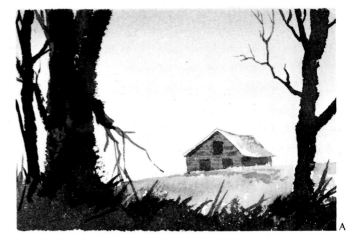

Gates

Where there are fences there are gates. Gates are essentially the same as the fences they belong to (except replacement gates which are now usually metal). Brand-new gates look uninteresting to me, but after a while use and rust give them interest. Gates usually make an excellent center of interest. It's hard to place them in a position of lesser importance, although size and the amount of detail will, of course, help determine their importance.

Don't ignore the moss on wooden fences or the rust on metal ones. These things belong with fences and will make your painting more alive. I suggest that you study fences on the spot and that you practice a little on closeup details.

BUILDINGS

Structures are mechanical forms: some seem to belong with their surroundings, some stand out like sore thumbs; you must discriminate as you choose them. (See demonstration, pp. 118-120.)

Single Buildings

A single building (A) usually establishes a good center of interest. Pay careful attention to its location on your painting. Sunlight will show brightly lit and shaded sides of the building. The shadows of the structure must be considered as a unit, a compositional element of the building. The amount of detail that you paint should depend on the importance of the structure and on its distance from you.

Never use a ruler to draw the lines of your structure. Don't worry about not being able to draw a straight line. Really straight lines are stiff and very hard to accept esthetically in a painting — if you can draw straight, you should purposely move your hand to avoid the artificial appearance a straight line produces. A free, hand-drawn edge is much more interesting and beautiful than an edge drawn with the help of a ruler.

Don't isolate your structure from the rest of the painting, nest it on the ground and relate it to its surroundings. Trees, shrubs, and fences nearby must tie in and feel right when you are finished with your composition.

Buildings in Groups

Building groups (B) should be painted in a similar manner. However, they're more complex. Relate them to one another to create the best composition. Falling shadows of roof peaks, trees, and other forms will add complexity to the buildings but should never distract from their form and value.

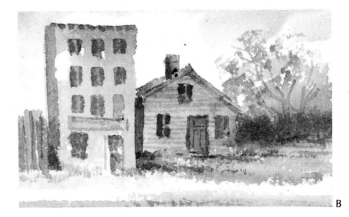

Buildings in the Distance

Residential groups should show some sign of life. Wise use of details on nearby structures and simple washes on distant ones will create a good feeling of complexity.

Cities, towns, and large groups of buildings in the distance (C) must be simplified. A few outstanding structures should be painted with a little more care, but masses of buildings of similar sizes should be handled as parts in an over-all pattern. Extreme details must be avoided. Industrial details should be painted freely in spite of their streamlined appearance. They're part of the same unit of distant buildings as smaller dwellings are. Cater to the whole unit and don't let strong industrial forms break it up.

C

PEOPLE AND ANIMALS

Combining landscape material with activities of people or animals requires a great deal of control. Figures should add, not take away, from the unity of the composition. Simplicity is generally the best rule to follow. The location of people and the color of their clothes must be planned to add to your composition what you intended, whether it's a blending complement or a snappy contrast. (See demonstration, pp. 121-123.)

Keep Figures Simple

People should never be overworked in detail if you want your painting to remain a landscape. Simple washes, keeping reasonable proportions in mind, are more effective than extremely detailed figures. Fresh, flowing brushstrokes add a refreshing complement of life to your painting.

People with very few clothes on (bathing suits, for example) or in the nude must be painted with healthy fleshtones and with as little detail as is necessary to identify the general characteristics of the figure (A). Your own good taste should be your guide as to how far to go. Persons fully clothed require the same

simplicity in treatment, but you must pay more attention to the fall and pull of materials as they create wrinkles. Again, my advice is to keep them simple — a few well-placed brushstrokes hint enough about the garments to explain their action. Make hundreds of quick drawings of people. Get to know them.

A

Animals

Animals more often complement the landscape than contrast with it. After all, it's their natural environment. Their coloring and characteristic movements belong in their surroundings. Complement your painting by representing them accurately. Learn to know a little about their anatomy and what they look like before you attempt to paint them. Their proportions and accurate silhouettes are more important than the fine details of their fur or the shine in their eyes.

To become familiar with animals, I highly recommend as many visits to your local zoo as possible. Captive animals can be studied thoroughly and you should make many drawings of each species to get to know their customary movements and proportions from every angle. You should study birds, if possible, in their natural environment. Seagulls, for instance, must be seen riding the wind free to be appreciated. Keep any study drawings you do for future use.

Placing Figures in a Landscape

If you're uncertain where to place your figures of people or animals, I suggest a method using tracing paper. Draw your figure or figures on separate pieces of tracing paper. Lay each one over the almost completed landscape and move them until you find a satisfactory location. Then trace them lightly.

Be careful with dimensional relationships; your figures should be placed in the correct distance for their size. Don't lose patience if they don't look right, it simply means you need more study and more practice. In the beginning, try not to ad-lib too much — paint from nature as much as possible.

11. HELPFUL SUGGESTIONS

This chapter is devoted to suggestions in using photography as a tool, presenting your finished watercolors, selling ideas, and general hints which I hope you'll find useful.

PHOTOGRAPHY AS A TOOL

Photography has been frowned upon by some artists as being a crutch for dishonorable cheats. Nothing could be further from the truth. With the constantly advancing quality of cameras and dependable film, it's not only easy to bring home exciting painting material, but it can be an important part of the creative process as well.

Take Your Own Photographs

It's essential that you take your own photographs so that you can experience the subject by choosing it and composing it in the camera's view-finder. In this respect, photography is identical to painting. If you don't have a camera, you have to resort to small sketches, which are also perfectly satisfactory. Even the most aggressive critic of photography must admit that a color slide is a truer reference to nature than a pencil note. One disadvantage is that the quality and the type of film can seriously affect the color impression of your subject. This is another reason I say it's essential to take the shot yourself; you'll know when you have an inaccurate color rendering on the slide.

Equipment

Even with drawbacks, slides really offer more than enough in terms of reference value. The first things you need to take good slides are a dependable camera and good film. The camera doesn't have to be expensive, but, naturally, the better the camera, and the more accessories you have to go with it, the more opportunities you'll have within your reach. I have a Kodak retina single-lens reflex camera, and use 35mm. film. I also use a medium range telephoto lens and a closeup attachment. And in addition to the camera's own 1.9 lens, I prefer Ektachrome color film because of its dependable color qualities and because it tends to show more shadow details than other film. (I want to point out that this is entirely a matter of personal preference.)

Advantages

Photography has several outright advantages compared with small doodles. Time is the biggest advantage. You can record the shape of a lightning bolt with a camera. You can faithfully reproduce very short-lived subjects which would be impossible to draw or paint in time: a ripple in the water, the foamy beads in the air created by waves splashing against the rocks, a seagull landing on water, a falling leaf in mid-air, etc.

How to Use Slides

Look at your slides through a small viewer rather than a projector. Remember: you don't want to copy them; you want to use them as references. This is essentially what you do when you paint from nature. Change things around just as you would if you were on the scene. Your painting should be the fruit of your creative thinking; it should never look like a photograph. If you can't discipline yourself in this respect, photography will harm your work and you should never touch it.

PRESENTATION AND SELLING IDEAS

When you're finished with your painting, you'll have to consider pleasing ways to present it to the viewing public. Framing watercolors is a little more tricky than varnished work, because the watercolor surface cannot be cleaned and must be protected from dust, oil fumes, smoke, steam, etc.

Matting

Let's start with matting your watercolor. Select a pleasant, neutral color which complements your painting. Avoid loud colors, as they will distract from your work. If your painting is light in value, use a dark mat; if it is mostly dark, use a mat of a lighter color. I prefer warm tones for my paintings — neutral beiges or charcoal browns are my current choices.

Learn to cut the opening (window) in your mat on a bevel (slant). This will give the job a professional finish that will enhance your painting. To cut on a bevel you must have a ruler with a strong steel edge which is cut on a slant to guide your knife on an even angle. A razor-sharp knife is essential. It will allow you to make each cut with only one slice of the blade. More than

one cut will leave ridges on the bevel and detract from its neat appearance. Double mats in complementary shades look even more professional than single ones.

Don't use cheap material for matting your paintings; a painting good enough to frame deserves a few extra nickels for a good quality mat. Leave about 2" or 3" of space around your painting. I leave an even width all around, although some prefer the bottom portion to be a little wider. The mat opening (window) that touches the painting should cover your painting at least 1/8" all around. If you use a heavy grade paper, it's enough to tape the top of your painting only; but on thin paper, I like to use tape all around. In this case, use a good quality masking tape which allows the paper to shrink and expand.

Framing

A thin frame which blends with your mat and your painting is sufficient for smaller paintings. On larger ones, you should increase the width of the frame to give it strength enough to support the weight of the glass which must always be in front of a watercolor painting. Any heavy cardboard is suitable for backing your matted painting. However, if you use corrugated cardboard instead, put a thin sheet of plastic protector between the back of your painting and the corrugated cardboard. This is necessary because the ripples of the corrugated cardboard are glued with a chemically offensive material that will, in time, eat a lined pattern through to your painting. A low-glare glass, to cut down on reflection, is available, but it tends to fog your painting should you use more than two thin mats. After you've fastened the glass, the matted painting, and the backing into the frame, either with thin nails or with small, diamond-shaped metal supports, cover the opening between the frame and the backing with a wide enough tape to seal out dirt and humidity.

Pricing

The supreme test of being able to criticize the value of your own work comes with pricing it. The monetary value of your work is in exact ratio to the demand. Start with low prices. You can always increase your prices, but to cut them is usually disastrous. A humble beginning is a practical way to prove the desire to share your work with others. If you can't keep up with the demand, slowly raise your prices until supply and demand are in balance. If you can interest an art gallery in selling your work, they will be the most reliable help in establishing prices, for they know what the market is for the quality of work you have to offer. Remember, commission increases with price.

Don't dicker. Stick to your prices firmly. It's important to protect the interest of those who've already bought your work. Consider a sale final.

Keep a record of your paintings by numbering them. It's a good idea to keep a small book listing each painting as well as anything connected with it (location, painting date, size, customer's name and address, price, etc.).

Dealers

Eventually, you'll consider selling through dealers. A good art gallery deserves a good commission. On the surface, this commission looks steep, but their reputation is at stake when they accept your work. The professional prestige that only a gallery can offer is impossible to evaluate; and besides, you'll have more time to paint and fewer business headaches. Promoting an artist is as much of a profession as painting, and most of us can't be good at both. When you leave your sales worries in the hands of an ethical dealer, you'll have found the friend that your career needs.

GENERAL HINTS

And now, here's some practical advice; hints that were useful to me and perhaps can be of some use to you. First, let's look at the positive side of painting and consider the "do's."

Get Used to Making Decisions and Carry Them Through

Any creative endeavor, and especially watercolor painting, requires a decisive mind to make the hand do the right things at the right time.

Learn to See Life's Hidden Little Subtleties

What seems common to an average person should engage an artist's curiosity and trigger his mind to action.

Discipline Yourself to Paint Only the Essentials

Although you may find this difficult until you've gained technical skill, it will improve your painting immensely.

Be Careful with the Use of Color

Use only those few colors which are essential for your painting. Bright colors are no substitute for value, composition, and pictorial strength.

Have Good Tools at Your Command

Good results require good utensils. You won't know how well you paint until you've painted with good materials.

Be Inventive

This ability is what will make your painting fresh, different, and your own personal, esthetic property forever.

Be Your own Best Critic

If you're not honest with yourself, how can you expect sincerity from others? Listen to other people's opinions, but analyze them for your own use. Each of your paintings should be good enough to keep for yourself. And now, on the negative side, here are a few "don'ts."

Don't Copy

When you copy someone else, you're led into another's world. This world may not be compatible with your personality and you may rob your mind of the creative opportunity to express its own idea. Copying another's work beyond a certain point may be more dangerous than you think.

Don't Accept Advice Unconditionally From Anyone Until You've Tried it Out

It may not complement your temperament. Remember, your individual qualities are reflected in your paintings. Let them be truly your own.

Beware of Compliments

Your polite friends can give you false confidence if you're not alert. If somebody likes your work — even if he offers to buy it — that alone doesn't mean that it's good.

Try Not to Explain Your Paintings

One of the surest admissions of guilt is a long list of explanations of what you should have done differently. If your idea has to be explained, it should have been written, not painted.

Don't Give Up if You Don't Succeed at First

A change of luck may be as close as the next painting!

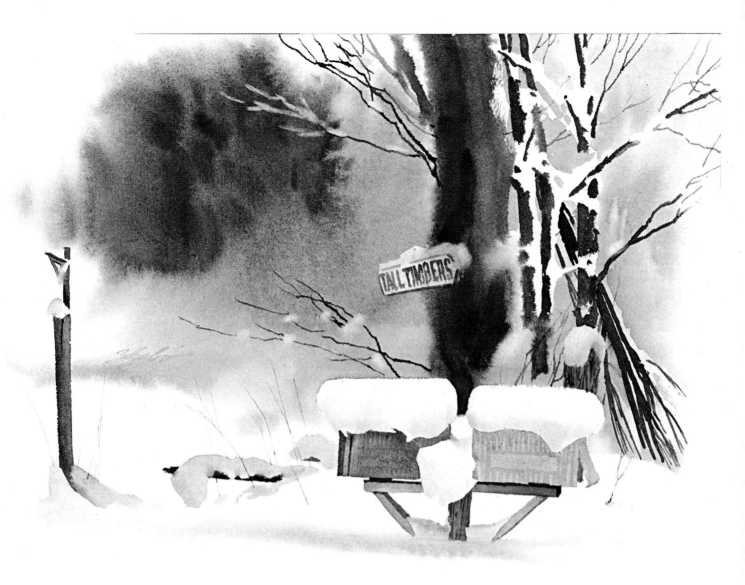

Tall Timbers *Courtesy of Coutts Hallmark Cards. Collection Mr. and Mrs. L. R. Kingsland.*

DEMONSTRATIONS

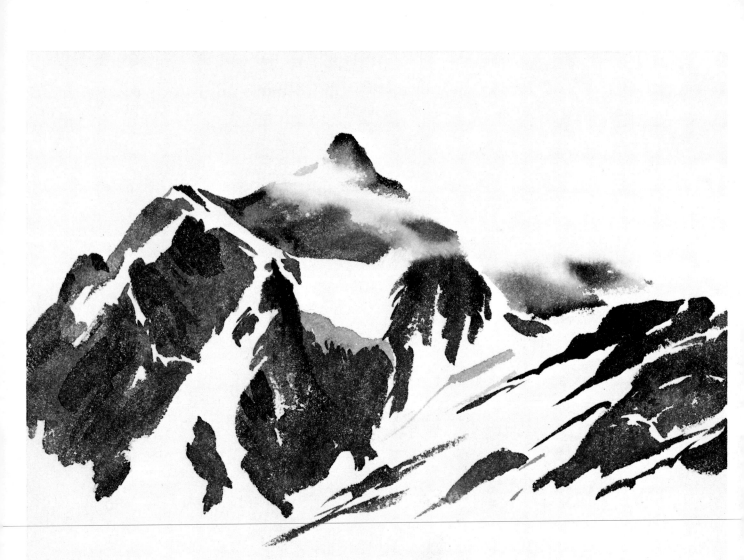

Mount Baker, Washington (Step 1)
70 lb. d'Arches paper mounted onto a painting block, 18" x 24". My palette was cadmium lemon, Hooker's green No. 2, burnt sienna, ultramarine blue, Winsor (phthalocyanine) blue, cobalt blue, and charcoal gray. I began without any preliminary pencil drawing with the heavy dark rocks of the mountain peak, using charcoal gray mixed with Winsor blue (I could also have used ultramarine blue). I carefully avoided the snow covered areas, where thin clouds hid part of the highest peak, and prevented the inside edges of the dark washes from drying sharp by wetting the paper directly next to it with clean water.

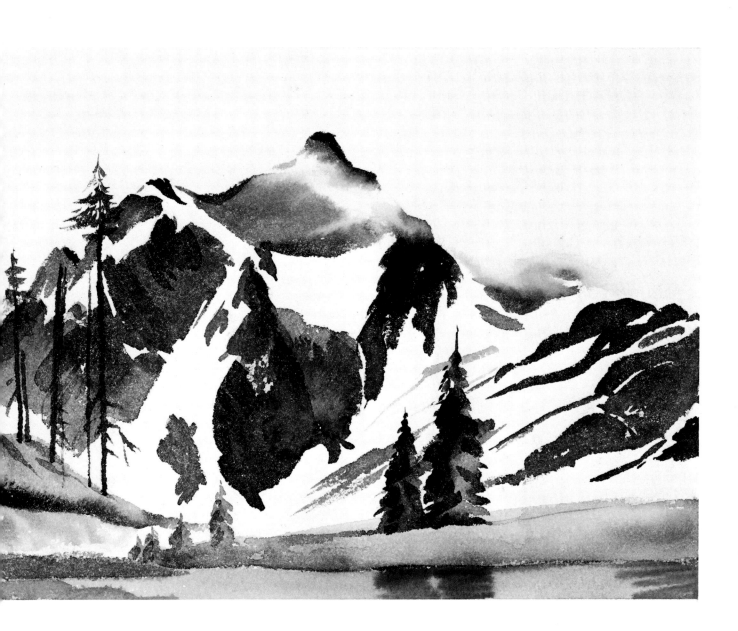

Mount Baker, Washington (Step 2)

I painted in the foreground, using cadmium lemon and Hooker's green, with Winsor blue for the grassy spots and the slim young pines in the foreground. Winsor blue with a touch of Hooker's green gave me the cool color of the water up front. Before this wash dried, I applied a heavy, concentrated pigment of the same mixture for the reflection of the pines. I followed with the rugged, weather-tortured pines in the left middleground, using a painting knife, heavily loaded with charcoal gray, for the trunks and branches. I used drybrush touches for the scrawny, leafy parts. I dropped a touch of burnt sienna on the sloping soil on the left middleground as well as onto the pre-moistened cloud area, where I added a touch of ultramarine blue.

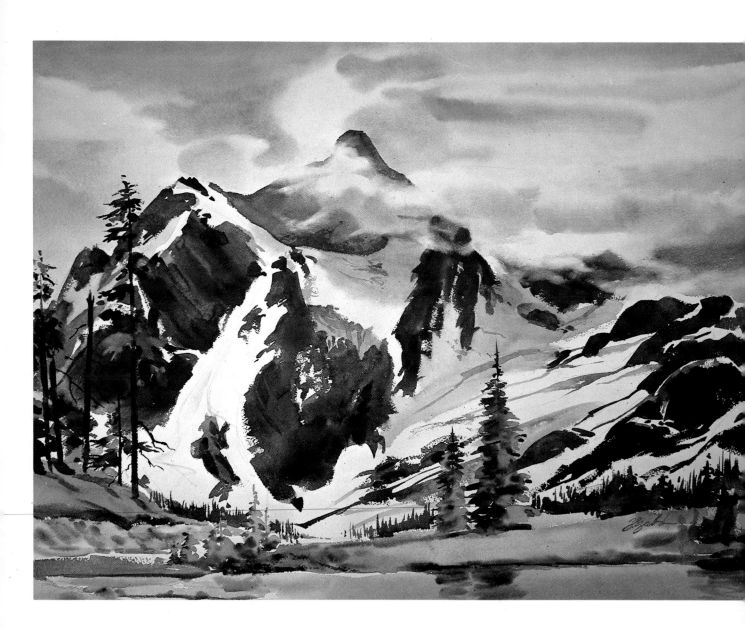

Mount Baker, Washington (Step 3)
In this final stage, I painted the wind-swept blue sky onto wet paper with brisk strokes of cobalt blue, ultramarine blue, and charcoal gray washes, following with the gentle shadow of the cloud on the snowy slope, using ultramarine blue and charcoal gray. Next, I painted the distant young pine forest in the middleground with Winsor blue and charcoal gray. *Collection Mr. and Mrs. R. C. Lewis.*

Assignment: Using the techniques described in this demonstration, place typical objects into the composition on the left to add interest to the shoreline. For further details, see *Know Your Environment,* p. 26.

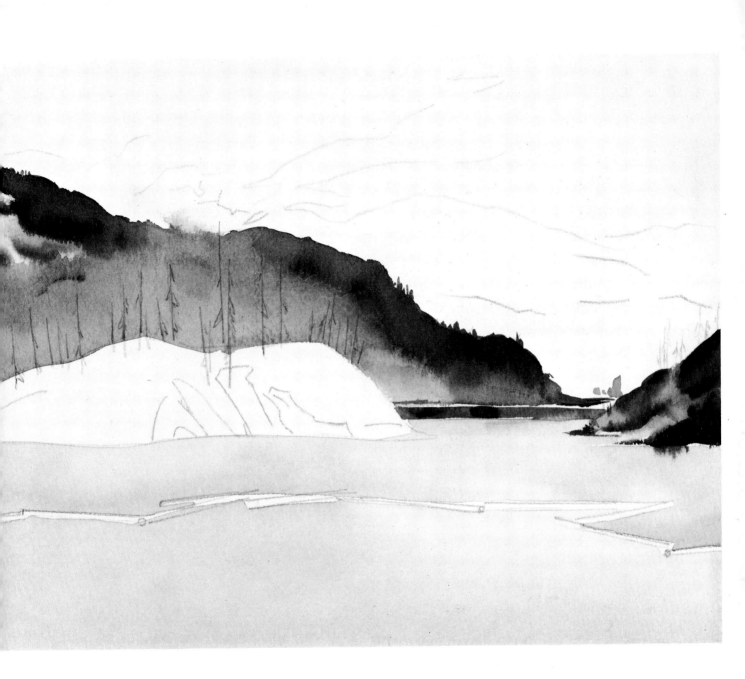

Harrison Lake (Step 1)
300 lb. d'Arches rough finished paper, 20'' x 24''. My palette was Winsor (phthalocyanine) blue, cobalt blue, ultramarine blue, Hooker's green, burnt sienna, burnt umber, sepia, cadmium lemon, and brown madder. I sketched in the composition with an HB pencil, which is dark enough to be visible but easy to erase. My first wash covered the dark hill directly behind the pine covered island; I used Winsor blue and sepia. It was important that I get the value right, so that the pine trees (which I painted later) would stand out in front. I painted the partially exposed island to the right of this first wash, leaving the silhouetted trees for later. A light wash of Winsor blue over the water was applied next, carefully missing the floating logs.

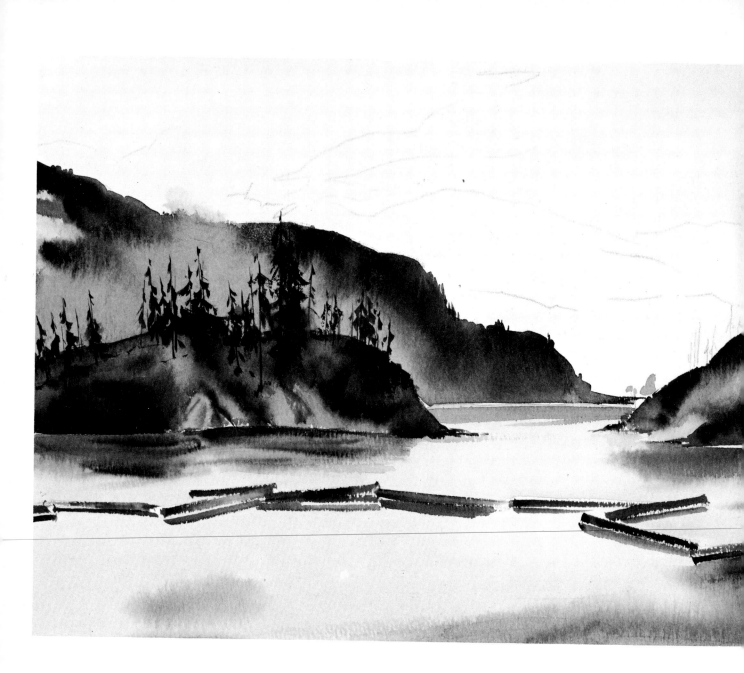

Harrison Lake (Step 2)

After the wash on the dark hill dried, I painted the island, which required the greatest care. I used rich paint for the shrub covered rocks, loading the brush to its capacity each time I touched the paper. After a yellow-green wash, I slapped in quick touches of Hooker's green and Winsor blue to indicate the undergrowth. A few brushfuls of burnt sienna took care of the exposed rocks. Then came the trees; I used drybrush technique against the hillside, but allowed the paint to blend freely where it joined the wet area. The lazy reflection of the islands, as well as a touch of dark at the very bottom of the painting, had to be timed when the first wash of the water was about to lose its saturated shine. The floating logs, with their dark reflections, followed.

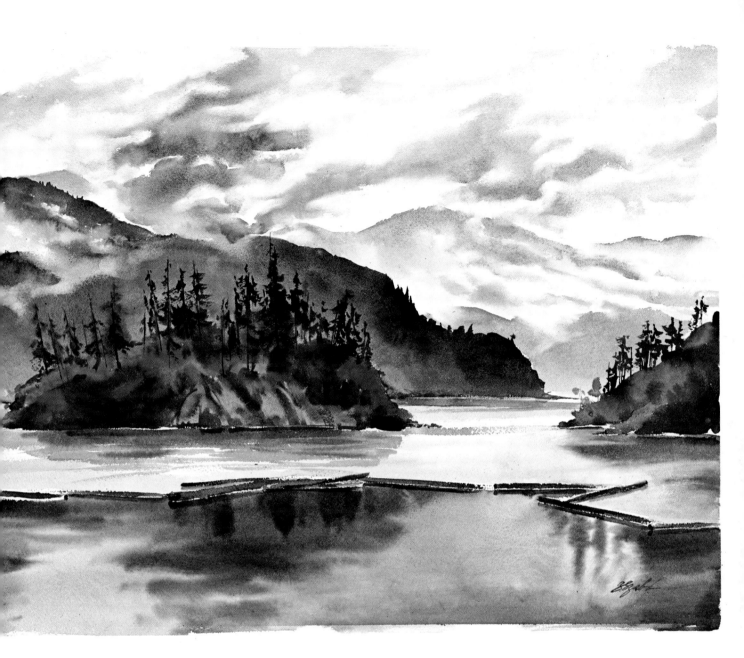

Harrison Lake (Step 3)

Cobalt blue was the main color used for the distant mountains and the clouds in this final stage. Burnt umber, ultramarine blue, and sepia supplied the modeling colors for the clouds. The application of paint was rapid, allowing the colors to blend here and there, yet I carefully controlled the direction of its flow. Then came the deep reflections below the logs: Winsor blue, cobalt blue, ultramarine blue, sepia. Finally, I added the distant pines on the small island point at center right. A few crisp finishing touches, including some white sparkles on the logs, were applied with a razor blade. The gentle blending of the cloud patches against the hill and the mountain was wiped back with a saturated bristle brush; I blotted up the loosened pigment several times with an absorbent tissue. *From the Painters of Canada Series, Courtesy of Coutts Hallmark Cards. Collection Mrs. E. Szabo.*

Assignment: Complete the painting in the sketch above, using the direct method described in this demonstration. For further details, see *Conventional or Direct Painting,* p. 16.

Eleanor's Favorite (Step 1)
300 lb. d'Arches rough finished paper, 22" x 30". My palette was Antwerp blue, manganese blue, charcoal gray, brown madder, scarlet, burnt sienna, and yellow ochre. With no preliminary pencil drawing, I saturated the top two-thirds of the paper with clean water, starting sharply at the bottom edge of the misty forest in the distance. I applied sweeping washes of a pale mixture of Antwerp blue and charcoal gray into the sky, using a 1" wide oxhair brush, followed immediately by a heavier concentration of pigment applied with a 1" wide bristle brush. A touch of burnt sienna, Antwerp blue, and manganese blue gave me a cool color, creating a feeling of distance.

Eleanor's Favorite (Step 2)
After the shine of the wash disappeared, I applied the softly modeled, heavy treetrunk in the foreground. At the same time, to build up strength, I painted in the slightly blurred, heavy treetrunk of the pine in the distance. While these washes were drying, I applied the weedy, snow covered foreground, softly modeling it with yellow ochre, Antwerp blue, and charcoal gray.

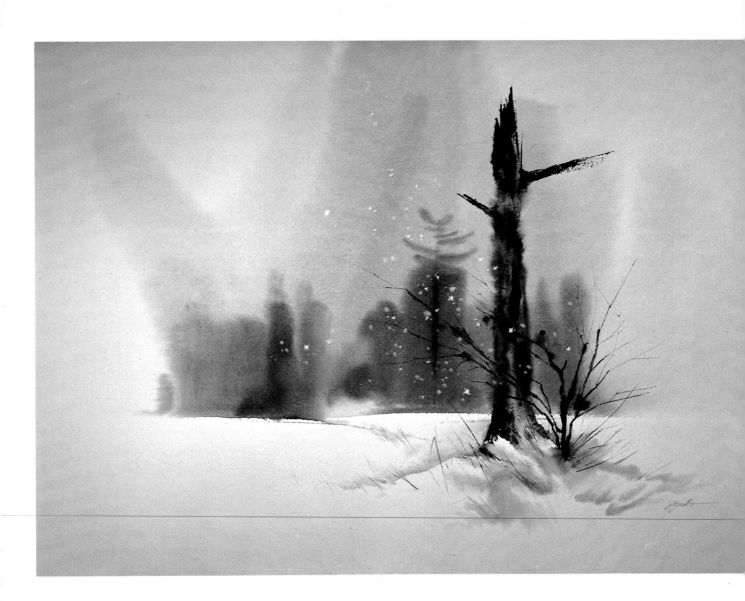

Eleanor's Favorite (Step 3)

The young shrub in the foreground was next in this final stage. I used a painting knife with heavy charcoal gray and burnt sienna pigment. Exciting, small washes exploded wherever these strokes touched a slightly damp spot. I left these as they happened. I painted some scarlet and brown madder leaves onto the twigs, again allowing accidents to come as they would. Brown madder blurs and charcoal gray drybrush on the old stump brought it into the foreground and finished the modeling of the important areas. I applied a few weeds protruding through the snow with the thin edge of a painting knife. The snowflakes were done in the last few touches. The softer flakes were wiped back with the point of a stiff wet brush from the dry paint; the crisp ones were picked out with the sharp point of a painting knife blade. Note the carefully controlled survival of the white paper. *Collection Mr. and Mrs. K. R. Shadlock.*

Assignment: Complete the painting in the sketch above, using the method of painting on wet paper described in this demonstration. For further details, see *Painting on Wet Paper*, p. 19.

Silent Wind (Step 1)

Whatman paper mounted on heavy cardboard, 11″ x 15″. My palette was yellow ochre, burnt sienna, sepia, ultramarine blue, Antwerp blue, manganese blue, and cerulean blue. I began without any preliminary pencil drawing, starting with a gentle wash of Antwerp blue and sepia to define the silhouette of the lump-like rock. The value of this hue was about as light as the color on the far left tip of the rock in the finished painting. I avoided the area where the wooden pole was going to come later. As this wash reached the bottom portion of the rock, I used a wide bristle brush to apply heavy brushfuls of burnt sienna, sepia, and a touch of ultramarine blue on the right front, gently blending this wash into a denser, greenish mixture of Antwerp blue, sepia, and yellow ochre. My brushstrokes were playfully applied to imitate the growth of the rough weeds. Into this wet wash, I scraped a few gentle lines to indicate some definition of the tall grass.

Silent Wind (Step 2)
I splattered some fine drops of pigment over the area of the rock, indicating moss-like growth. I used an ultramarine blue and burnt sienna mixture, as well as manganese blue (I could also have used cerulean or Antwerp blue) mixed with sepia (I could also have used burnt sienna). Each time I had a few nicely shaped splashes, I waited until they dried before adding more. As I loosely shook the paint off the brush, drops sometimes fell into unwanted areas. I immediately blotted these with a tissue before the color had a chance to set. Next, I painted the wooden pole with the supporting stick and the wooden pulley. Burnt sienna, ultramarine blue, yellow ochre, and Antwerp blue gave me a soft blend of woody color. I indicated the cracks on the pole with the tip of my brush handle.

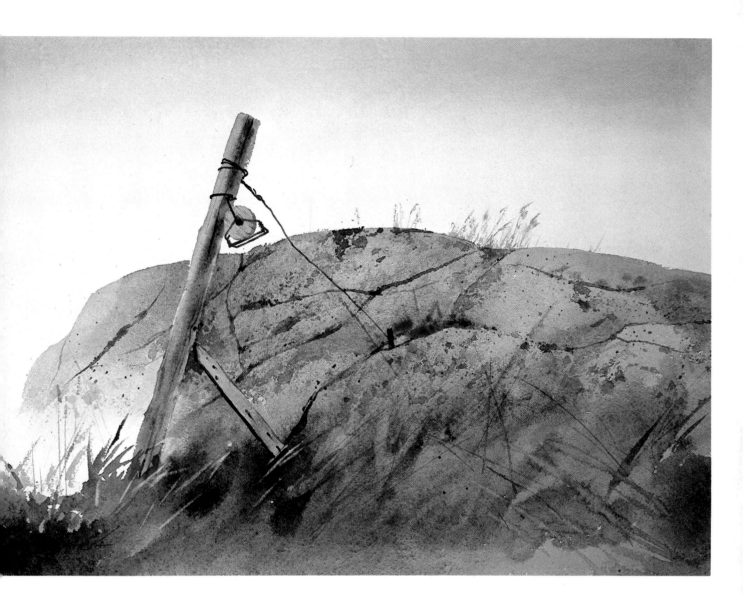

Silent Wind (Step 3)

In this final stage, I applied the cracks in the rock with a painting knife, holding it very loosely to allow it to blend the paint freely and create accidental movements in the lines. Next, I applied the rusty wires with a worn-out, very thin sable brush, using sepia and burnt sienna, with Antwerp blue here and there. I painted the delicate weeds on top of the rock with the fine edge of a painting knife, adding the bushy heads on top with a fine sable brush in drybrush technique. I did the same to the left of the bottom of the pole. Last, I wet the top of the paper and applied a subtle, blue-gray wash of Antwerp blue and sepia, slightly darker on top and blending into pure white near the rock. *Collection L. I. Cooper.*

Assignment: Give texture and pattern to the boards, rocks, and grass in the sketch to the left, using the methods described in this demonstration. For further details, see *Texture and Pattern,* p. 22.

Glowing Old Maple (Step 1)
Whatman paper mounted on heavy cardboard, 11" x 15". My palette was cadmium lemon, cadmium orange, yellow ochre, burnt sienna, warm sepia, alizarin crimson, Winsor (phthalocyanine) blue, and charcoal gray. With no preliminary pencil drawing, I painted the bright maple foliage lit by the sun. I used generous washes of cadmium lemon, cadmium orange, and burnt sienna, allowing the washes to flow into each other. After the first wash was dry, I painted sharper foliage details with alizarin crimson and warm sepia washes. I also painted the thin, dark branches with a painting knife.

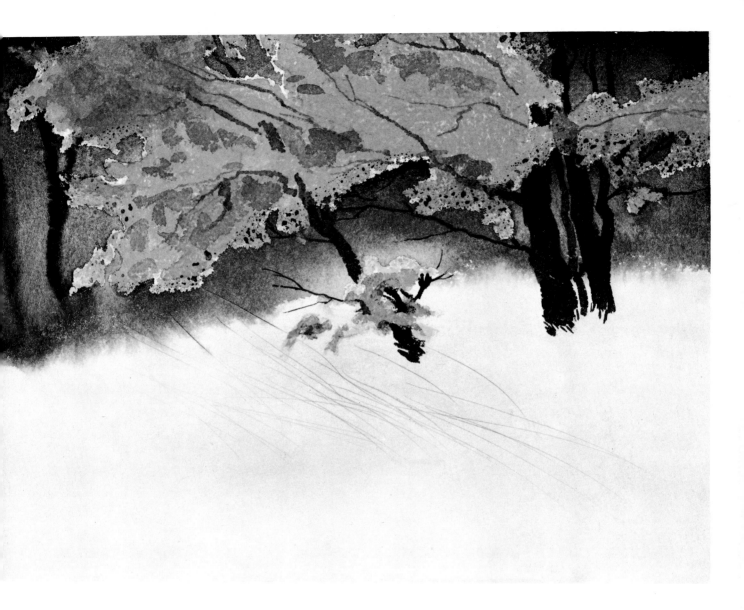

Glowing Old Maple (Step 2)
After drying, the finished foliage area was masked out. I rubbed a stick of paraffin onto the surface as hard as possible to cover all the pores of the paper. Then I followed the edges as well as I could, slipping over here and there into the white background. After I'd finished, I proceeded with the dark background, ignoring the foliage, which now was well protected by the wax coating. Winsor blue, yellow ochre, and warm sepia gave me the greenish shades. Charcoal gray helped with the darker areas.

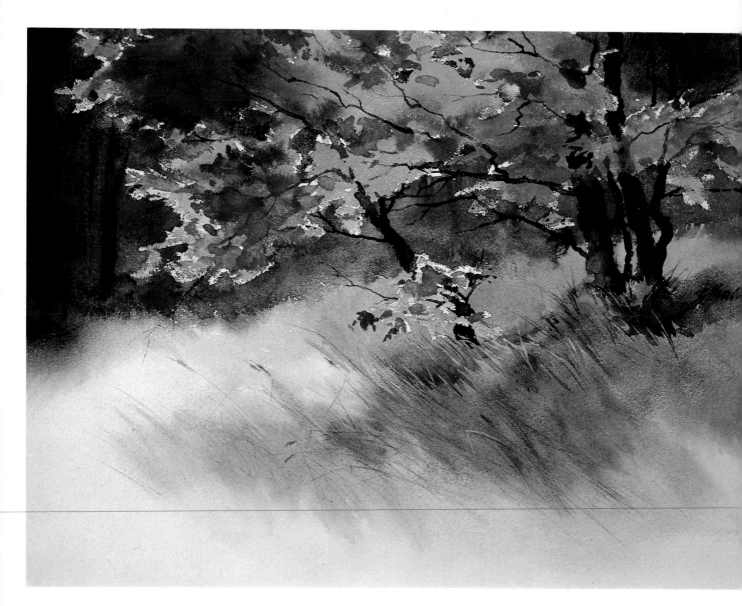

Glowing Old Maple (Step 3)

In this final stage, I wet the bottom half of the paper, wetting the dark wash on top to soften the lower edge as it flowed into the clear wash. I then applied soft washes to the foreground grass on the wet paper. After these washes dried, I painted the dark branches of the trees, as well as the sharp weeds, using a fine brush and the edge of a painting knife. When the painting was finished, I removed the wax in the following way. I heated an electric iron to medium heat, laid two layers of tissue on top of the wax, then applied the hot iron. As the wax melted, it soaked into the tissue. I quickly lifted it and repeated this procedure about eight times, using a clean tissue each time, until the tissue no longer absorbed any wax. *Collection Mr. and Mrs. Ray Seel.*

Assignment: Mask out the boats, seagulls, and pier posts in the composition to the left, using the technique described in this demonstration. For further details, see *Masking Technique and Using the Razor Blade*, p. 23.

Blue Rocks, Nova Scotia (Step 1)
Whatman paper mounted on heavy cardboard, 11" x 15". My palette was cadmium orange, burnt sienna, sepia, Antwerp blue, Payne's gray, and charcoal gray. I wet the top half of the paper and slapped in a gentle wash of mist behind the building, using sepia, Antwerp blue, and a touch of charcoal gray.

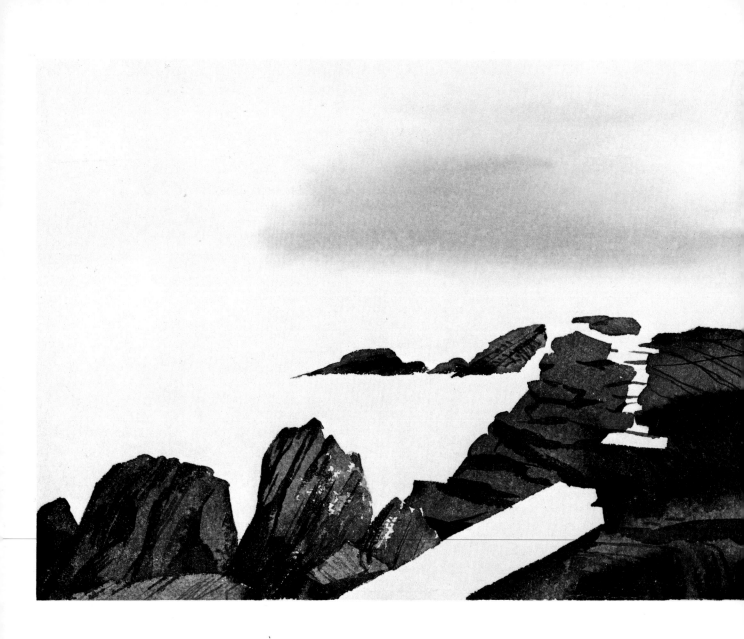

Blue Rocks, Nova Scotia (Step 2)
I painted the rocks directly onto the dry paper, starting at the end of the rocky path. My colors were Payne's gray and a touch of burnt sienna. I left out the silhouette of the light rocks and the planks. As the paint dried, I added the drybrush modeling of the rocks.

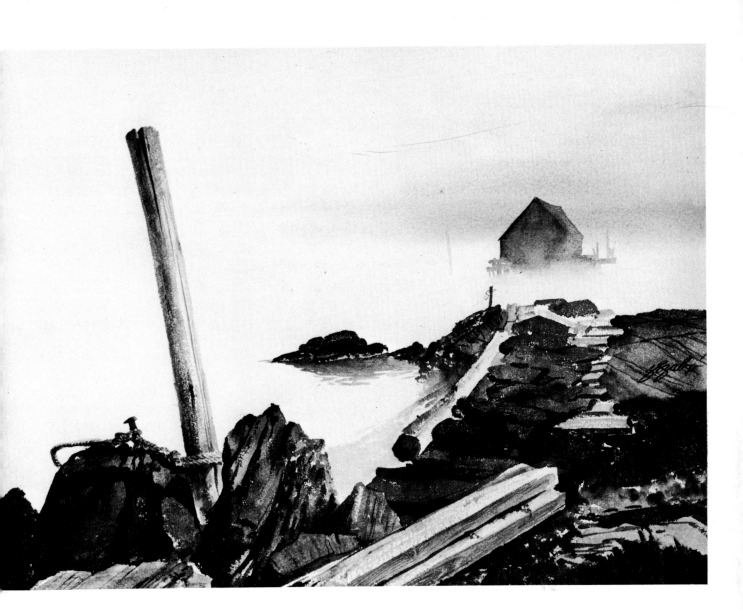

Blue Rocks, Nova Scotia (Step 3)

In this final stage, I painted the light rocks on the path, the wooden planks, and the large beam, using Payne's gray and burnt sienna. Then I painted the post which supports the rope. The light, weathered, woody quality of the post comes from several layers of drybrush washes, with each wash allowed to dry before the next application. I scraped the twist of the rope into the wet wash with the tip of my brush handle. Next came the rusty spike, for which I used burnt sienna, then the old fisherman's hut in the mist with the bottom part fading into wet area. The little stick with wires on it at the point, the reflections of the rocks, and the falling shadow of the pole and rope on the rock (left foreground) supplied the finishing touches. *Collection Mr. and Mrs. K. R. Shadlock.*

Assignment: Complete the painting in the sketch to the left, using the drybrush technique described in this demonstration. For details, see *Drybrush*, p. 17.

Trees in Snow (Step 1)
Whatman paper mounted on heavy cardboard, 11" x 15". My palette was cadmium yellow deep, burnt sienna, Vandyke brown, ultramarine blue, Winsor (phthalocyanine) blue, and charcoal gray. First, I wet the top half of the paper and slapped in the mist of the background forest, using Vandyke brown and ultramarine blue in a single wash. A couple of wet strokes of Winsor blue hints at the frosty shrubs at the bottom of the bush.

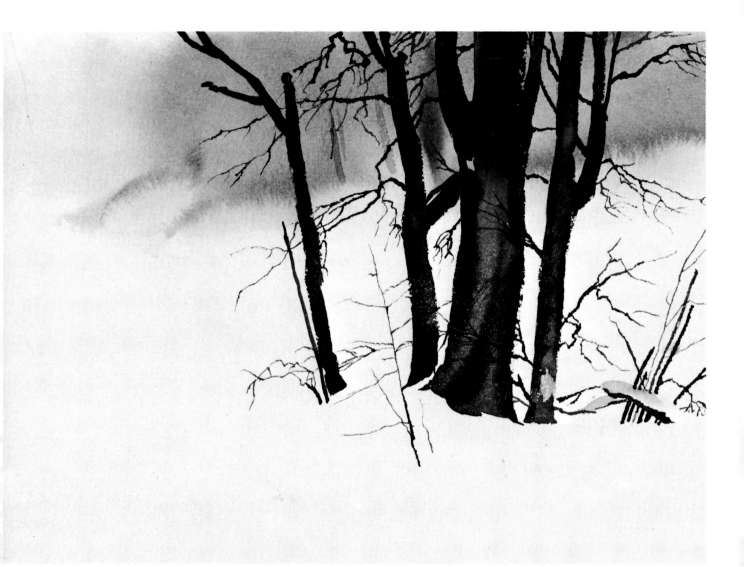

Trees in Snow (Step 2)
After the first wash dried, I painted the dark parts of the large treetrunks with Vandyke brown and ultramarine blue, then oozed burnt sienna onto the sunlit crevices. After this, I applied all the smaller branches, as well as the young shoots in the foreground, with my painting knife. I used a scraping motion, taking advantage of the flexible blade.

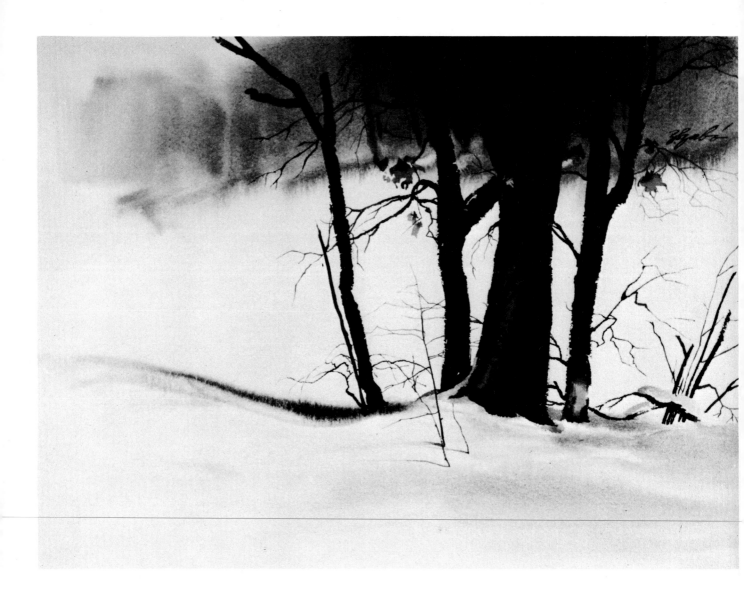

Trees in Snow (Step 3)
After wetting the lower third of the paper, I painted the foreground shadows with ultramarine blue and a touch of charcoal gray. After this wash dried, I painted in the snow, the shadows of the young twigs, and, finally, using cadmium yellow deep and burnt sienna, I painted on the leftover leaves, which supply bright color and finish the painting. *Private Collection*.

Assignment: Complete the painting in the sketch to the left, using the painting knife techniques described in this demonstration. For further details, see *Painting Knife Techniques*, p. 20.

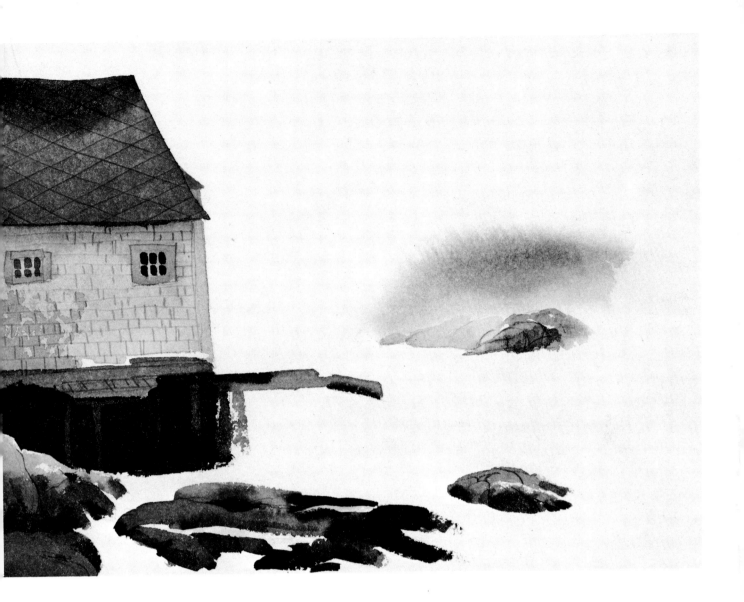

Peggy's Cove (Step 1)

Whatman paper mounted on heavy cardboard, 11" x 15". My palette was yellow ochre, cadmium orange, burnt sienna, sepia, brown madder, ultramarine blue, Antwerp blue, and charcoal gray. With no preliminary pencil drawing, I started painting the rocks in the foreground, allowing drybrush edges to survive. The modeling was done with cadmium orange and burnt sienna washes with charcoal gray edges. The cracks were scraped into the wet wash with the tip of my brush handle. My reason for starting with the rocks was to make sure the tide wouldn't cover them before I'd finished the rest of the painting! I then proceeded

with the building in the left middleground, using a sepia and ultramarine blue wash to produce the aged look of the wood of the wall. Antwerp blue and sepia proved right for the roof. The line definition on the side, as well as the roof of the building, is the result of paint worked into the wet wash with a brush handle. I applied these details quickly, before the wash had a chance to dry. I wet the top half of the paper next to the distant fog covered hill in the background. A subtle wash of ultramarine blue and burnt sienna defined the hill. The lower rocky edge is the result of blending drybrush touches into the wet wash on top.

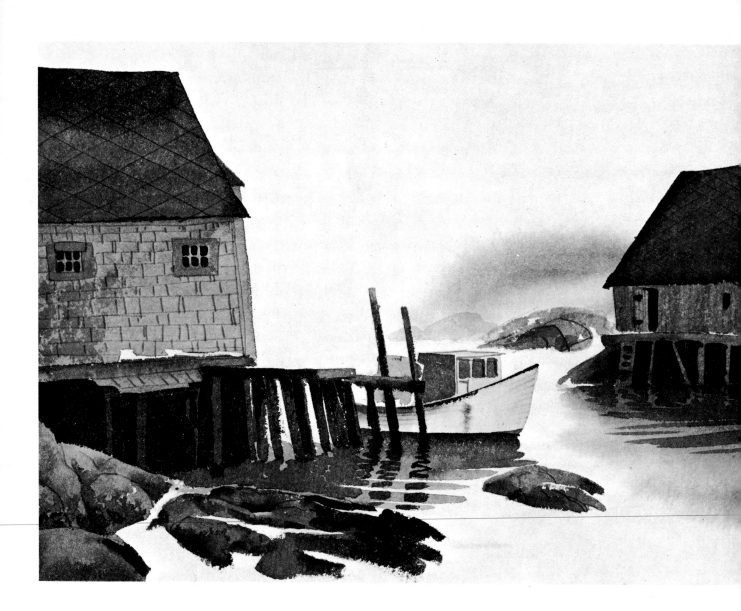

Peggy's Cove (Step 2)

I painted the light, gray-blue wash of the boat beside the dock and its reflection, indicating water ripples blending into a dark, deep color under the main building in the left center. The line indicating board direction on the hull of the boat was done by working the brush handle point in the wet wash. I added the rust colored touches at the same time. Turning to the building in the right middleground, I used Antwerp blue, ultramarine blue, charcoal gray, and burnt sienna in varied combinations to make the colors more subtle. The dark washes below the dock, as well as the door and window openings, had to be applied after the first washes were dry.

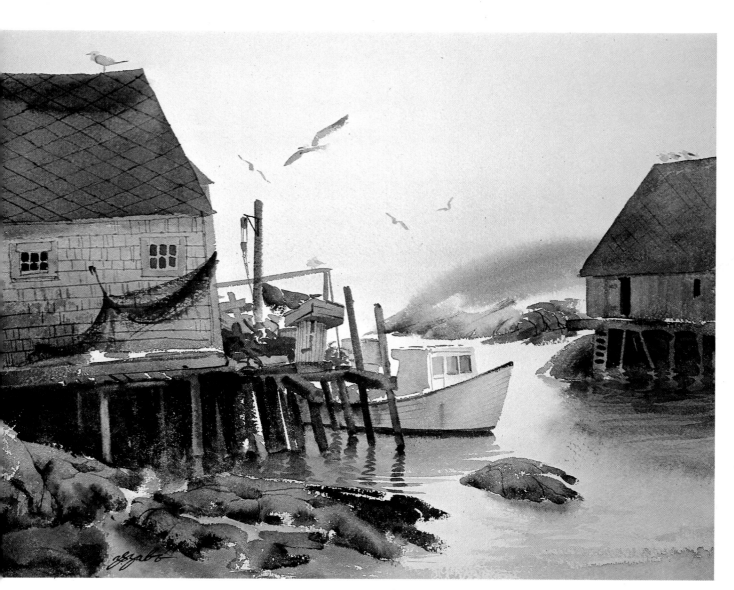

Peggy's Cove (Step 3)

The supporting beam pillars of the main building and the detailed clutter on the platform followed in this final stage. I painted small areas separately, to prevent details from running into each other. The lobster trap and the pole with the pulley were better defined than the hints of the clutter below and were painted with burnt sienna, sepia, charcoal gray, and brown madder. I painted the drying nets on the side of the building with brisk drybrush strokes of Antwerp blue, charcoal gray, and a touch of yellow ochre. Finally, I added the finishing touches of the dark reflections of the wooden pillars, the light reflections near the rocks up front, and the soft reflection on the right center. The inevitable seagulls completed the composition. They were painted in ultramarine blue and charcoal gray with a touch of brown madder for their beaks. *Collection Mr. and Mrs. Peter Rollason.*

Assignment: Improve the arrangement of the scene to the left by rearranging the objects into more interesting relationships with one another. For further details, see *Relationships*, p. 30.

Plowed Field (Step 1)

300 lb. d'Arches rough finished paper, 15″ x 22″ (half sheet). My palette was burnt sienna, sepia, brown madder, charcoal gray, yellow ochre, cadmium orange, ultramarine blue, and Winsor (phthalocyanine) blue. I began without any preliminary pencil drawing. The reflection of the setting sun glistening on the farmhouse window makes it the center of interest and adds a touch of the unusual to this painting (see finished painting, p. 96). I painted the farmhouse and the trees onto dry paper, using yellow ochre and burnt sienna on the house wall, and Winsor blue and sepia for the dull, distant green pines next to the building. Burnt sienna, with a little brown madder, supplied the color for the sunlit, taller deciduous trees in the distance as well as for the fine line of the snow fence on the horizon.

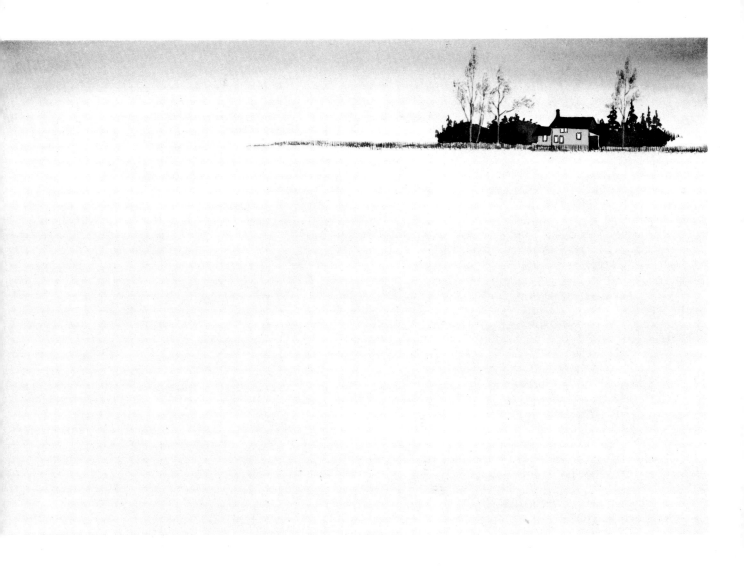

Plowed Field (Step 2)
I wet the top, sky, portion of the paper, then carefully slipped over the lacy trees once with a wet brush, without disturbing their crisp quality. One sweep of Winsor blue and sepia wash gave me a sky gently flowing into the lower edges of the wet area.

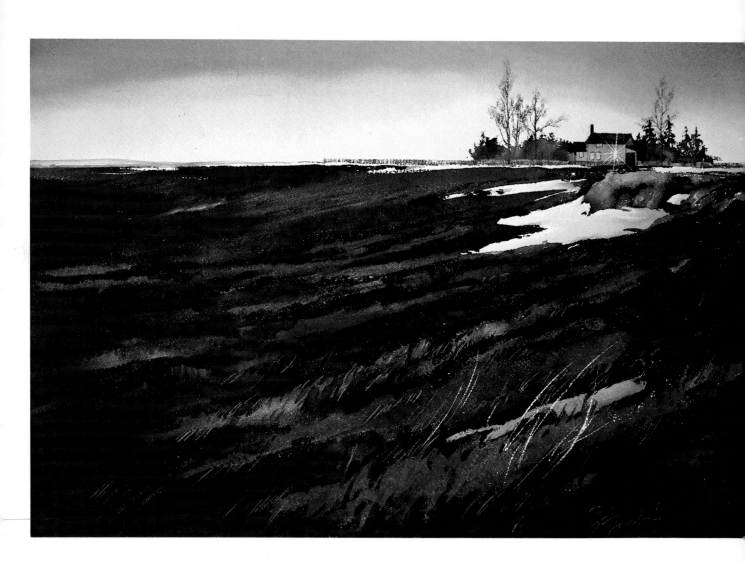

Plowed Field (Step 3)

In this final stage, I painted the sunlit bit of soil below the farmhouse in the middleground, using yellow ochre, burnt sienna, brown madder, and charcoal gray. The plowed field was next. I painted this large area with a 1″ wide bristle brush, following the direction of the pattern of the plow furrows. I started from the top left and worked toward the top right, applying new layers of additional paint and covering more and more surface as I advanced toward the bottom. I left the snow patch area clear, as well as the shaded blue snow patch in the foreground. As I reached the foreground, I defined more weeds and more of the character of the plowed field. My colors were burnt sienna, brown madder, sepia, and charcoal gray. Next, I painted the thin line of blue hills on the distant horizon and the modeling of the snow patches (top left), including the shaded one up front. After everything was dry, I scraped in a few tall weeds (right front) and added the sun's glistening reflection in the farmhouse window with the sharp point of a painting knife blade. *Collection Mr. and Mrs. D. Turnbull.*

Assignment: Complete the sketch above, accentuating the feather as the center of interest. For further details, see *Center of Interest,* p. 32.

Summer Memories (Step 1)

Whatman paper mounted on heavy cardboard, 11″ x 15″. My palette was scarlet red, brown madder, burnt sienna, Vandyke brown, ultramarine blue, Winsor (phthalocyanine) blue, and charcoal gray. I painted this sketch with no preliminary pencil drawing, when the temperature was just near freezing. I saw the blizzard coming in the distance, so I had to work fast. I defined the silhouetted form of the three red chairs carefully, leaving out the snow covered areas. I used a rich wash of scarlet red and applied it with a fine sable brush. I wet the paper above the chairs up to the edge of the snow. Again, I used a small sable brush to apply the footprints and the grayish tones near the edge of the water. The gray color was made from Vandyke brown and a touch of ultramarine blue. After this, I modeled the snow next to and on top of the chairs with ultramarine blue, charcoal gray, and a touch of Vandyke brown.

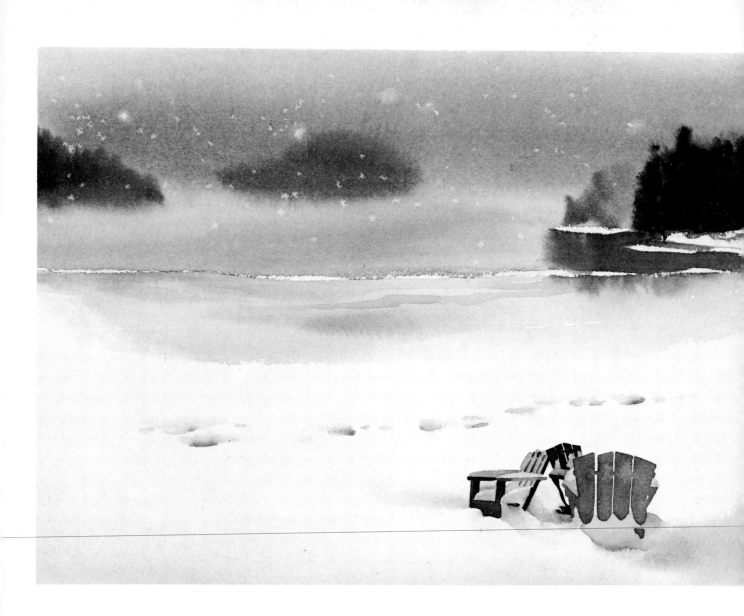

Summer Memories (Step 2)

When the blizzard started to close in, I had to work fast. I wet the top third of the paper, except the snow covered lower edges of the point on the right middleground. I slapped a rich mixture of Vandyke brown and ultramarine blue onto the wet area, adding a dark horizontal stroke right across the place where the distant island is located. This created a feeling of horizon. With a little moisture in the brush, I painted in the island and the two tree covered points of land on both sides, using Winsor blue, burnt sienna, and charcoal gray mixtures. At this point, the snow started to fall; it dropped in big, husky flakes onto my carefully controlled, smooth wash. I ran into a nearby building, holding the painting upside down. Inside, I turned the painting up again and discovered that the accidental snow drops caused by the small back runs from melting snowflakes were lovely!

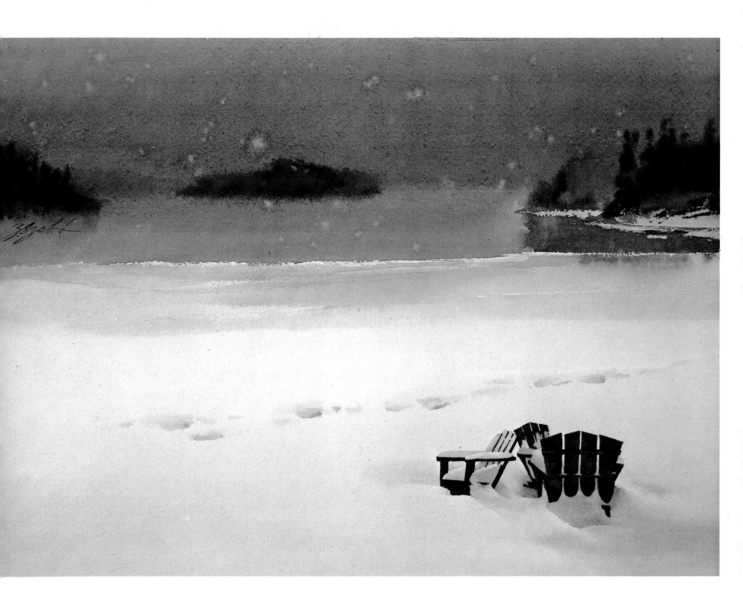

Summer Memories (Step 3)
In this final stage, I finished the red chairs in fine detail indoors from memory and the help of a photograph. Brown madder and charcoal gray supplied the values for modeling. *Collection Mr. F. J. Robinson.*

Assignment: Complete the scene in the sketch to the left, showing the perspective of the view. For further details, see *Three Dimensions, Perspective,* p. 33.

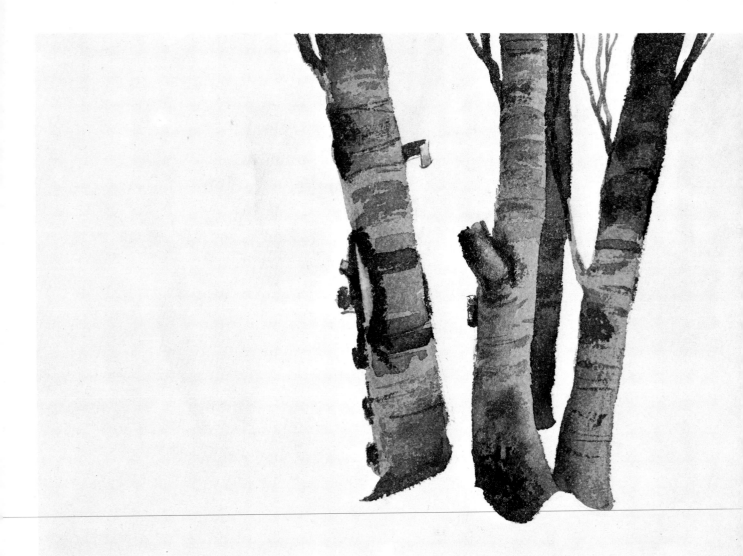

Revisited (Step 1)
300 lb. d'Arches rough finished paper, 22" x 30". My palette was burnt sienna, Vandyke brown, charcoal gray, yellow ochre, ultramarine blue, and Antwerp blue. With no preliminary pencil drawing, I used a 1" wide tapered bristle brush to paint in the heaviest treetrunk (left). I moved the brush, loaded with a heavy wash of medium-strength gray color, horizontally. This gray color was a mixture of well-diluted ultramarine blue and burnt sienna. The edges were left loose, rather than ruler straight. While this wash was drying, I painted the remaining trunks of the birch clump in the same way. As these washes started to dry, I applied heavier horizontal strokes of burnt sienna, charcoal gray, ultramarine blue, and Vandyke brown, allowing them to form soft edges in the drying first wash.

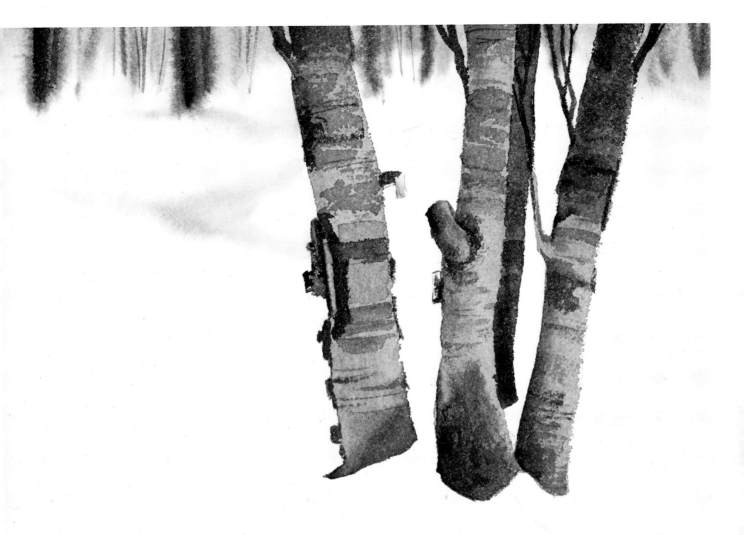

Revisited (Step 2)
I saturated the top half of the paper, avoiding the birch trunk areas which were already painted. While the paper was wet, I quickly slapped in the distant forest, using Vandyke brown, ultramarine blue, and charcoal gray. The first washes were light. As the paint stopped running, I applied the soft suggestions of treetrunks, using less water and more paint in the brush. This blending gives an exciting hint of the deep forest. At the same time, and using the same bristle brush, I painted the modeling of the snow in the middleground, using a soft wash of ultramarine blue and charcoal gray.

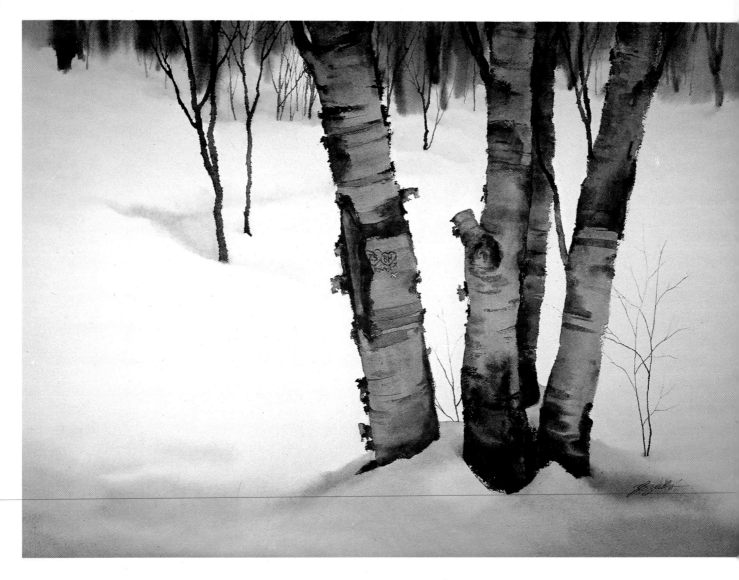

Revisited (Step 3)

The mound of snow in the foreground around the bottom of the birch clump was next. I started with a sharp edge between the treetrunks, moving rapidly toward the bottom and the sides. The sharpness blended into soft modeling as the brush touched the wet area. The modeling of the snow is free and uneven because of the different amounts of paint in each brushful of wash. The young trees in the foreground, middleground, and background are entirely the result of painting knife application. A rich mixture of Vandyke brown and Antwerp blue over the dry washes gives sharp details. The ragged bark and the final modeling on the treetrunks, as well as the heavier branches, were directly applied with the drybrush technique. As a final touch, I put in the carving marks on the birch. *Collection Mrs. Elizabeth Szabo.*

Assignment: Complete the sketch to the left, concentrating on values and forms as described in this demonstration. For further details, see *Value and Form,* p. 34.

Snow with Weeds (Step 1)
Whatman Paper mounted on heavy cardboard, 11″ x
15″. My palette was burnt sienna, raw umber, ultra-
marine blue, Winsor (phthalocyanine) blue, and char-
coal gray. First, I wet the top half of the paper. With a
1″ wide bristle brush, I painted the sky, the distant
hills, and the fuzzy evergreens.

Snow with Weeds (Step 2)
After the paper dried, I painted the thin branches of the snow covered tree and the few scrawny trees on the far left with a painting knife. I used burnt sienna and Winsor blue for the dark lines.

Snow with Weeds (Step 3)
Last came the dry weeds in the white foreground. Their tilted angle indicates the pressure of the snow. I painted these weeds with raw umber and charcoal gray, using a soft sable brush with a good point. *From the Painters of Canada Series, Courtesy of Coutts Hallmark Cards. Private Collection.*

Assignment: Complete the sketch to the left, using your white space to fullest advantage. For further details, see *The Value of White Space,* p. 35.

Algonquin Rivulet (Step 1)
Whatman paper mounted on heavy cardboard, 11" x 15". My palette was burnt sienna, brown madder, Vandyke brown, ultramarine blue, and cerulean blue. After wetting the paper, I applied varied strokes to indicate the forest. I used Vandyke brown, ultramarine blue, and burnt sienna in varying consistencies. Directly next to the forest, I painted the shaded snow with logs scattered in it. I carried this modeling down to the creek.

Algonquin Rivulet (Step 2)

Next, I painted the dark logs at the edge of the forest with Vandyke brown and ultramarine blue. With the same dark wash, I painted the creek, allowing dry-brush edges to hint at fresh snow. As I reached the bottom of the creek, I wet the paper below it. As I touched the wet paper with the brown wash, the exciting ooze that you see here happened.

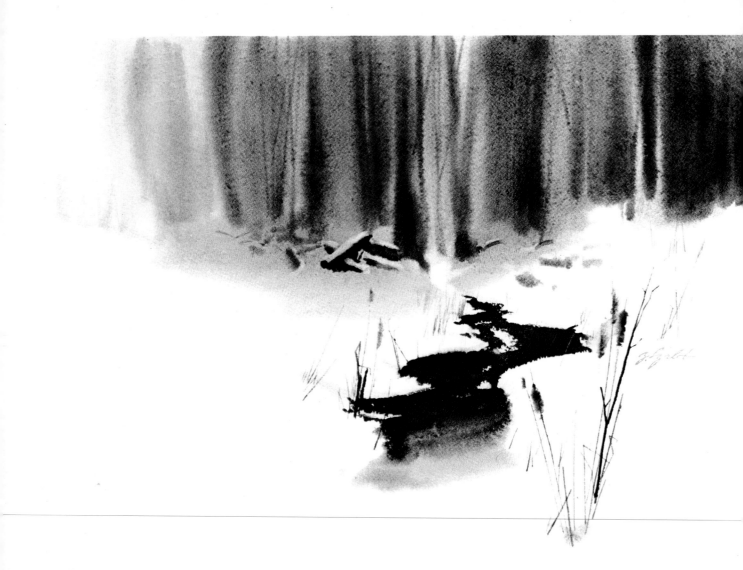

Algonquin Rivulet (Step 3)
In this final stage, I did the weeds. For the bulrush heads, I wet the paper where the soft head was to go. I painted in a stroke of heavy pigment, allowing it to dry soft. And, finally, I painted in the thin stems and twigs with a painting knife and a small sable brush. *From the Painters of Canada Series, Courtesy of Coutts Hallmark Cards. Collection Mr. and Mrs. J. W. Bessey.*

Assignment: Model the snow in the sketch to the left, using the method described in this demonstration. For further details, see *Snow*, p. 58.

Cape Breton Island (Step 1)
Whatman paper mounted on heavy cardboard, 11″ x 15″. My palette was cadmium lemon, burnt sienna, yellow ochre, sepia, ultramarine blue, and Antwerp blue. I started with a large wash of sepia, yellow ochre, and ultramarine blue over the sandy drop, as well as in the foreground. Near the top right, I hinted at grass by mixing Antwerp blue and cadmium lemon.

Cape Breton Island (Step 2)
A few simple, large washes of sepia and ultramarine blue with some Antwerp blue followed the lazy roll of the waves. I allowed the whitecaps to remain untouched and white.

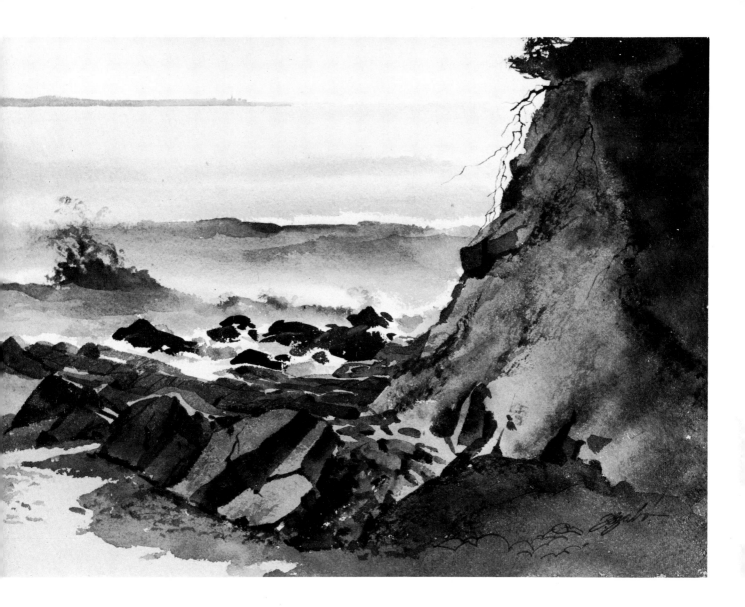

Cape Breton Island (Step 3)

In this final stage, the detail on the sand and rocks, as well as their shadows, followed. Sepia and ultramarine blue supplied the color. The drybrush wave splash in the left center and the distant point on the left horizon were rendered; the roots hanging out of the land bank on the top right, applied with a painting knife, helped to finish the job. *Private Collection.*

Assignment: Complete the painting in the sketch to the left, emphasizing the sandy foreground. For further details, see *Sand and Soil,* p. 51.

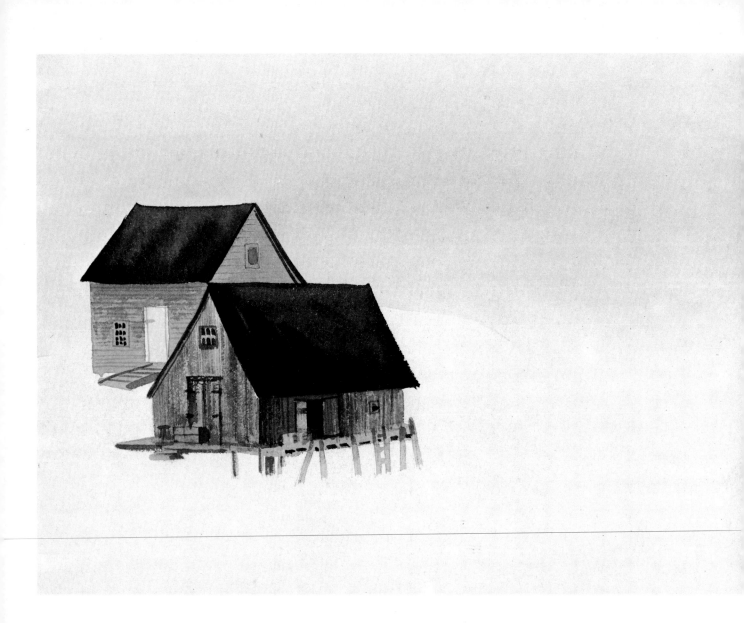

Peggy's Cove in Mist (Step 1)
Whatman paper mounted on heavy cardboard, 11" x 15". My palette was yellow ochre, burnt sienna, sepia, ultramarine blue, and charcoal gray. First, I established the two main fishermen's huts with several layers of drybrush washes of charcoal gray and sepia. I slapped on the lighter value reflections below the buildings with charcoal gray. Next, I wet the top part of the paper, avoiding the edges of the buildings. I painted a soft mist of fog into this with a gentle wash of sepia and charcoal gray, as well as the misty hut in the right middleground.

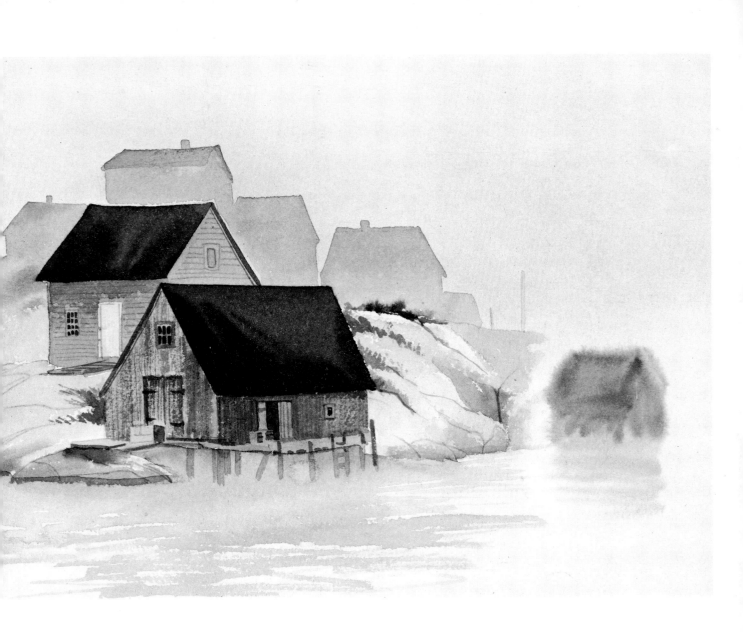

Peggy's Cove in Mist (Step 2)
Next came the bleached rocks on both sides of the
huts. The line pattern of the rocks was done with the
point of my brush handle. Where the rocks touch the
water's edge, a touch of burnt sienna hinted at rusty
deposits. The dry weeds in the cracks had similar
coloring. I followed this with light washes of charcoal
gray on the houses in the background. These are
rendered vaguely, because the fog hides most details.

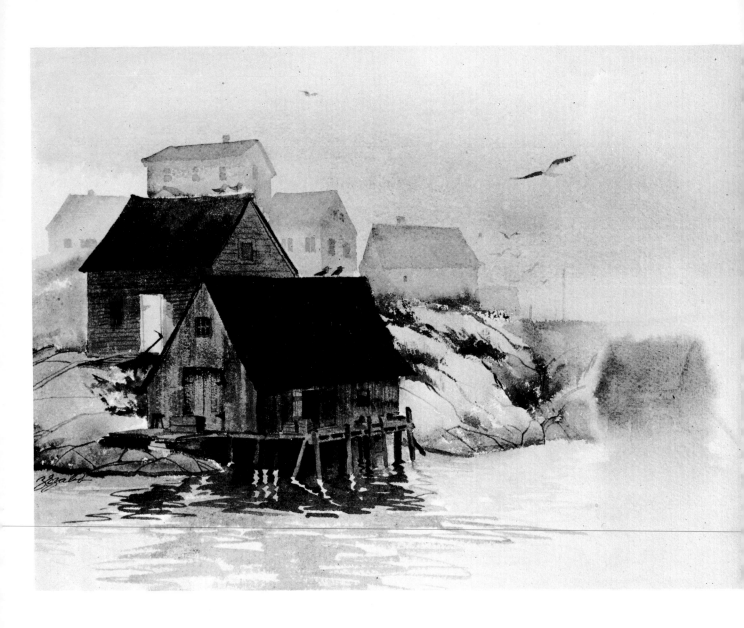

Peggy's Cove in Mist (Step 3)
In this final stage, I added the dark reflection under the main building and the inevitable seagulls. *Collection Mr. and Mrs. D. Grey.*

Assignment: Complete the sketch to the left by painting it as if seen through fog or mist. For further details, see *Fog and Mist,* p. 55.

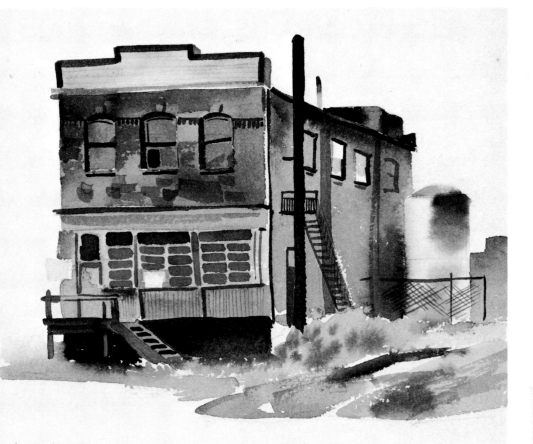

Rainy Afternoon (Step 1)
300 lb. d'Arches rough finished paper, 22" x 30". My palette was vermilion, brown madder, burnt sienna, warm sepia, cadmium yellow medium, ultramarine blue, Hooker's green No. 2, and charcoal gray. I started with the front of the old building, painting the red brick color with vermilion, brown madder, and sepia. I continued with the side of the same building in Hooker's green, adding details as drying allowed. Then I indicated the wet weeds and the muddy drive, leaving out the edge of the wet sidewalk.

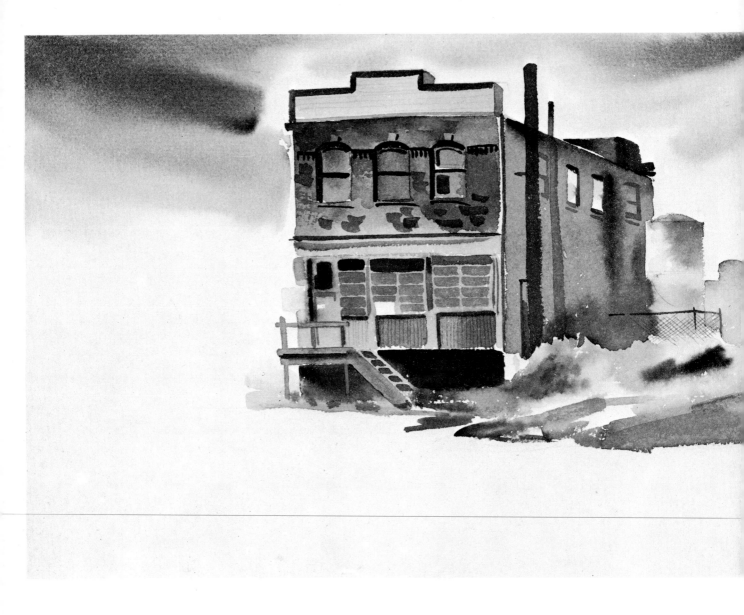

Rainy Afternoon (Step 2)
I wet the sky area and applied large washes of a mixture of ultramarine blue and warm sepia with a soft, 1″ wide, flat brush.

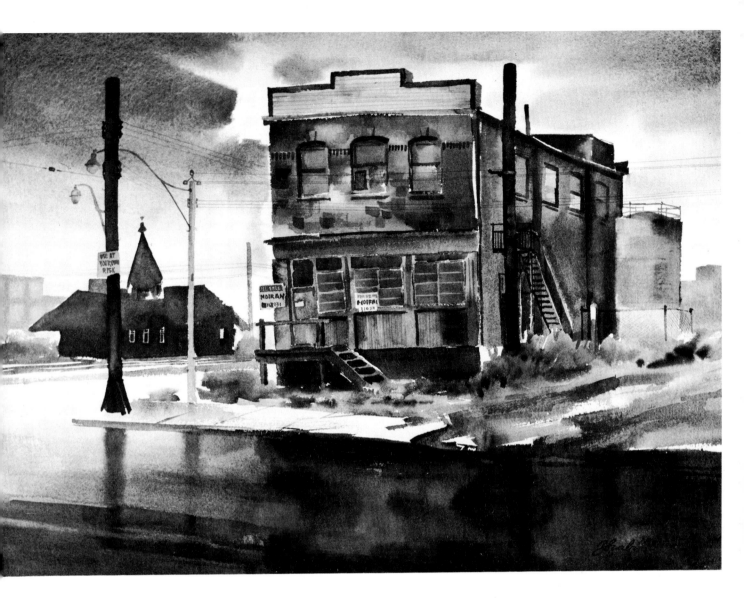

Rainy Afternoon (Step 3)

In this final stage, I painted the old railway station with a roof of ultramarine blue which freely flowed into the warm sepia bottom. I painted the lampposts and sidewalk details at the same time. Next, I finished the dark foreground reflections, using the same color as for the objects that caused the reflections, but darker. As a final touch, I finished the signs to add atmosphere to the painting. *Collection Mr. and Mrs. George Yeats.*

Assignment: Complete the sketch of rain and puddles to the left. For further details, see *Rain,* p. 56.

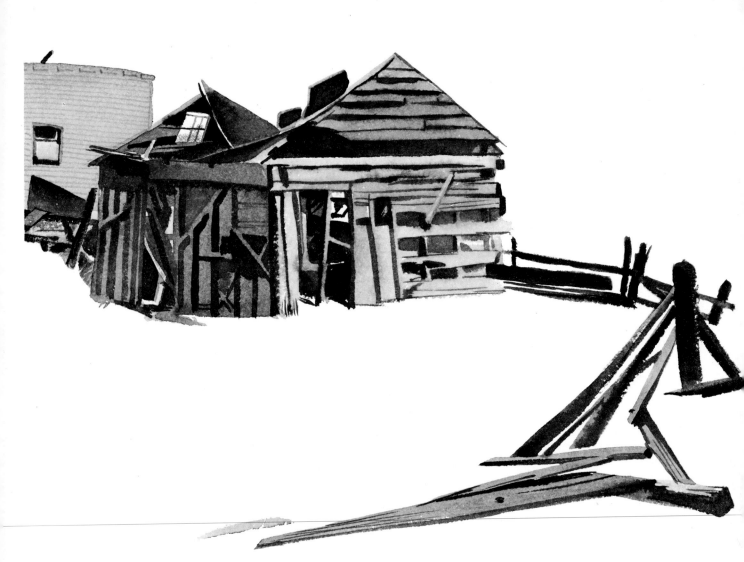

Spring Puddle (Step 1)
300 lb. d'Arches rough finished paper, 22'' x 30''. My palette was yellow ochre, burnt sienna, Vandyke brown, charcoal gray, Hooker's green No. 2, cobalt blue, and Winsor (phthalocyanine) blue. I painted the collapsing building with a direct painting method on dry paper, building up details as I went along. Cobalt blue, Vandyke brown, and charcoal gray were my colors for the old boards and for the fallen fence.

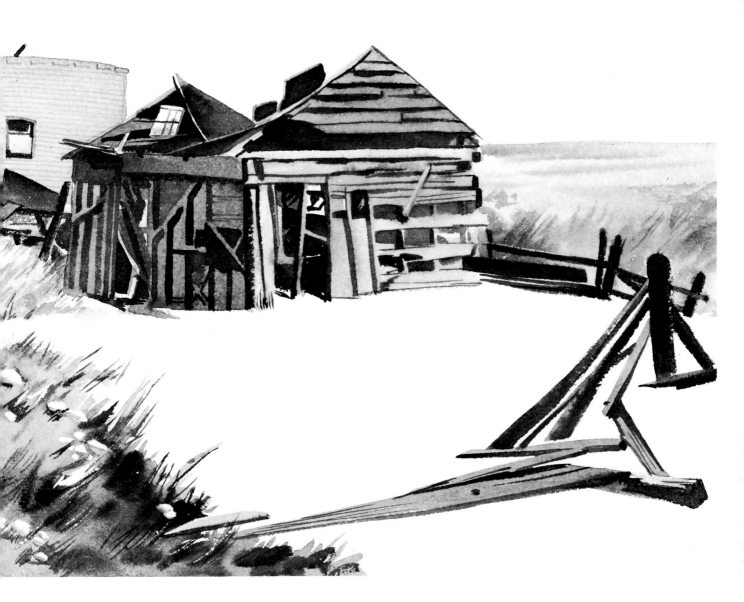

Spring Puddle (Step 2)
I applied the grass and pebbles in the foreground and the weeds in the middle, right up to the horizon. For this, I used yellow ochre, Hooker's green No. 2, and Vandyke brown, in varying combinations.

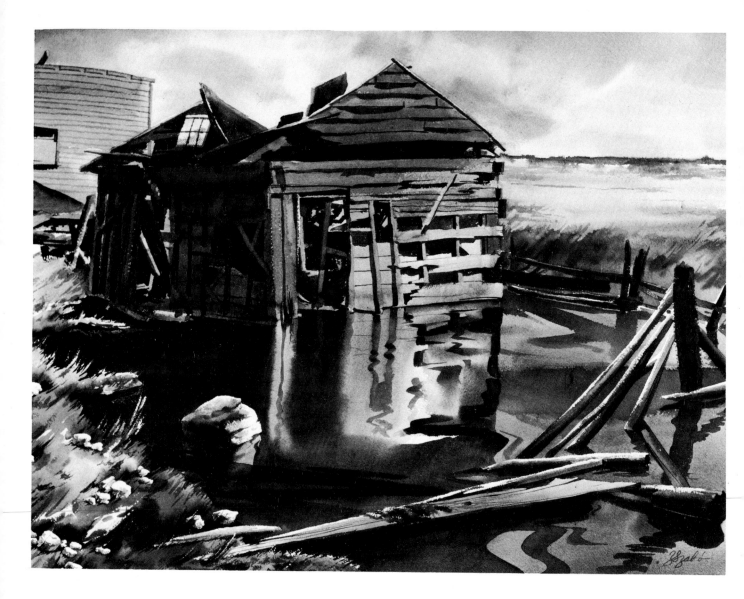

Spring Puddle (Step 3)

In this final stage, I painted the large puddle with its reflections, done partly wet-in-wet; some of the final reflections had to be painted on dry paper. I used Winsor blue, Vandyke brown, and charcoal gray for the color of the water. I painted the sky on wet paper with light washes of cobalt blue and a touch of charcoal gray. I finished the painting by detailing the rock in the water that I had left out as a white silhouette from the reflection. *Collection Mr. and Mrs. Les Buckler.*

Assignment: Complete the composition of buildings in a group in the sketch to the left. For further details, see *Buildings,* p. 64.

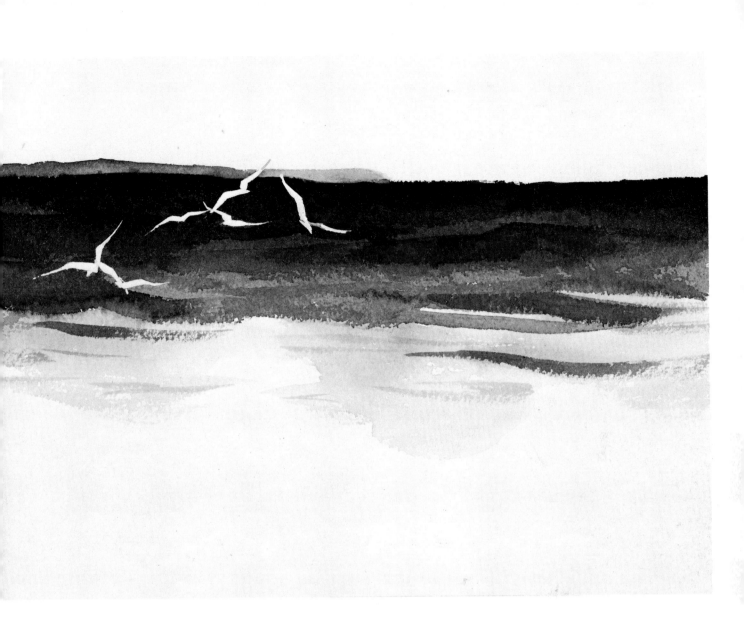

My Children (Step 1)
300 lb. d'Arches rough finished paper, 11" x 15". My palette was vermilion red, yellow ochre, Vandyke brown, ultramarine blue, Winsor (phthalocyanine) blue, and charcoal gray. First, I painted the water, starting at the horizon, using Winsor blue and yellow ochre with some Vandyke brown, and leaving the shape of the white seagulls unpainted by painting around them. After this layer of washes dried, I added more wave details, coming down to the light edge of water. At the same time, I painted the pale blue shoreline above the horizon.

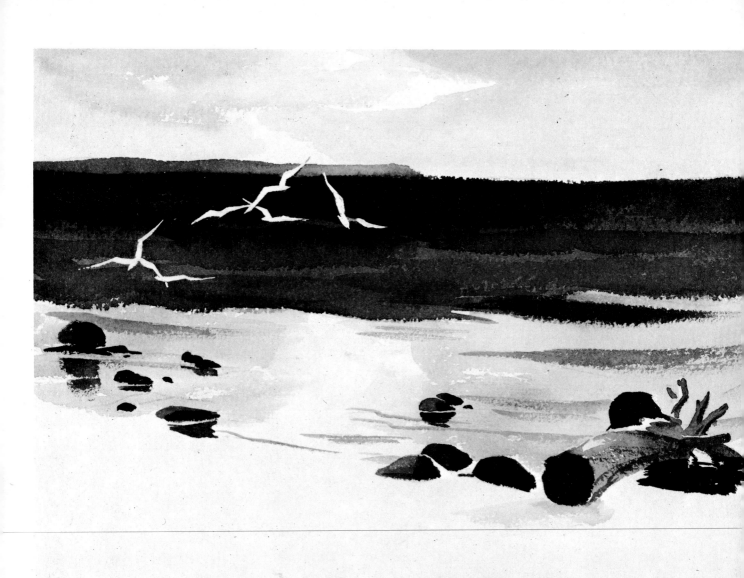

My Children (Step 2)
Next, I slapped on a light ultramarine blue and charcoal gray wash for the sky, then the shaded side of the large stump. Ultramarine blue and Vandyke brown were my colors. I followed with the shore rocks and their reflections.

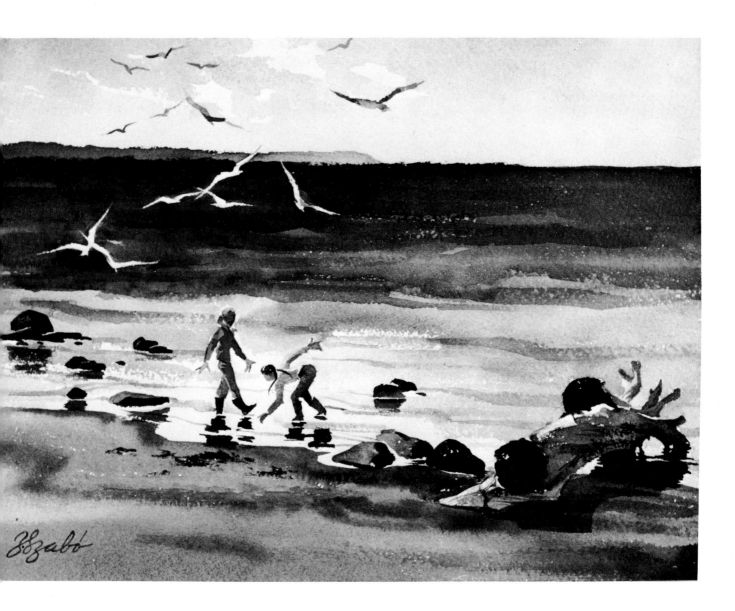

My Children (Step 3)
In this final stage, I painted the sandy foreground. I used yellow ochre and ultramarine blue, with oozing charcoal gray to indicate dark wave marks in the sand. I continued with the shadow of the stump on the sand, the seagulls above the horizon, and my two children playing at the water's edge. The red jacket on the boy and the bluejeans on the girl made them stand out as the center of interest. *Collection Mrs. Elizabeth Szabo.*

Assignment: Place as many figures in the composition to the left as you think necessary to add interest. For further details, see *People and Animals,* p. 65.

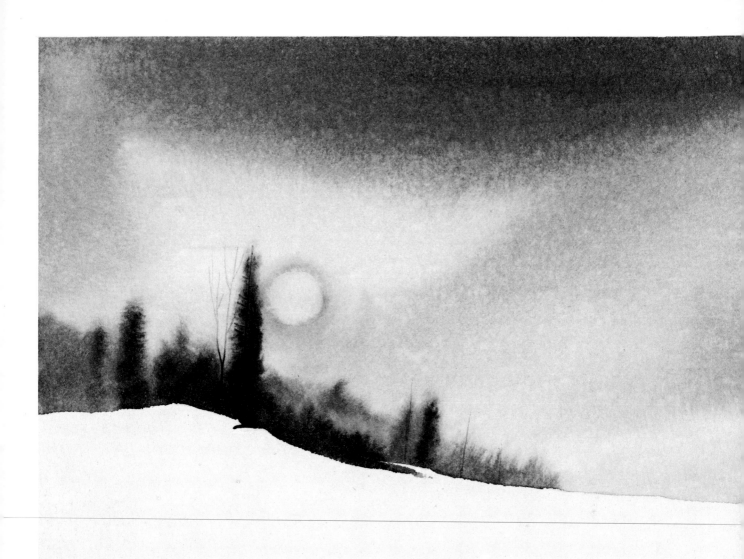

Misty Sun (Step 1)

Whatman paper mounted on heavy cardboard, 11" x 15". My palette was yellow ochre, burnt sienna, warm sepia, brown madder, Antwerp blue, Winsor (phthalocyanine) blue, and charcoal gray. First, I wet the top part of the paper, down to the edge of the rocky hill. I painted large sweeping washes of Antwerp blue, warm sepia, and charcoal gray. I encouraged the paint to remain darker near the outside edges to give a framing effect. I painted heavy loads of Winsor blue, burnt sienna, and Antwerp blue on the edge of the horizon to give the misty effect of evergreens. The hint of twigs was produced by the tip of my brush handle. Before these washes dried, I wiped back the shape of the misty sun with a clean, thirsty brush.

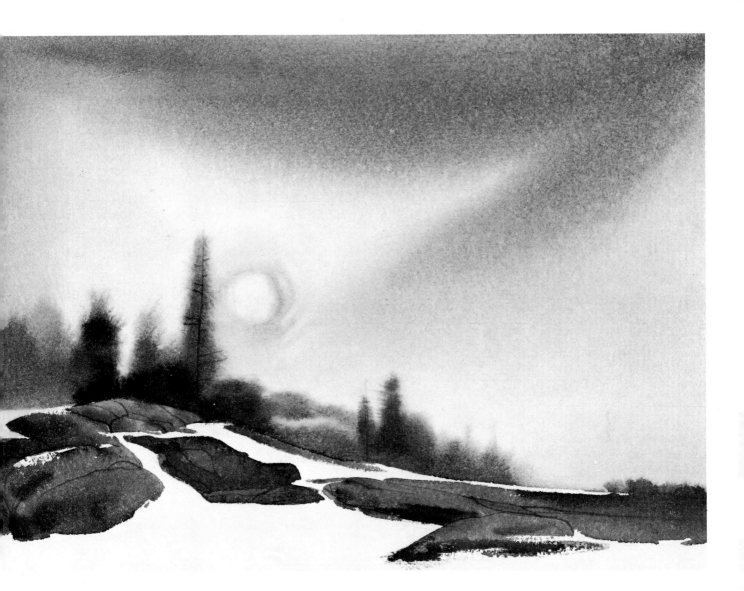

Misty Sun (Step 2)
I painted in the rocks with simple washes of warm sepia, brown madder, burnt sienna, Antwerp blue, and charcoal gray. I scraped the cracks and rocky edges into the wet washes with the tip of my brush handle. I didn't touch the area of snow, which is pure paper.

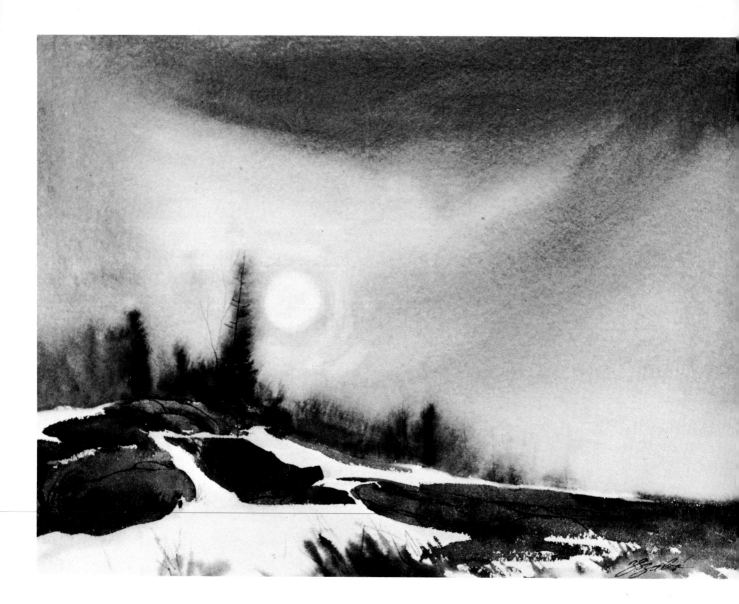

Misty Sun (Step 3)
In this final stage, I wet the lower edge of the paper and dropped in the dry weeds, using thin strokes of burnt sienna and yellow ochre, finishing with a few thin lines of scraggly grass blades. *Collection Mr. F. J. Robinson.*

Assignment: Complete the composition in the sketch to the left by adding the sky of your choice. For further details, see *Sky and Clouds,* p. 60.

St. Joseph's Island (Step 1)

300 lb. d'Arches rough finished paper, 22" x 30". My palette was yellow ochre, cadmium orange, cobalt blue, ultramarine blue, Antwerp blue, and charcoal gray. With no preliminary pencil drawing, I saturated the whole paper with a soft sponge. Starting at the horizon line I painted a medium-strength layer of yellow ochre wash downward across the whole sheet, using a soft, wide brush. A light value of cadmium orange followed above the horizon, getting lighter as the horizontal strokes advanced further upward. I washed the same brush and applied a heavy coat of Antwerp blue and cobalt blue starting at the very bottom. This wash got lighter, fading into the yellow ochre wash while still wet. A dark wash of ultramarine blue and cobalt blue, starting at the very top of the sky and fading into the pale orange horizon, finished the first large background wash. A light wash of ultramarine blue and sepia gave me the wind-swept clouds in the sky.

St. Joseph's Island (Step 2)
Knowing approximately where the concentrated dark value of the trees on the island would be, I took advantage of the still-wet wash of the water and painted in the softly blending reflections and wave patterns. I used heavily concentrated pigments of Antwerp blue, ultramarine blue, and sepia for the reflections. For the more distant wave patterns, I reached for light touches of Antwerp blue and sepia.

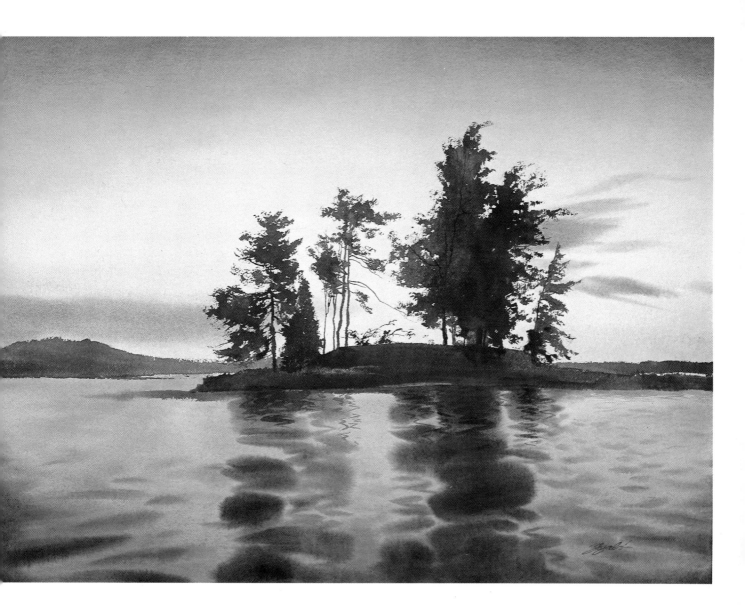

St. Joseph's Island (Step 3)

After these washes were dry, I painted in the distant, hilly shoreline with a simple wash of Antwerp blue and sepia. Using the same color combination, but more concentrated, I painted in the rock of the island and the foliage of the trees with a No. 12 sable brush. I used as much drybrush on the edges as possible to indicate the lacy foliage effect created when trees are silhouetted as a result of back lighting. After this wash dried, I painted the treetrunks and branches with a painting knife, using the same colors but, again, more concentrated. Inside the largest tree, I used almost straight paint, making sure it showed up against the already dark wash. Finally, a few straight detail reflections next to the island finished the job. *Collection Zoltan Szabo Syndicate.*

Assignment: Complete the scene to the left by adding a sunset, using the technique described in this demonstration. For further details, see *Sunsets,* p. 61.

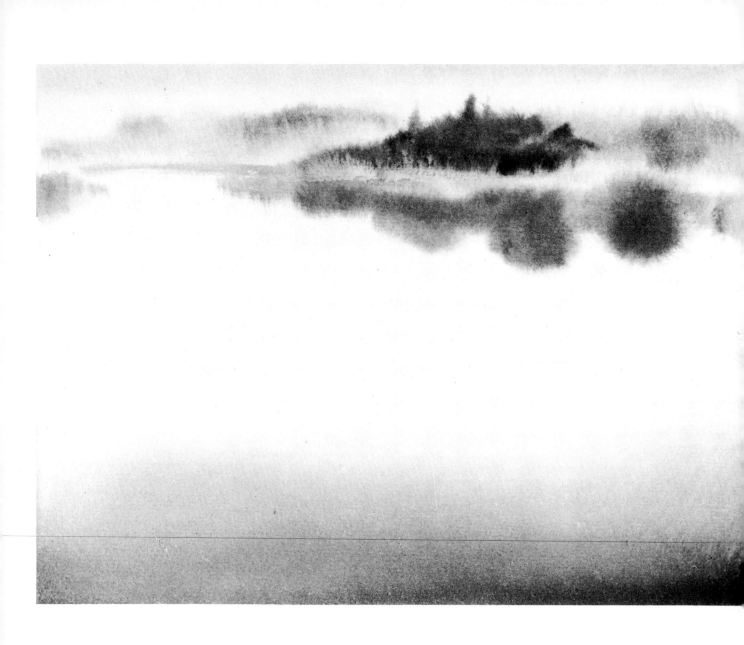

Rattray Estates (Step 1)

300 lb. d'Arches rough finished paper, 22'' x 30''. My palette was yellow ochre, burnt sienna, warm sepia, brown madder, ultramarine blue, Antwerp blue, and charcoal gray. Beginning without any preliminary pencil drawing, I completely saturated the top half of the paper. I used a firm 1'' wide bristle brush for the soft background washes. I started with the misty blue hills, using ultramarine blue and charcoal gray. I painted the partially tree covered hill, then started on the extreme right with a wash of ultramarine blue and warm sepia. I dropped a few brushfuls of burnt sienna into this wash to indicate the brownish shrubs on the slopes. The pine forest near the point of land was done with heavy, concentrated vertical brushstrokes of Antwerp blue, warm sepia, and burnt sienna applied with the same brush. I painted the soft reflection of the hills in the water with the same colors, but with lighter value than the hills directly above them. The light yellow ochre wash between the hills and their reflection helps create a dividing line between hills and water. Then I wet the bottom half of the paper and applied the dark color of the water. I mixed my wash from Antwerp blue, warm sepia, and ultramarine blue. I applied this wash with a soft 1'' wide brush, starting with heavy pigment at the bottom and moving with continuous sweeping strokes from side to side, advancing upward and losing pigment gradually until I lost all color from the brush. This operation seems simple, but you mustn't lift the brush if you want continuous tone. If you stop for any reason, you must load your brush with pigment again and start over from the bottom.

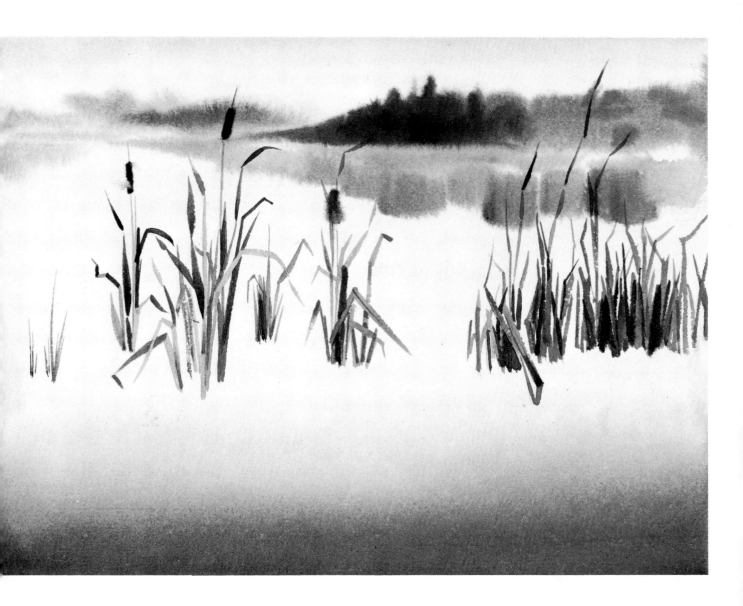

Rattray Estates (Step 2)

After the paper dried, I proceeded with the bulrushes. I started with the plants themselves, without their reflections. Yellow ochre and burnt sienna were used for the leaves, along with lighter greens made from Antwerp blue and yellow ochre. I used a medium size sable brush with a good point to give reality to the twisting, pointed leaves. I proceeded with darker and darker values, using more warm sepia and charcoal gray to create the deeper values that suggest a heavy concentration of weed clumps. Next, I painted the bulrush heads. I applied a single stroke of clean water with a 2″ wide brush to where the soft bulrush head was to come. I picked up almost pure paint of warm sepia and charcoal gray with a medium size sable brush and painted in one wide stroke into the middle of the wet spot. The edges blurred slightly. I repeated this for the others, except that I dragged some of the dark pigment with a small sable brush into the wet area, suggesting the loose, wind-torn seedlings.

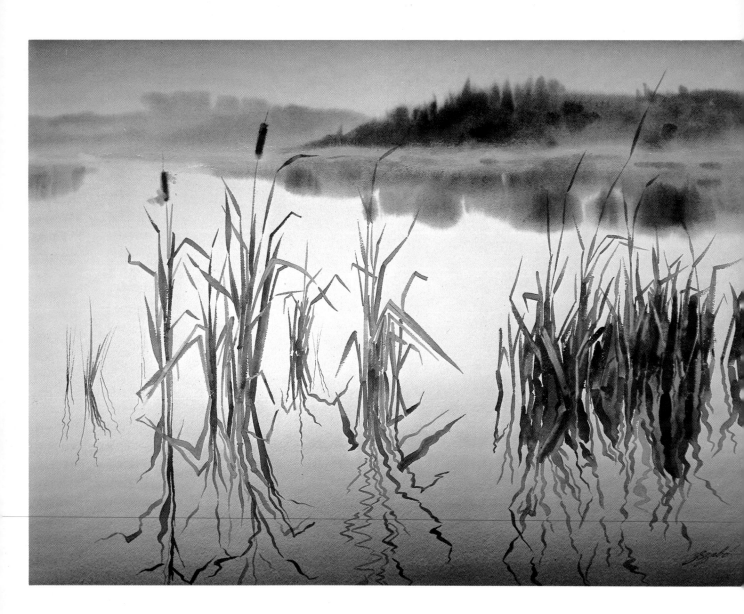

Rattray Estates (Step 3)
In this final stage, I approached the reflections of the bulrush clumps and leaves in the same way as the plants themselves, but I painted them just a little darker — using wavy brushstrokes as I went further from the point where the reflections started. Each protruding leaf and stem has its own reflection, so I followed all of them individually. *Collection Mr. and Mrs. K. R. Shadlock.*

Assignment: Complete the sketch to the left of still water and reflections, using the technique described in this demonstration. For further details, see *Still Water and Reflections*, p. 53.

Lumberman's Bridge (Step 1)
70 lb. d'Arches paper mounted into a painting block, 18″ x 24″. My palette was Hooker's green No. 2, ultramarine blue, Winsor (phthalocyanine) blue, yellow ochre, burnt sienna, warm sepia, and charcoal gray. Beginning without any preliminary pencil drawing, I wet the top half of the paper, allowing two or three spots to dry. I painted in the blue, cloud-torn mountains in the back with a large sable brush, starting at the sharp edge where the green foliage stops. I blended Winsor blue, warm sepia, and charcoal gray into the wet sky.

Lumberman's Bridge (Step 2)
While the top wash was drying, I proceeded with the loose rocks at the bottom left corner. Applying only lighter washes first, using burnt sienna, Hooker's green, and charcoal gray, I followed with the beams of the bridge, using yellow ochre, burnt sienna, ultramarine blue, and charcoal gray. Next, I painted the gushing waters of the creek, combining smooth washes rolling over rocks with drybrush splashes here and there. I used Hooker's green with Winsor blue and charcoal gray.

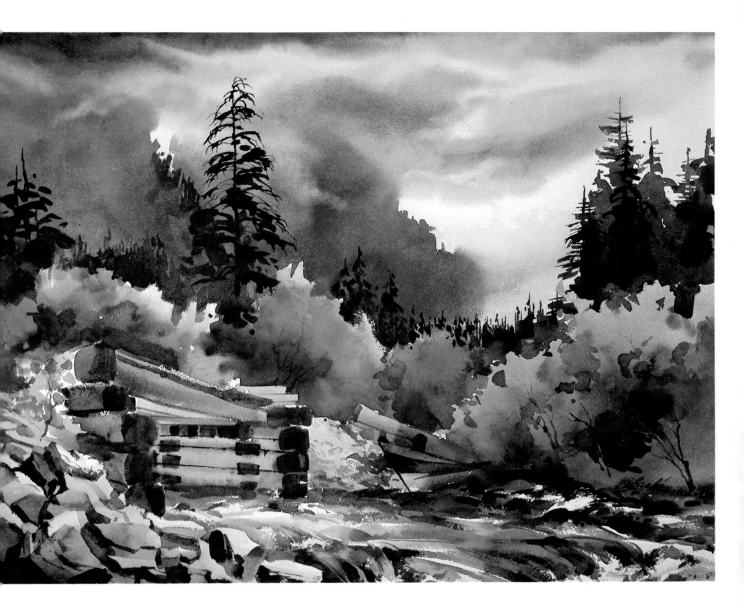

Lumberman's Bridge (Step 3)

In this final stage, I painted the lush green shrubs in the middleground, using yellow ochre, Hooker's green No. 2, and ultramarine blue. Next, I painted the crisp, shaded edges of the rocks into dry pigment on the lower left, as well as the sharp dark modeling in the water. Then I painted the tall, dark pine forest in the middleground, using a medium size sable brush with a good point. Winsor blue, charcoal gray, and warm sepia were my colors. Last, I painted the scrawny pine above the bridge reaching into the clouds. I used a painting knife and a small sable brush over dry pigment. My colors were charcoal gray and Winsor blue. *Collection Dr. and Mrs. D. R. Milloy.*

Assignment: Complete the sketch of moving water to the left, using the technique described in this demonstration. For further details, see *Moving Water, Moving Reflections,* p. 54.

Devil's Paintbrush (Step 1)

Whatman paper mounted onto heavy cardboard, 15''
x 22''. My palette was cadmium yellow medium,
cadmium orange, sepia, brown madder, ultramarine
blue, and charcoal gray. This painting was done very
quickly, with no preliminary pencil drawing. First, I
established the general background wash — many
heavy loads of pigment applied to saturated paper —
with a 1'' wide bristle brush. I used ultramarine blue,
sepia, and charcoal gray in various combinations. The
decorative shapes of the four-leafed weeds suggested
a hint of pattern. I scraped the outline shapes into the
wet wash with the tip of my brush handle wherever
the wet pigment allowed. As this wash started to dry,
just before the shine of the wetness disappeared, I
dropped a heavy brushful of cadmium yellow medium
where the largest flower is located. The fresh load of
wet pigment lifted and pushed aside the dark back-
ground color. I quickly squeezed out the remaining
paint from my medium size sable brush and soaked up
the surface moisture from the flower along with some
extra color. I repeated this touch two more times,
until I had the desired clean color effect, then painted
the two smaller flowers the same way. When the
yellow pigment was drying, but still moist, I painted a
thin line of brown madder with the tip of a fine sable
brush, using a small, circular stroke.

Devil's Paintbrush (Step 2)
Next to the yellow flowers, and directly below them, I painted the broad-leafed weeds, using cadmium orange and ultramarine blue. Again, I used the tip of my brush handle to scrape the veins into the leaves. I added a few quickly drawn hints of weeds to the outside edges. I applied the line effect to dry paper with a bamboo pen dipped into a mixture of charcoal gray and cadmium orange.

Devil's Paintbrush (Step 3)

In this final stage, I wiped back the dry background pigment where the soft yellow flower and bud are located on the top left, using a firm sable brush with a good point which was moist enough to loosen the dry pigment with a gentle scrub. After this, I blotted it up with a tissue. While the paper was still moist, I painted a yellow wash over the flower and modeled the center with a spot of brown madder and charcoal gray. After it dried, I painted the dark thin lines separating the petals. I wiped back the stem of the large flower (called a devil's paintbrush) where the background was dark and continued it with a dark line as the background faded into light value. In this way, I created enough contrast to show the stem. *Collection Mr. and Mrs. J. K. Russell.*

Assignment: Add weeds, flowers, etc. to the composition on the left, using the methods described in this demonstration. For further details, see *Undergrowth, Shrubs, and Weeds,* p. 49.

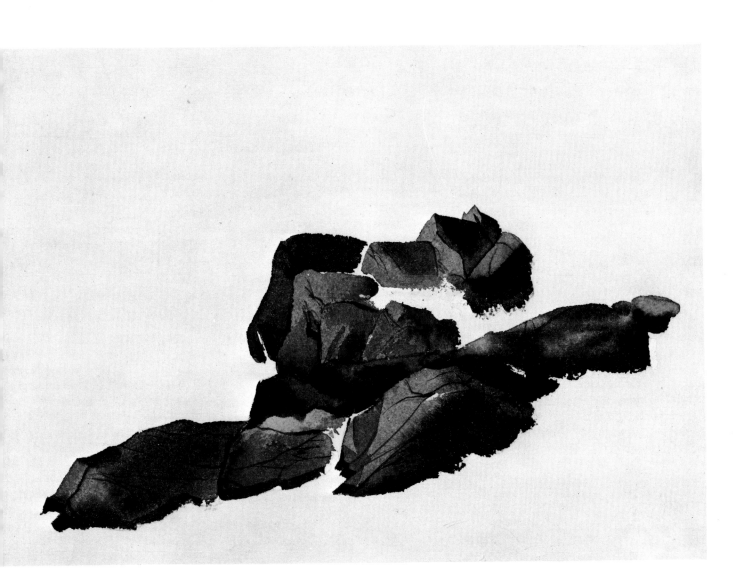

Black Brook Creek (Step 1)
Whatman paper mounted on heavy cardboard, 11″ x 15″. My palette was cadmium orange, burnt sienna, brown madder, charcoal gray, Winsor (phthalocyanine) blue, and ultramarine blue. I painted these bright rocks in the setting sun with no preliminary pencil drawing. I established the whole painting in half an hour. The reddish color of the rocks was tackled first. I painted each rock to completion, one at a time, as I went along. I used a No. 10 sable brush, freely loaded with cadmium orange and burnt sienna for the sunlit spots. Brown madder helped with the modeling. Ultramarine blue mixed with the previous colors supplied the shaded sides of the wet rocks; the hues reflecting the sky's blue color came from the addition of a little Winsor blue. I scraped the cracks of the rocks into the wet wash with the point of my brush handle and allowed drybrush strokes to freely define the white foamy splashes along the lower edges.

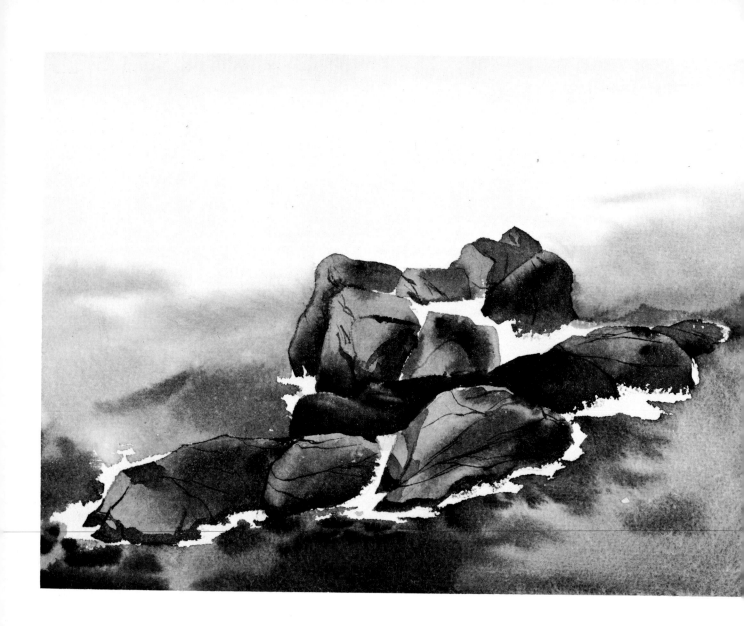

Black Brook Creek (Step 2)
I wet the remaining part of the paper, except the spots next to the rocks, where I tried to preserve the white foam and prevent the blue wash of the water from creeping in. Then I applied large, dark tones of Winsor blue and a touch of cadmium orange. Going from dark at the bottom to lighter at the top, I imitated the movement of the waves with the brushstrokes, permitting them to blend gently on the wet paper.

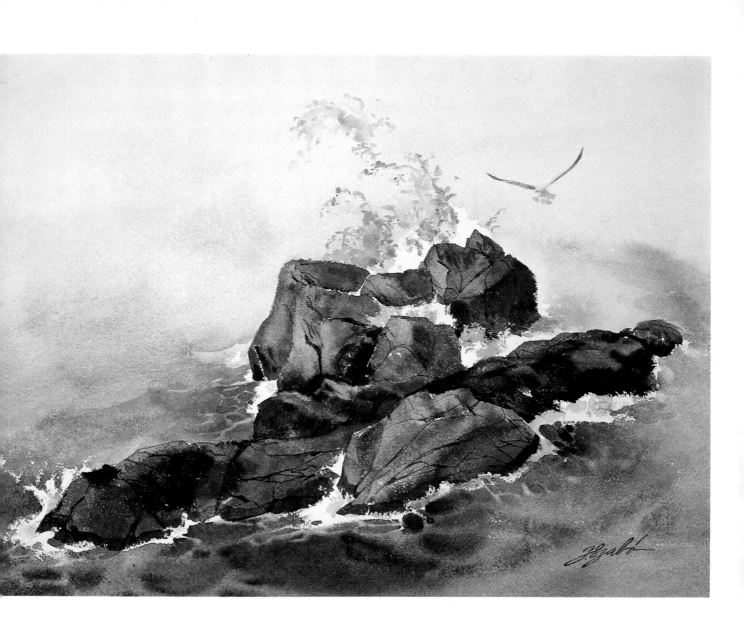

Black Brook Creek (Step 3)

In this final stage, I finished the water by adding dark washes close to the foam, allowing thin light lines to survive between them. This gives the impression of white foam gently dissolving into water. Next, I painted the large splashes of water reaching up from behind the rocks. I used a medium size sable brush and the same colors as for the main body of water. Then in a drybrush technique I painted in a few splashes of ultramarine blue and charcoal gray where the white foam was in the shadow of the rocks. Finally, I painted the lone seagull with ultramarine blue and charcoal gray. *Collection Mr. and Mrs. L. R. Kingsland.*

Assignment: Paint the rocks in the seascape to the left, using the technique described in this demonstration. For further details, see *Rocks,* p. 50.

Snake Fence (Step 1)
Whatman paper mounted on heavy cardboard, 11" x 15". My palette was yellow ochre, burnt sienna, warm sepia, manganese blue, Antwerp blue, ultramarine blue, and charcoal gray. I wet the whole paper and applied gentle washes of ultramarine blue and sepia to model the deep, distant snow and the edge of the forest on top. For the snow, I used the same colors, but much more sepia than ultramarine blue. The scattered young trees were followed by the two young birches on the left middleground, finished in slightly more detail, including some burnt sienna drybrush touches.

Snake Fence (Step 2)
The partially snow-buried snake fence came next. I used drybrush strokes almost exclusively, varying manganese blue, yellow ochre, burnt sienna, sepia, and charcoal gray washes to complement and detail the aged wood.

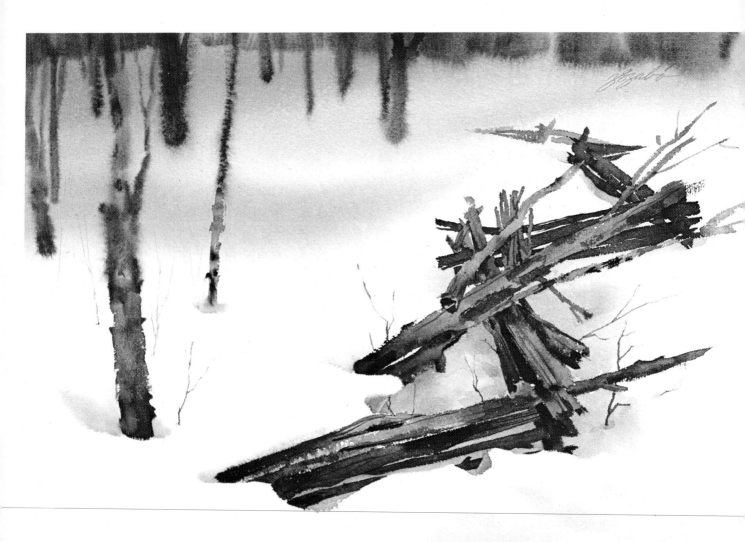

Snake Fence (Step 3)
Then, in this final stage, I modeled the deep snow next to the fence, using ultramarine blue, sepia, and charcoal gray. The fine twigs in the snow completed the composition. *From the Painters of Canada Series, Courtesy of Coutts Hallmark Cards. Private Collection.*

Assignment: Add a fence of any type to the scene to the left. For further details, see *Fences*, p. 63.

Old Stump (Step 1)

300 lb. d'Arches rough finished paper, 15'' x 22'' (half sheet). My palette was cadmium lemon, cadmium yellow medium, burnt sienna, Vandyke brown, brown madder, ultramarine blue, and charcoal gray. I started with the center of interest, with no preliminary pencil drawing. The stump was my first step. Using a large, soft sable brush, I applied large washes of burnt sienna, charcoal gray, brown madder, and ultramarine blue in the shadow areas. I modeled the surface as I advanced on the drying paper.

Old Stump (Step 2)
I followed with the foreground, painting it in ultra-marine blue and charcoal gray, with touches of burnt sienna. This color makes the foreground appear to be on a shaded elevation.

Old Stump (Step 3)
I used light colors (cadmium lemon, cadmium yellow medium, ultramarine blue, and charcoal gray) for the background to make it look lit by the sun and to contrast with the stump. I painted generous washes onto wet paper, allowing them to ooze into soft modeling. Last, I painted in the little twig in the right foreground, scraped in the light definitions on the stump with the dull edge of a pocket knife, and slapped in the tall weeds with a painting knife. *Collection Mrs. Elizabeth Szabo.*

Assignment: Complete the sketch of a freshly cut stump to the left. For further details, see *Stumps and Moss,* p. 48.

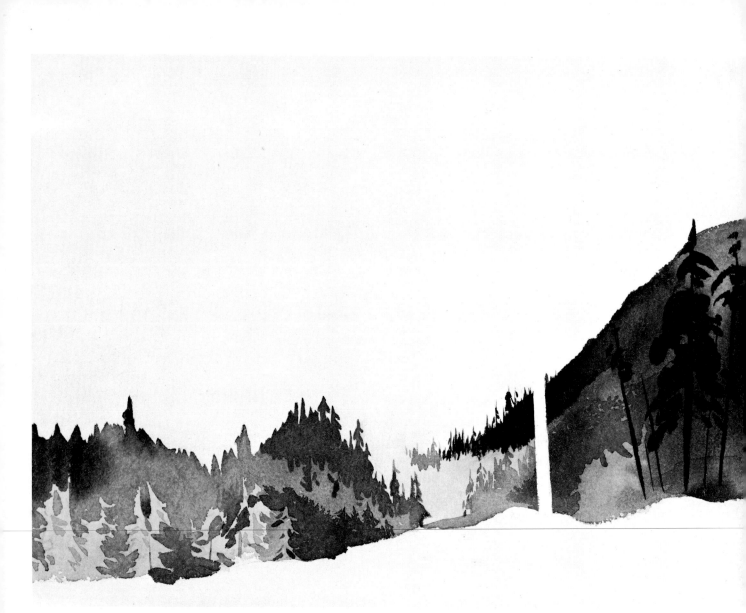

Young Forest (Step 1)

300 lb. d'Arches rough finished paper, 26″ x 28″. My palette was cadmium lemon, burnt sienna, Hooker's green No. 2, cobalt blue, ultramarine blue, and charcoal gray. I started with a large, quick wash of Hooker's green and cadmium lemon over the area of the young forest. After this dried, I applied the details of the evergreens with the same color, but a little darker. To get the right shade, I added ultramarine blue.

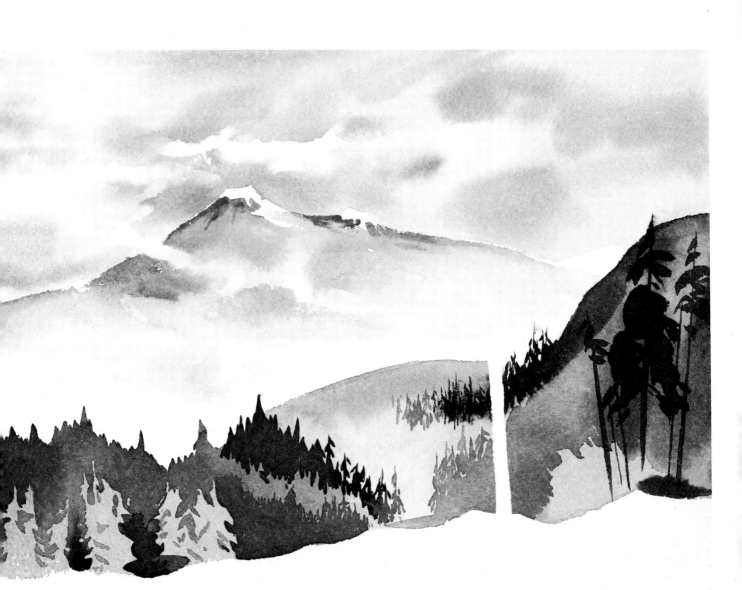

Young Forest (Step 2)
Next came the sky. I applied generous washes of cobalt blue, burnt sienna, and charcoal gray, allowing them to touch and blend here and there. As I reached the white mountain peak, I continued as before, except I switched to ultramarine blue, cobalt blue, and a touch of charcoal gray. The round mountaintop in the middle center has the same colors, but they're deeper in value.

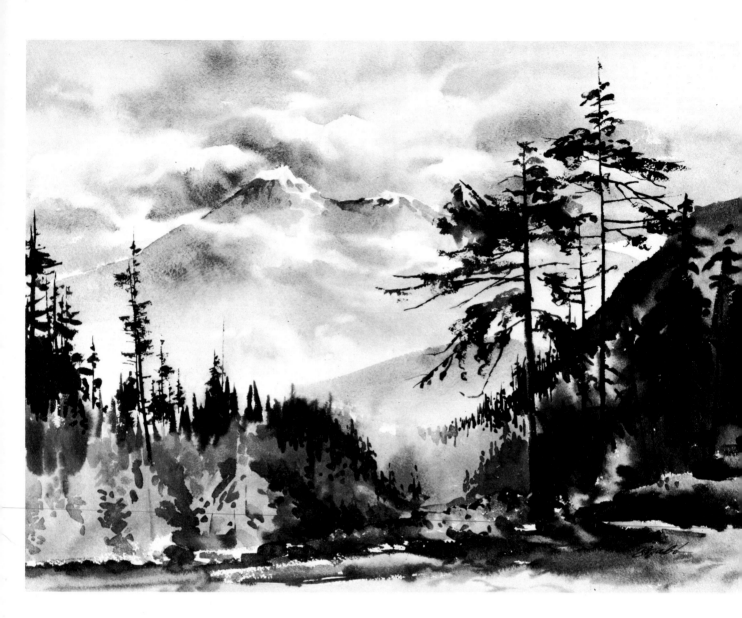

Young Forest (Step 3)

In this final stage, I continued with the earthy foreground, using charcoal gray, burnt sienna, and ultramarine blue in a direct painting method on dry paper. Last, I painted in the scrawny evergreens that had survived a forest fire. The technique was painting knife and drybrush, and the colors were Hooker's green and charcoal gray. *Private Collection.*

Assignment: Complete the sketch of evergreen trees to the left. For further details, see *Evergreens and Palm Trees,* p. 45.

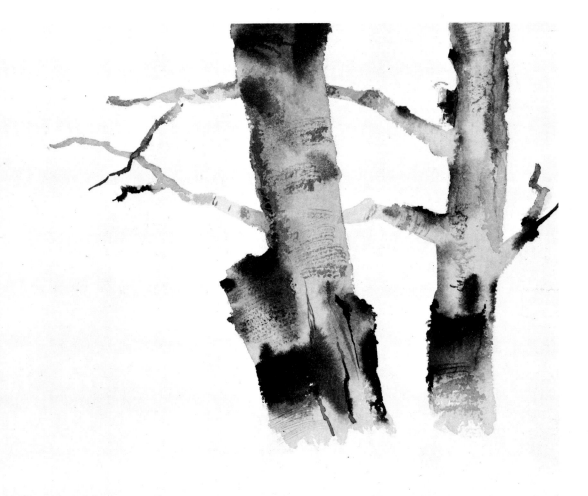

Birch Couple (Step 1)
Whatman paper mounted on heavy cardboard, 15" x 22". My palette was cadmium yellow medium, cadmium orange, yellow ochre, burnt sienna, Vandyke brown, ultramarine blue, Antwerp blue, and charcoal gray. With no preliminary pencil drawing, I started with the heavy birch trunk, using a thin shade of charcoal gray and ultramarine blue, applied with a 1" wide bristle brush. While this wash was wet, I applied darker values of the same color to the softly modeled shade. I scraped the fine line details into the wash before it dried with my brush handle and painted the dark spot near the bottom where the white bark had peeled off. I went through the same procedure with the other birch on the right, painting the heavier light branches behind the other trees.

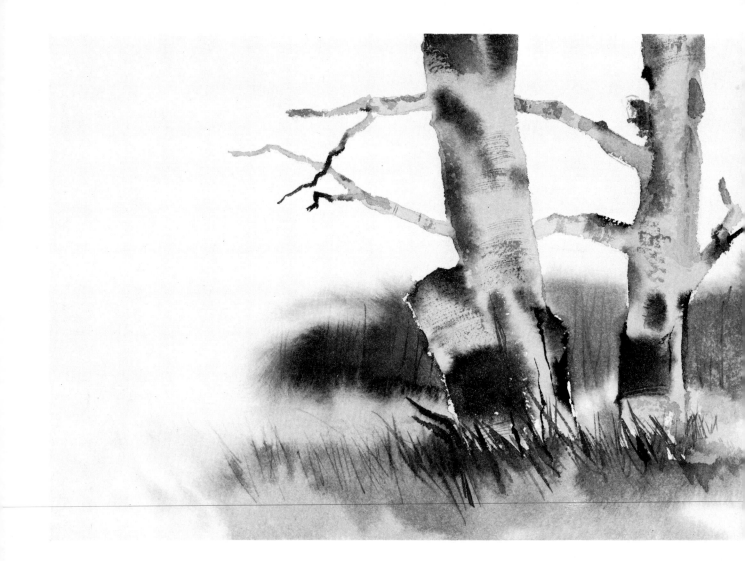

Birch Couple (Step 2)

I wet the paper with a wide bristle brush where the distant autumn forest blended into the sky. First, I painted the dark treetrunk area of the forest, using a charcoal gray and Vandyke brown wash varied with a touch of burnt sienna. A light wash of cadmium orange and burnt sienna followed, indicating the foliage part of the forest. Note the happy accident of backrun between these two washes in the low center of the painting. The thin trees were defined with the brush handle, indicating the edge of the forest. The soft washes of the weeds, done in yellow ochre, burnt sienna, and Antwerp blue, created the playful bounce in the foreground and the middleground.

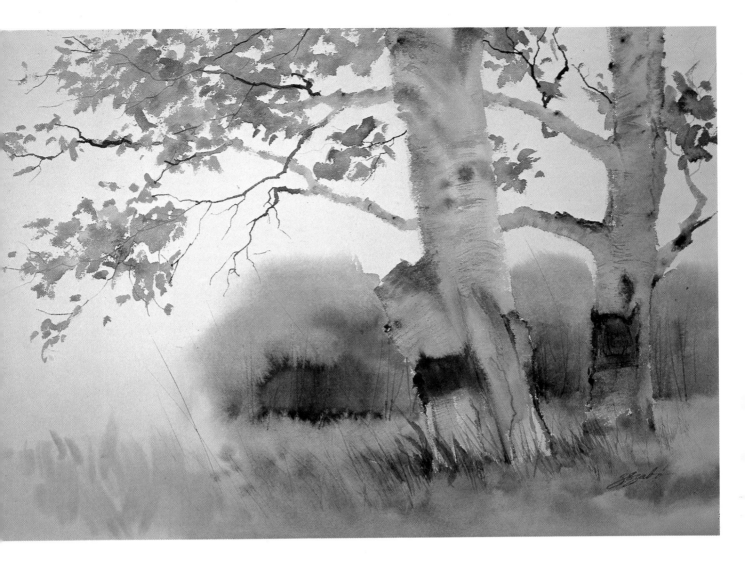

Birch Couple (Step 3)

In this final stage, I painted the clumps of foliage, bouncing from one clump to the next, back and forth, switching brushfuls of color, and allowing them to blend here and there. I used cadmium yellow medium, Antwerp blue, burnt sienna, and Vandyke brown to give variety to the leaves. I continued with the fine branches which connect the foliage with the heavier branches. I applied the final details to the fine weeds with a small brush and the edge of a painting knife. After a few more details on the treetrunks, defined with drybrush strokes, the painting was finished. *Collection Mr. and Mrs. L. R. Kingsland.*

Assignment: Add some deciduous trees to the scene on the left. For details, see *Deciduous Trees,* p. 44.

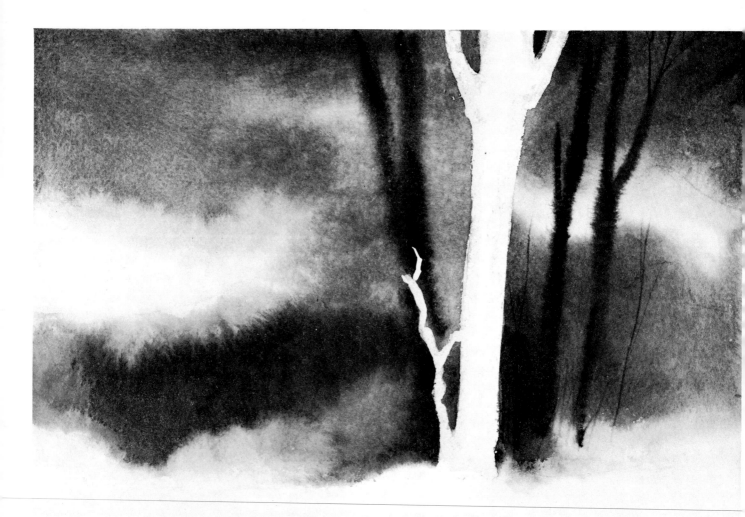

Birch at Hart Lake (Step 1)

Whatman paper mounted on heavy cardboard, 11" x 15". My palette was charcoal gray, ultramarine blue, yellow ochre, burnt sienna, Vandyke brown, and brown madder. Beginning without any preliminary pencil drawing, I started with the background. I wet the top three-quarters of the paper with clean water, avoiding the birch treetrunk area, as well as the young birch trunk. I painted the threatening, stormy sky with a heavy layer of Vandyke brown, ultramarine blue, and charcoal gray, using a soft, 1" wide brush. Then I painted the dense, leafless forest in the distance, using the same colors, but darker in value. I swept a few strokes of heavy pigment, indicating blurry dark trees in the middleground, using a small sable brush with hardly any water. Before these washes had a chance to dry, I scraped a few young trees in with the tip of my brush handle.

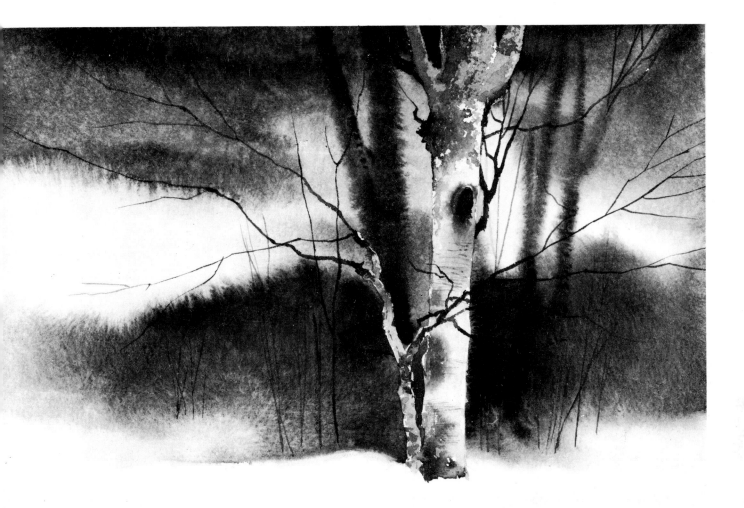

Birch at Hart Lake (Step 2)

After these washes had dried, I finished the birch tree with burnt sienna, charcoal gray, and Vandyke brown. Some horizontal lines on the dark parts were scraped into wet washes with the tip of my brush handle. On the stem of the young tree, I used an abundance of burnt sienna, brown madder, and yellow ochre. The fine branches hanging off sideways were done with painting knife strokes freely dragged into the dry paper.

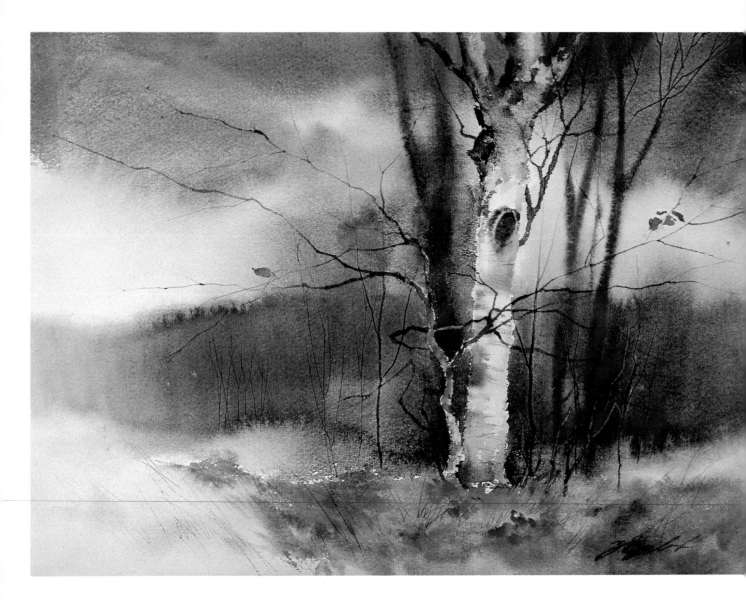

Birch at Hart Lake (Step 3)

In this final stage, I wet the foreground, which, so far, had been untouched. I painted splashy touches of burnt sienna and brown madder, which allowed greens to peep through. The green was made from yellow ochre and a touch of ultramarine blue. The crisp weed lines were scraped with the tip of my brush handle into the wash. While this area was drying, I carefully painted the few dry leaves clinging to the branches. Burnt sienna and brown madder silhouette these leaves nicely against a light background. I applied the few thin blades of grass on the lower left with the edge of the painting knife after the paper dried. *Collection Mr. and Mrs. J. W. Bessey.*

Assignment: Complete the forest sketch to the left, noting that there's forest in the distance as well as in the foreground. For further details, see *Forests,* p. 46.

Beech Tree Against the Sky (Step 1)
Whatman paper mounted on heavy cardboard, 11'' x 15''. My palette was cadmium lemon, warm sepia, cobalt blue, Antwerp blue, and charcoal gray. A vignetted freedom gives this sketch its spring-like feeling. To achieve this, I wet the top half of the paper with clear water, using a soft sponge. I painted a wide wash of cobalt blue, Antwerp blue, and charcoal gray on the left center of the sky, then dragged two more wide sweeps into the wet area directly above the first stroke, achieving the wind-swept feeling of the sky.

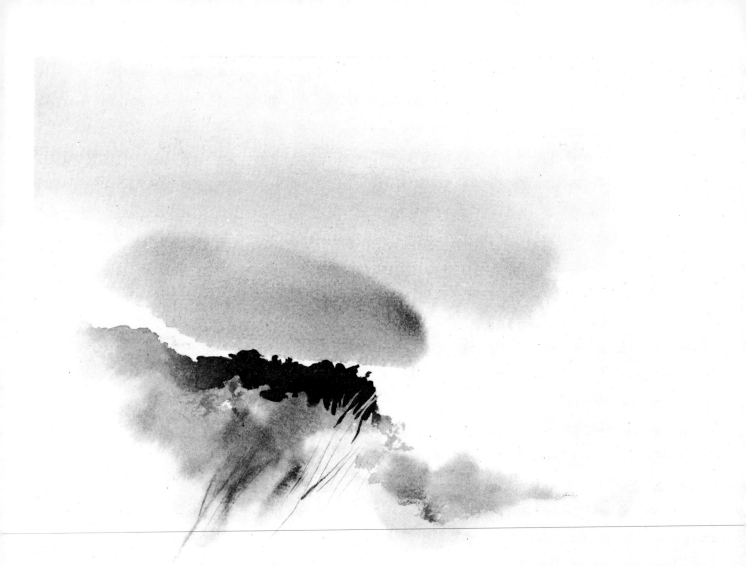

Beech Tree Against the Sky (Step 2)
I wet the bottom half of the paper, using a wide but thin bristle brush, then went on to the grass in the foreground. I used cadmium lemon, Antwerp blue, and cobalt blue to get my variety of greens.

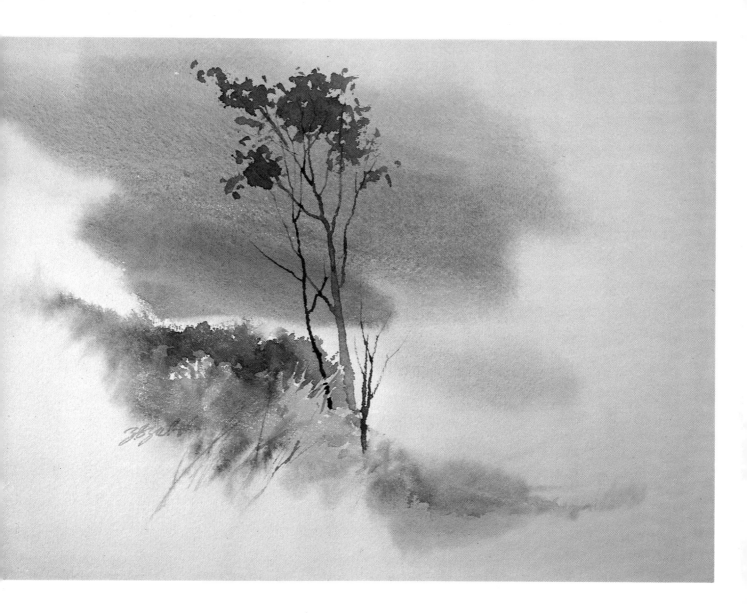

Beech Tree Against the Sky (Step 3)

In this final stage, I painted the loose green foliage of the tall young tree on top of the dry background with a medium size sable brush, then painted the main treetrunk with the same brush, using Antwerp blue, cadmium lemon, and charcoal gray. I used a painting knife to paint the loose, wiggly, thin branches which connect the foliage to the main trunk. Next, I carefully placed the two dry, scrawny trees next to the live one, creating a gentle contrast. I used Antwerp blue and charcoal gray for this. Finally, with the help of a painting knife, I added a few thin weeds in the lower left foreground for the last touch. *Collection Mrs. Marjorie Sutton.*

Assignment: Complete the sketch to the left of a day in early spring. For further details, see *Spring,* p. 39.

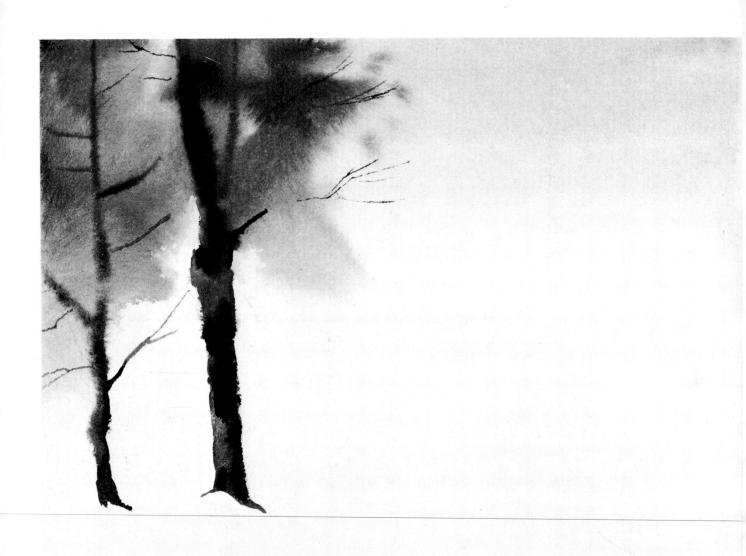

Passing of Day (Step 1)
Whatman paper mounted on heavy cardboard, 11" x 15". My palette was Antwerp blue, ultramarine blue, cadmium lemon, raw sienna, burnt sienna, sepia, and brown madder. With no preliminary pencil drawing, I wet the sky area with clear water. I put a bit of Antwerp blue into this wash, starting at the top with horizontal strokes of a wide, soft brush, and losing color strength as I advanced toward the horizon. I painted the soft, blurred foliage of the foreground trees into this moist wash, continuing their trunks into the dry lower half.

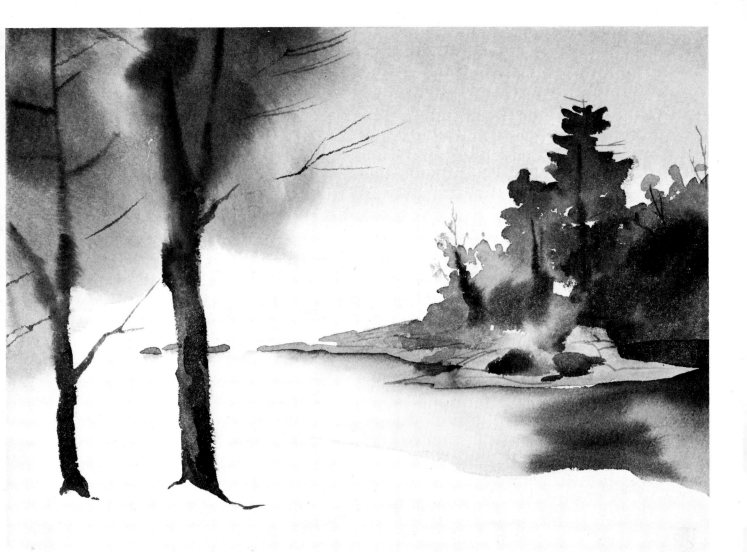

Passing of Day (Step 2)

The rocky point of land in the middleground was followed by the lush bushes and trees. First, I painted the rocks with simple washes of burnt sienna, brown madder, and a touch of sepia. While these washes were still wet, I scraped in some rock design with the tip of my brush handle. I painted the lush foliage with rich loads of cadmium lemon, Antwerp blue, and sepia, allowing the separate brushfuls of color to blend slightly wherever they touched each other. For the tall pines, I used a No. 6 round sable brush, applying a quick wash which encouraged the edges to remain as loose drybrush touches. I painted a few branches and twigs with a painting knife, using a scraping motion. Next, I wet the area directly below the rocks with clear water and painted in the reflections while the paper was still saturated.

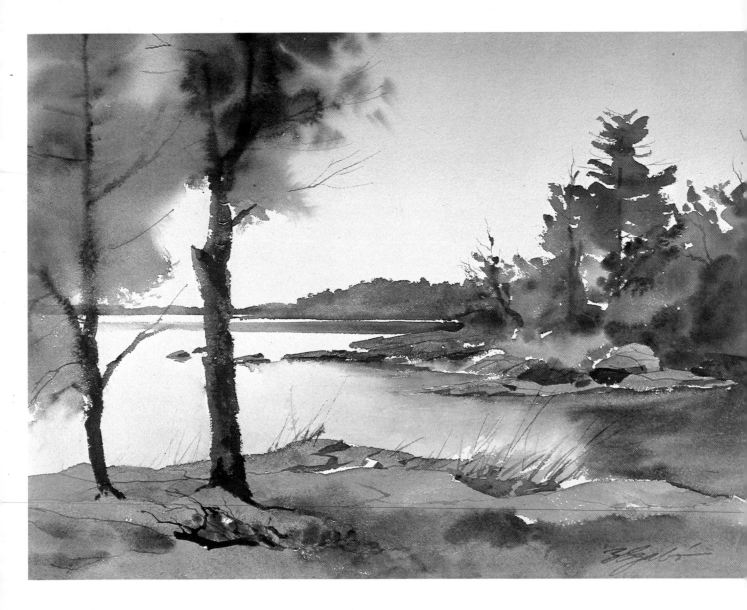

Passing of Day (Step 3)
While the reflections were drying, I painted the distant shoreline and the reflecting breeze mark into the white water area directly below it. The foreground rocks followed next. Medium strong washes of burnt sienna, Antwerp blue, ultramarine blue, and cadmium yellow were blended slightly to create an interesting color pattern. Cracks in the rocks were done with the tip of my brush handle; the thin, dark lines were done with a fine brush. Finally, I did the fine weeds in the foreground with a painting knife. *Collection Mr. and Mrs. L. R. Kingsland.*

Assignment: Complete the sketch to the left of a summer day. For further details, see *Summer*, p. 40.

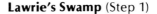

Lawrie's Swamp (Step 1)
Whatman paper mounted on heavy cardboard, 11'' x 15''. My palette was vermilion, yellow ochre, burnt sienna, ultramarine blue, sepia, alizarin crimson, and charcoal gray. With no preliminary pencil drawing, I wet the top third of the paper with a soft sponge. I painted heavy loads of ultramarine blue and charcoal gray washes, indicating the distant forest. Vermilion mixed with burnt sienna and yellow ochre were the colors I used in equally heavy concentration to indicate autumn foliage at the top of the forest. A few loose ultramarine blue and charcoal gray washes at the very top gave the effect of an overcast sky.

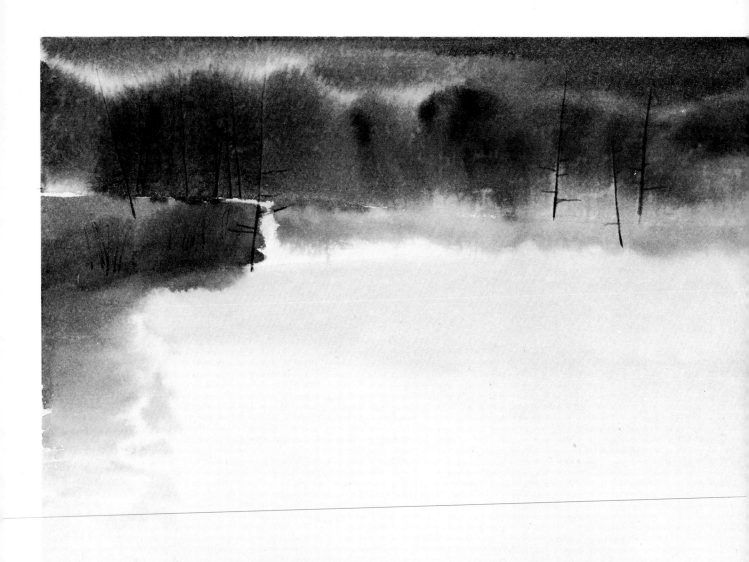

Lawrie's Swamp (Step 2)
Immediately after I wet the bottom portion of the
paper, the sponge touched still-wet paint (right half of
the painted area) and created a quick, blurry run. This
indicated reflection and was particularly successful
with the yellow ochre weeds in the top center area.
On the left center, I painted the massive, pale green
weeds and rushes in the distance and dragged their
reflection into the lower edge on the left hand side.
While the bottom half of the paper was still soaking
wet, I applied a large wash of a gentle shade by mixing
ultramarine blue and charcoal gray.

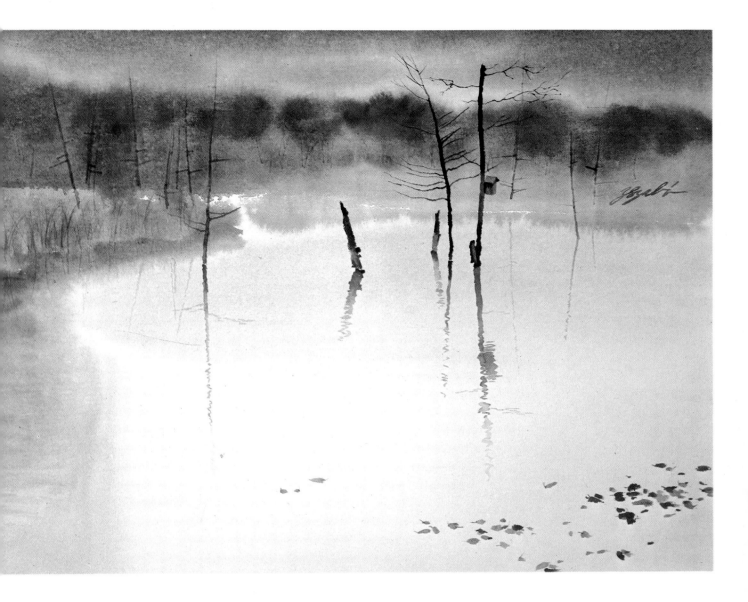

Lawrie's Swamp (Step 3)

With a painting knife, using sepia and charcoal gray, I painted in the dead, scrawny trees on the top left, as well as the other branch covered, dead trees in the right background and the center middleground. The two stumps and the dead tree with the birdhouse are the result of brush application on a dry background. For these, I used burnt sienna, sepia, and charcoal gray, loosely intermingled. Next, I painted the reflections of the trees and stumps, carefully painting the wiggly water movement near the lower edge of the reflections. After this, I painted the floating leaf in the lower right foreground. I used yellow ochre, burnt sienna, vermilion, and alizarin crimson. Last came the birdhouse on the tree and its reflection, painted with ultramarine blue, sepia, and a touch of charcoal gray. *Collection Dr. and Mrs. N. A. Sleeva.*

Assignment: Complete the autumn scene to the left. For further details, see *Autumn,* p. 41.

Wanapetei River (Step 1)
Whatman paper mounted on heavy cardboard, 11″ x
15″. My palette was Antwerp blue, ultramarine blue,
charcoal gray, yellow ochre, burnt sienna, sepia, and
brown madder. With no preliminary pencil drawing, I
wet the top quarter area where the distant forest is
indicated. Using a 1″ wide bristle brush, I applied a
wash of varied density mixed from sepia, Antwerp
blue, and ultramarine blue. I let the color concentrate
only at the lower part, where the forest meets the
snow covered hill. I scraped the hints of many trees
into this wet wash with the tip of my brush handle.

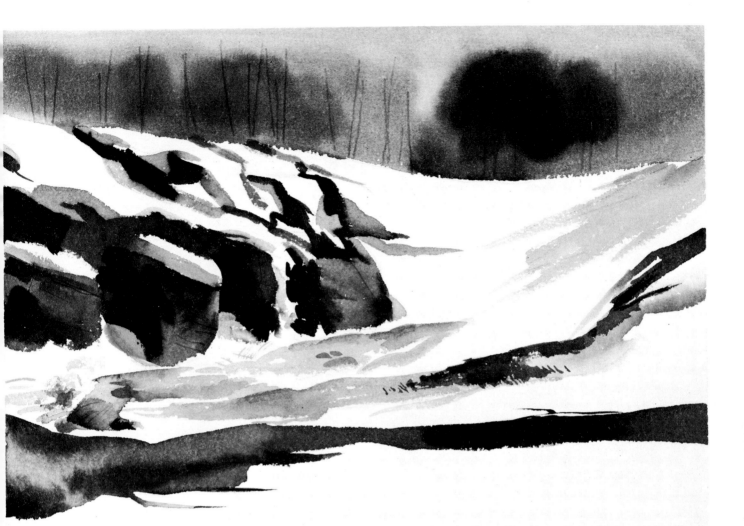

Wanapetei River (Step 2)

I painted in the large boulders in left center, as well as the weedy rocks directly below the cedar clumps in right center. I used burnt sienna, sepia, and a little brown madder to get the color of the rocks. A loosely handled ultramarine and sepia wash followed to show the thickness of the snow on the rocks and the modeling on the right, directly below the distant forest. I used the same color to show the shadows of the cedar clumps on the snow. Next, I painted the rushing water in the center, below the rocks, with yellow ochre, Antwerp blue, and charcoal gray. Across the lower third of the painting, on dry paper, I painted the blue-green water showing through the cracked ice. I used a medium size sable brush with a fine point, which proved an excellent tool to render the cracks in the breaking ice.

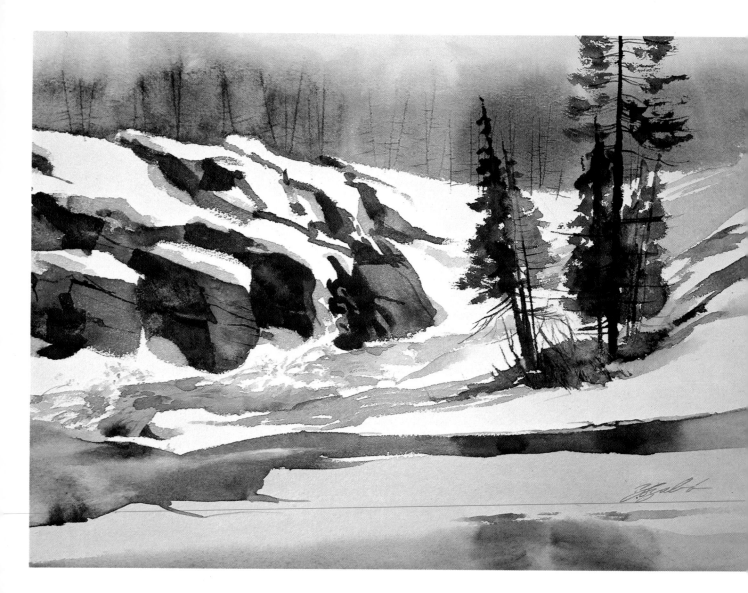

Wanapetei River (Step 3)
In this final stage, I painted the cedar clumps onto a dry background with a large size sable brush, using a drybrush technique to show the silhouette form of the foliage. I used burnt sienna, yellow ochre, and Antwerp blue in freely varied concentrations. Then I painted into these wet treetrunks with a small sable brush, using charcoal gray and Antwerp blue. While these touches were still wet, I applied the thin, scrawny branches with a painting knife by dragging the existing washes away from the treetrunks in rapid sequence. I also used a painting knife to indicate the loose twigs under the cedars. The last touch was the gentle reflection on top of the melting snow on the extreme bottom. The blue-gray color of this wash helped give this painting its three dimensional feeling. *Collection Mr. F. J. Robinson.*

Assignment: Complete the scene to the left of winter snow and ice. For further details, see *Winter*, p. 42.

The Weak One (Step 1)
Whatman paper mounted on heavy cardboard, 11″ x 15″. My palette was yellow ochre, burnt sienna, sepia, Hooker's green No. 2, ultramarine blue, and Antwerp blue. First, I wet the whole paper. I painted on the large, modeling washes of the snow with a soft, 1″ wide, flat brush, using ultramarine blue and sepia for color.

The Weak One (Step 2)
While the paper was still moist, I applied quick, small strokes for the pine branches. As the edges softened, I scraped in the needles with the tip of my brush handle. Later, I connected these little branches and painted the heavy snow on top to exaggerate the delicacy of the young tree. For the thin trunk, I used a painting knife with sepia and ultramarine blue color.

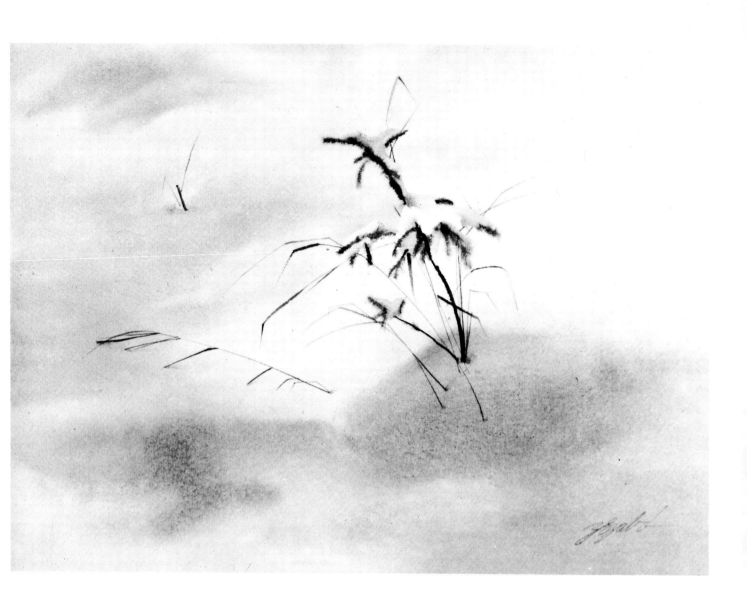

The Weak One (Step 3)
The delicate grass blades were done in this final stage. In order to complement my composition, they had to be painted individually, and I had to take great care with their design. I used yellow ochre, burnt sienna, sepia, and Antwerp blue in varied combinations to get the color of the dried weeds. *Collection Mr. and Mrs. T. Beckett.*

Assignment: Complete the painting in the sketch to the left, noting that there are three distinct planes: foreground, middleground, and background. Choosing which plane to emphasize is also part of choosing your subject. For further details, see *Choosing Your Subject,* p. 26.

Yesterday's News (Step 1)
300 lb. d'Arches rough finished paper, 22″ x 30″. My palette was yellow ochre, burnt sienna, sepia, ultramarine blue, and charcoal gray. First, I wet the paper. I painted the top edge of the hill, using ultramarine blue and sepia in varying combinations. I found my chisel tipped, 1″ wide bristle brush ideal for the effect I wanted. I went on to indicate the soft modeling of the snow and weeds. As drying permitted, I added details of grass clumps, using yellow ochre and sepia combinations.

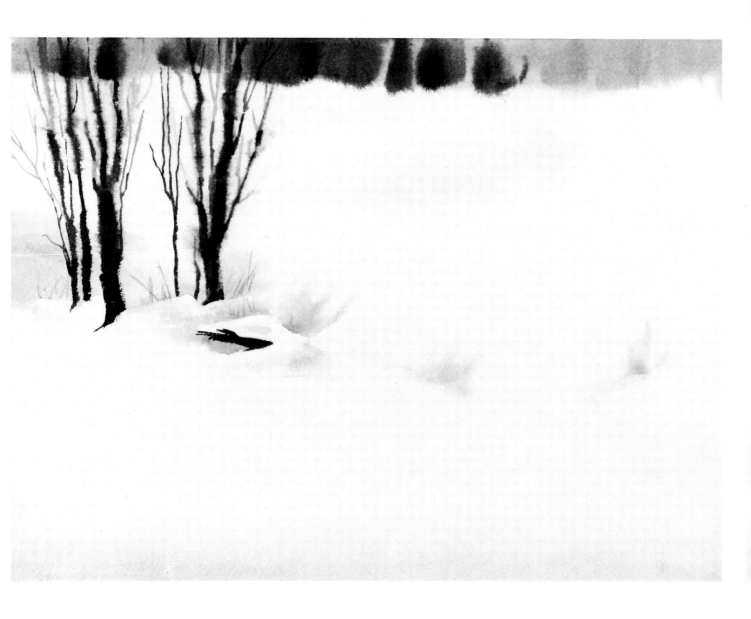

Yesterday's News (Step 2)
While the paper was still damp, I painted the young trees with a palette knife. Heavily concentrated sepia and charcoal gray supplied the right color. These scraping strokes went soft where the paper was moist and stayed sharp where the paper had dried.

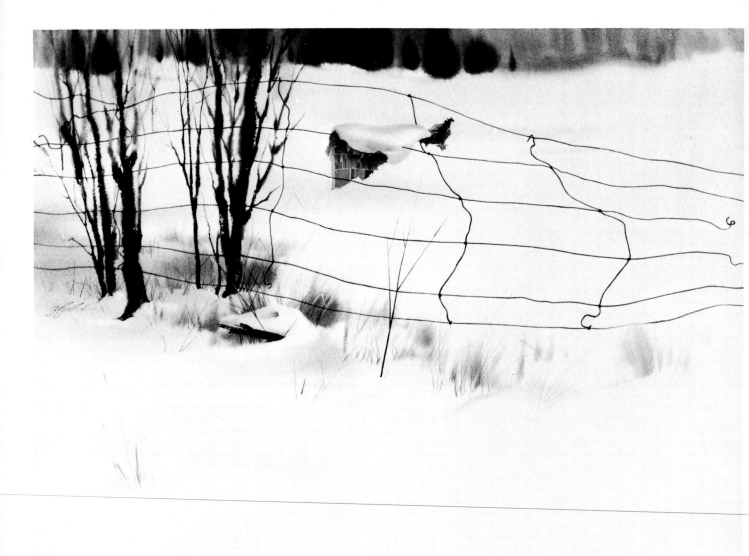

Yesterday's News (Step 3)

In this final stage, I used a worn-out, No. 2 sable brush loaded with charcoal gray to touch the wire fence with burnt sienna here and there to make it appear rusty. Then I painted the newspaper on the wire with yellow ochre and burnt sienna. I finished the painting with the snow on the newspaper and the finishing details on the weeds, particularly the clumps in the left foreground. *Collection Mr. F. J. Robinson.*

Assignment: Complete the simple subject to the left, emphasizing the detail of the chain as the focal point. For further details, see *Simple Subjects,* p. 27.

Memories (Step 1)

300 lb. d'Arches medium rough paper, 15'' x 22'' (half sheet). My palette was yellow ochre, burnt sienna, Vandyke brown, brown madder, ultramarine blue, and charcoal gray. With no preliminary pencil drawing, I wet the top half of the paper and painted in the sky, using heavily loaded brushfuls of ultramarine blue, Vandyke brown, and charcoal gray washes. I let these strokes flow freely.

Memories (Step 2)
After the sky had dried, I painted the burned-out house. The brick walls and the rubble were done with simple washes of burnt sienna and brown madder. The interior walls were dirtied yellow ochre tones. I painted the burned-out details as well as the fence on the right center with well-defined charcoal gray brushstrokes.

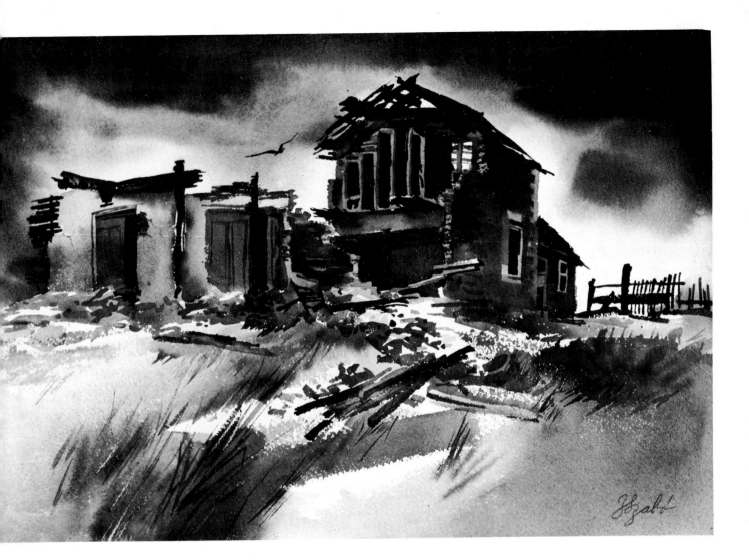

Memories (Step 3)
In this final stage, the foreground creates a lead-in pattern toward the building. I used yellow ochre, ultramarine blue, and Vandyke brown to create the dried-up, weedy colors. As a final touch of ghostly neglect, I dropped the lonely crow in above the ruins. *Collection Dr. and Mrs. E. Hersak.*

Assignment: Add as much detail as you can to the composition to the left without crowding the page. For further details, see *Complex Subjects,* p. 28.

BIBLIOGRAPHY

Blake, Wendon, *Acrylic Watercolor Painting*, Watson-Guptill, New York, 1970

Brandt, Rex, *Watercolor Technique*, 6th ed., revised, Reinhold, New York, 1963

Guptill, Arthur, edited by Susan E. Meyer, *Watercolor Painting Step-by-Step*, Watson-Guptill, New York, 1967

Hilder, Rowland, *Starting with Watercolour*, Watson-Guptill, New York, and Studio Vista, London, 1967

Kautzky, Ted, *Painting Trees and Landscape in Watercolor*, Reinhold, New York, 1952

Kautzky, Ted, *Ways with Watercolor*, 2nd ed., Reinhold, New York, 1963

Kent, Norman, edited by Susan E. Meyer, *100 Watercolor Techniques*, Watson-Guptill, New York, 1968

O'Hara, Eliot, *Watercolor with O'Hara*, Putnam, New York, 1965

Olsen, Herb, *Watercolor Made Easy*, Reinhold, New York, 1955

Pellew, John C., *Painting in Watercolor*, Watson-Guptill, New York, 1970

Pike, John, *Watercolor*, Watson-Guptill, New York, 1966

Whitaker, Frederic, *Whitaker on Watercolor*, Reinhold, New York, 1963

Whitney, Edgar A., *Complete Guide to Watercolor Painting*, Watson-Guptill, New York, 1965

INDEX

Edited by Margit Malmstrom
Designed by James Craig
Set in ten point Optima by Wellington-Attas Computer Composition, Inc.
Printed and bound in Japan by Dai Nippon Printing Company.